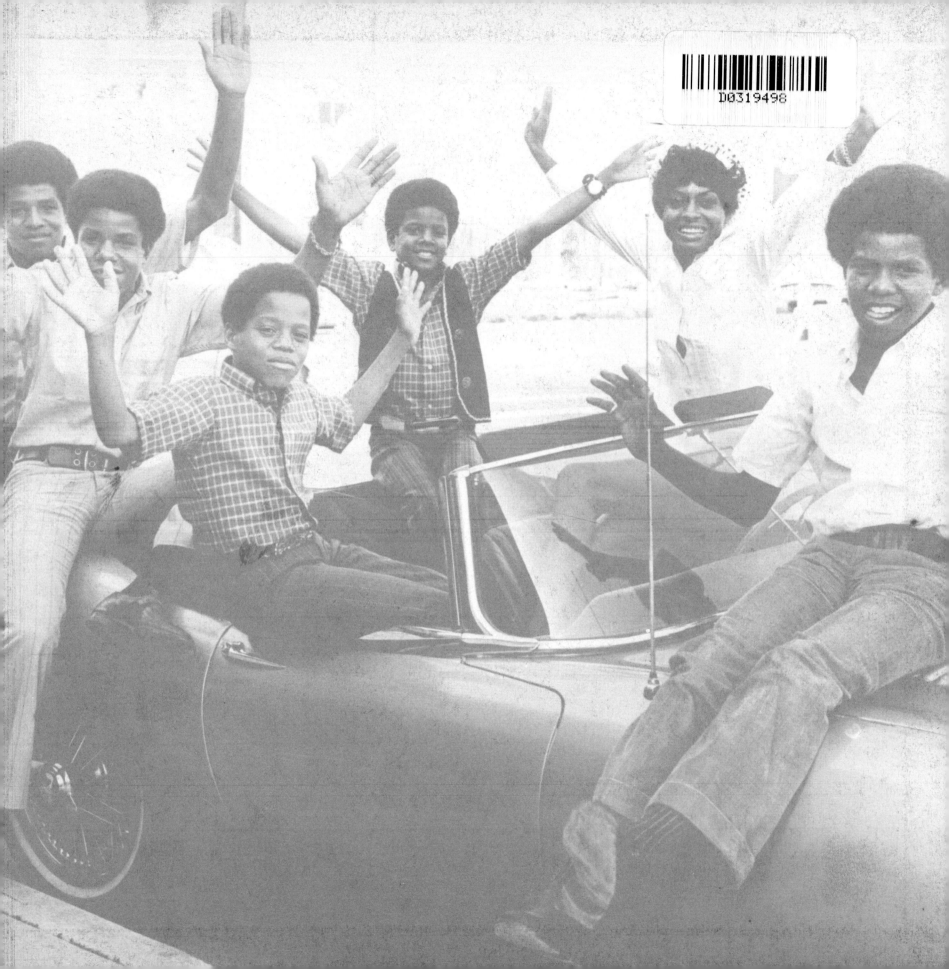

STARS AND CARS

STARS AND CARS

TONY NOURMAND

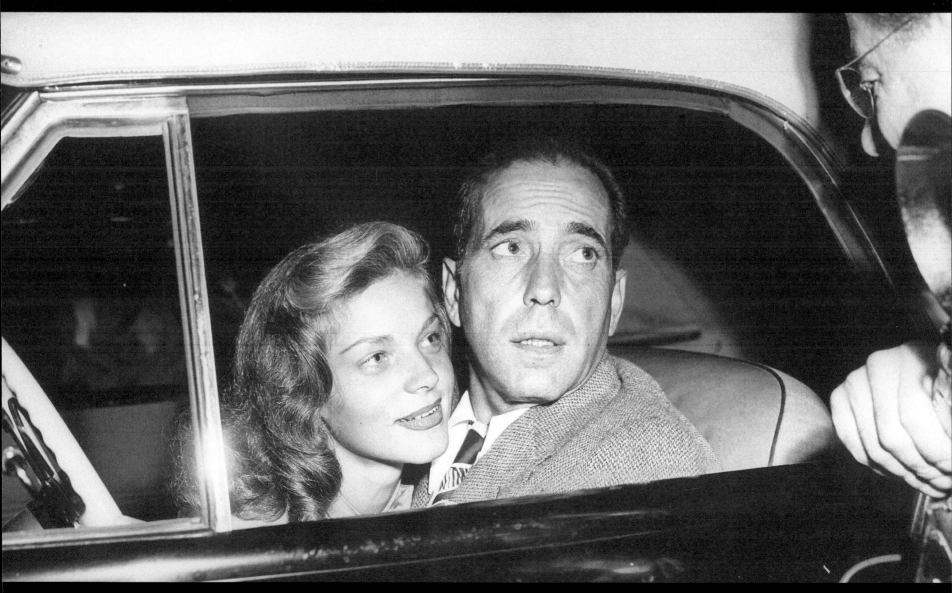

Art Direction and Design by Graham Marsh

First published 2007 by Boxtree,
an imprint of Pan Macmillan Ltd
Pan Macmillan, 20 New Wharf Road, London N1 9RR
Basingstoke and Oxford
Associated companies throughout the world
www.panmacmillan.com

ISBN 978-0-7522-2645-3

Compiled and edited by Tony Nourmand
Text by Nicholas Benwell and Roxanna Hajiani
Captions edited by June Marsh
Art Direction and Design by Graham Marsh
Page layouts by Joakim Olsson
Picture research by Rebecca McClelland

9 8 7 6 5 4 3 2 1

A CIP catalogue record for this book is available from
the British Library.

Printed by Butler and Tanner, Somerset

Visit **www.panmacmillan.com** to read more about all our books and to
buy them. You will also find features, author interviews and news of any
author events, and you can sign up for e-newsletters so that you're
always first to hear about our new releases.

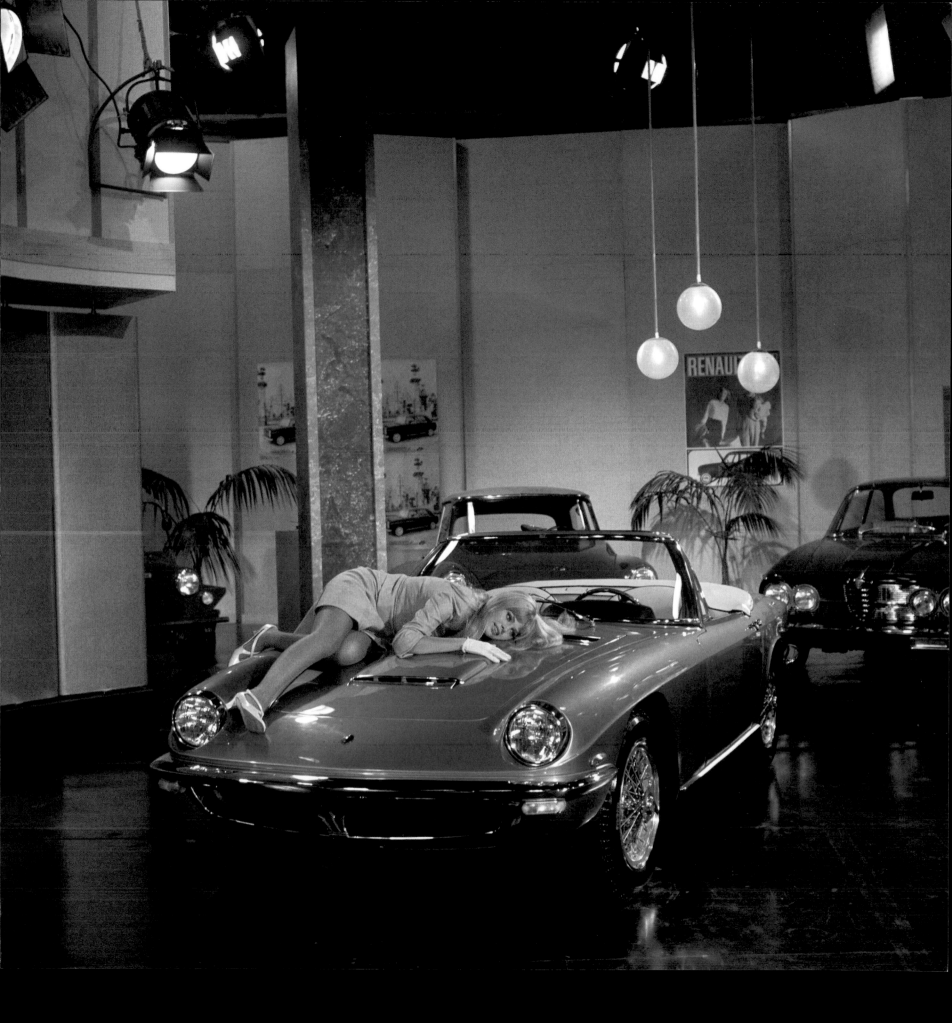

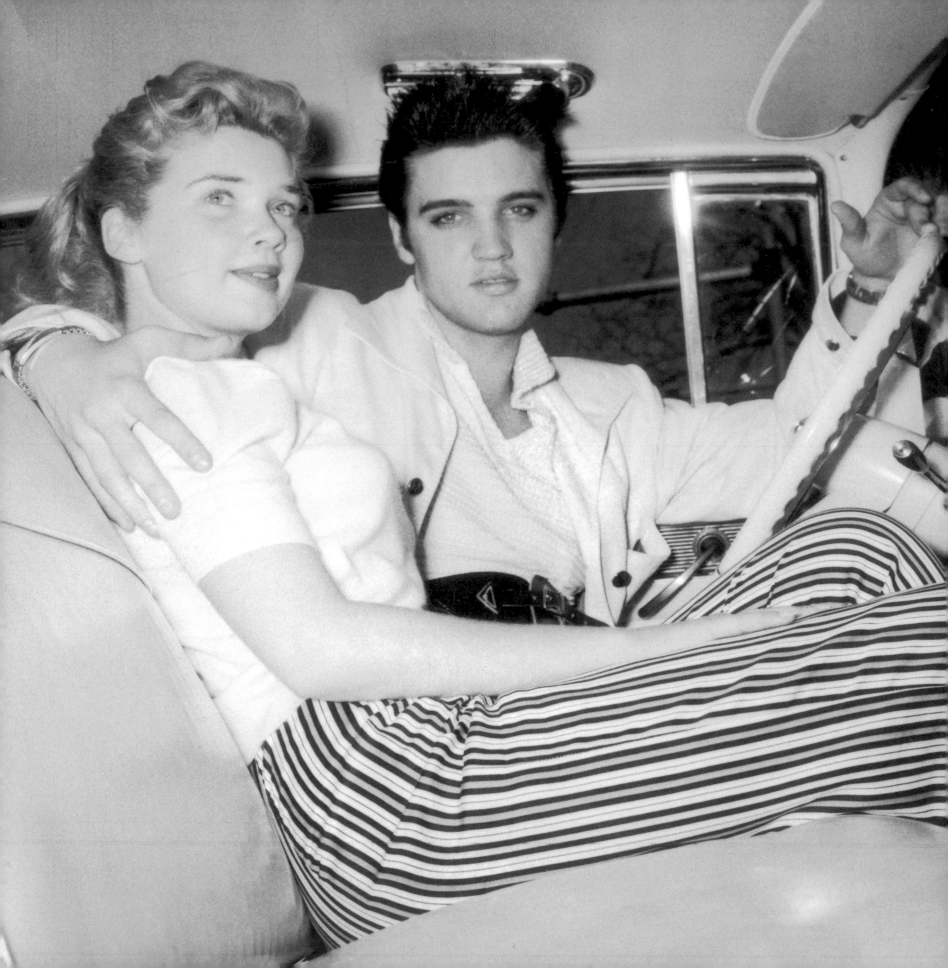

Contents

Acknowledgments and Credits

Thanks to the following friends and colleagues for their continual help and support: Alison Aitchison, Farhad Amirahmadi, Joe Burtis, Jon Butler, Glyn Callingham, Sarah Hodgson, John and Billie Kisch, Bruce Marchant, Gabriella Pantucci and Leslie Gardner. A special thanks to the following agencies and individuals for their invaluable help: Emanuela Acito (Reporters Associati S.r.l.), Ron Harvey, Alison Jo Rigney, Jesus Rabelo (Everett Collection), Daniel Bouteiller, Arnaud Dangerard (TCD), Dave Kent (The Kobal Collection), Andy Howick (MPTV.net), Eric Rachlis, Caroline Theakstone, Nicola Corbett, Philip Burnham-Richards (Getty Images), Pauline de Boisfleury (Hachette Photos), Martin Humphries (Ronald Grant Archive), Deborah Scannell (Corbis), Corin Flint, Gilbert Gibson (Aquarius Collection), S. Victor Burgos, Darren Davidson (Photofest)

Photographic credits: Front Cover MPTV.net, p.3 Hachette Photos KEYSTONE-FRANCE, p.5 REX, p.6 Hulton Archive/ Getty Images, p.9 Reporters Associati, p.10 Coll. Boutieiller, p.12 MPTV.net, p.13 MPTV.net, p.14 Coll. Boutieiller, p.15 MPTV.net, p.16 left MPTV.net, right The Kobal Collection, p.17 MPTV.net, p.18 Bettman/ Corbis, p.19 The Kobal Collection, p.20 The Ronald Grant Archive, p.21 The Ronald Grant Archive, p.22 MPTV.net, p.23 MPTV.net, p.24 The Kobal Collection, p.25 Getty Images, p.26 The Kobal Collection, p.27 Coll. Boutieiller, p.28 top The Kobal Collection, bottom Associated Press, p.29 Everett Collection, p.30 MPTV.net, p.31 The Kobal Collection, p.32 left The Kobal Collection, right The Kobal Collection, p.33 MPTV.net, p.34 left Coll. Boutieiller, right The Kobal Collection, p. 35 The Kobal Collection, p.36 Photofest, p.37 Clarence Sinclair/ Kobal/ Getty Images, p.38 The Kobal Collection, p.39 Photofest, p.40 Bettman/ Corbis, p.41 Everett Collection, p.42 The Kobal Collection, p.43 Kobal/ Getty Images, p.44 The Kobal Collection, p.45 Everett Collection, p.46 left The Kobal Collection, right The Kobal Collection, p.47 The Kobal Collection, p.48 Pictorial Parade/ Hulton Archive/ Getty Images, p.49 Corbis, p.50 © 1978 Gene Trindl/ MPTV.net, p.51 © 1978 Gunther/ MPTV.net, p.52 Everett Collection, p.53 The Kobal Collection, p.54 The Kobal Collection, p.55 MPTV.net, p.56 BertHardy/ Picture Post/ Getty Images, p.57 Steve Schapiro/ Corbis, p.58 left Everett Collection, right Coll. Boutieiller, p.59 Slim Aarons/ Getty Images, p.60 Everett Collection, p.61 MPTV.net, p.62 Bettman/ Corbis, p.63 Bettman/ Corbis, p.64 Pictorial Press, p.65 Pictorial Press, p.66 AFP/ PHOTO/ HO/ Getty Images, p.67 MPTV.net, p.68 left Hachette Photos © Sanford H. ROTH / SEITA OHNISHI / RAPHO, right Hachette Photos © Sanford H. ROTH / SEITA OHNISHI / RAPHO, p.69 Hachette Photos © Sanford H. ROTH / SEITA OHNISHI / RAPHO, p.70-71 Hachette Photos © Sanford H. ROTH / SEITA OHNISHI / RAPHO, p.72 Keystone/ Getty Images, p.73 John Drysdale/ Keystone/ Getty Images, p.74 Keystone/ Getty Images, p.75 Hulton Archive/ Getty Images, p.76 Neal Preston/ Corbis, p.77 Bettman/ Corbis, p.78 Bernard Gotfryd/ Hulton Archive/ Getty Images, p.79 Bettman/ Corbis, p.80 © 1978 Bob Willoughby/ MPTV.net, p.81 Pictorial Press, p.82 © 1978 Gerald Smith/ MPTV.net, p.83 © 1978 Sid Avery/ MPTV.net, p.84 Everett Collection, p.85 MPTV.net, p.86 The Kobal Collection, p.87 Photo by Joe Shere/ MPTV.net, p.88 MPTV.net, p.89 Reporters Associati, p.90 all Getty Images, p.91 Reporters Associati, p.92 © 1978 Bernie Abramson/ MPTV.net, p.93 © 1978 Bernie Abramson/ MPTV.net, p.94 John Dominis/ Time Life/ Getty Images, p.95 © 1978 Chester Maydole/ MPTV.net, p.96 left © 1978 Sid Avery/ MPTV.net, right © 1978 Sid Avery/MPTV.net, p.97 Coll. Boutieiller, p.98 Associated Press, p.99 Associated Press, p.100 Everett Collection, p.101 Hulton Deutsch Collection/ Corbis, p.102 Photofest, p.103 Hulton Archive/ Getty Images, p.104 © 1978 David Sutton/ MPTV.net, p.105 © 1978 Eric Skipsey/ MPTV.net, p.106 Everett Collection, p.107 Everett Collection, p.108 Gene Lester/ Getty Images, p.109 The Kobal Collection, p.110 © 1978 Sid Avery/ MPTV.net, p.111 Everett Collection, p.112 Bettman/ Corbis, p.113 Everett Collection, p.114 © 1978 Sid Avery/ MPTV.net, p.115 Everett Collection, p.116 Eve Arnold/ MAGNUM, p.117 Reporters Associati, p.118 POPPERFOTO/ ALAMY, p.120 QUINIO / STILLS/ GAMMA, p.121 Slim Aarons' Getty Images, p.122 left Larry Shaw/ REX, right Everett Collection, p.123 Pierre Vauthey/ Corbis, p.124 Bettman/ Corbis, p.125 Sipa Press/ REX, p.126 left Reporters Associati, right Reporters Associati, p.127 Hachette Photos © Ghislain DUSSART / RAPHO, p.128 REX FEATURES, p.129 Reporters Associati , p.130 Pictorial Press, p.131 QUINIO/ STILLS/ GAMMA, p.132 Everett Collection, p.133 Photo by Joe Shere/ MPTV.net, p.134 The Ronald Grant Archive, p.135 Aquarious, p.136 Fiat Auto Press, p.137 Reporters Associati, p.138 Bettman/Corbis, p.139 Everett Collection, p.140 REX FEATURES, p.141 Pictorial Press, p.142 Mirrorpix, p.143 Evening Standard/ Getty Images, p.144 Keystone/ Getty Images, p.145 George Stroud/ Express/ Hulton Archive/ Getty Images, p.146 Edward Quinn/ CAMERA PRESS, p.147 Roger Viollet/ Getty Images, p.148 Graham Stark/ Hulton Archive/ Getty Images, p.149 Graham Stark/ Hulton Archive/ Getty Images, p.150 Hulton Archive/ Getty Images, p.151 © 1978 Gunther/ MPTV.net, p.152-153 © 1978 David Sutton/ MPTV.net, p.154 Raymond Depardon/ Magnum Photos, p.155 Corbis, p.156 both Mirrorpix, p.157 POPPERFOTO/ ALAMY, p.158 MPTV.net, p.159 Photo by Joe Shere/ MPTV.net, p.160 I.B.L/ REX FEATURES, p.161 Sipa Press/ REX FEATURES, p.162 John Pratt/ Keystone/ Getty Images, p.163 Michael Webb/ Getty Images, p.164 © 1978 Gunther/ MPTV.net, p.165 Everett Collection, p.166 Wesley/ Keystone/ Getty Images, p.167 Wesley/ Keystone/ Getty Images, p.168 Pictorial Press, p.169 Pictorial Press, p.170 Tony Frank/ Sygma/ Corbis, p.171 Pictorial Press, p.172 Bettman/ Corbis, p.173 Alan Houghton/ REX FEATURES, p.174 Jim Gray/ Keystone/ Getty Images, p.175 Everett Collection, p.176 Terry O'Neill/ Hulton Archive/ Getty Images, p.177 John Minihan/ EveningStandard/ Getty Images, p.178 Keystone/ Getty Images, p.179 Dezo Hoffman/ REX FEATURES, p.180 Pictorial Press, p.181 Hulton Deutsch Collection/ Corbis, p.182 top AP/ EMPICS, bottom Mirrorpix, p.183 Michael Ward/ REX FEATURES, p.184 © 1978 Gunther/ MPTV.net, p.185 REX FEATURES, p.186 Corbis, p.187 Louie Psihoyos/ Corbis, p.189 Bettman/ Corbis, p.191 Getty Images, p.192 Alfred Eisenstaedt/ Time&Life/ Getty Images, End Pages Corbis, Back Cover Everett Collection.

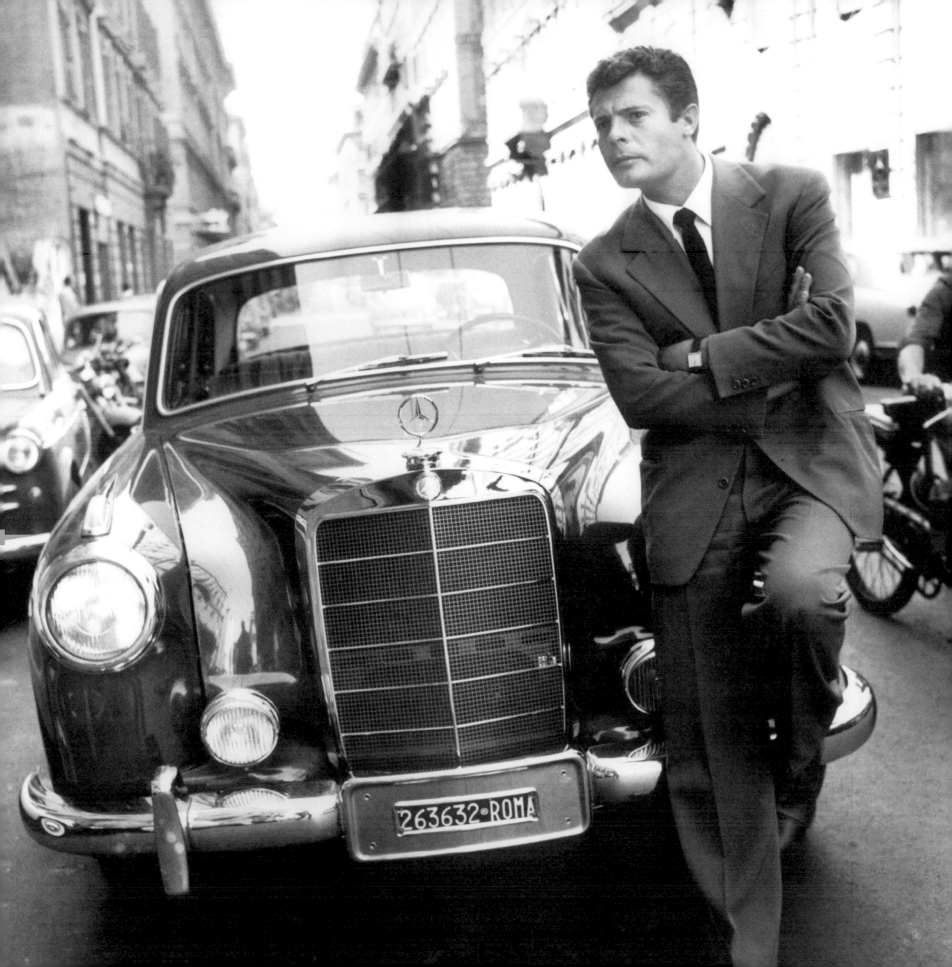

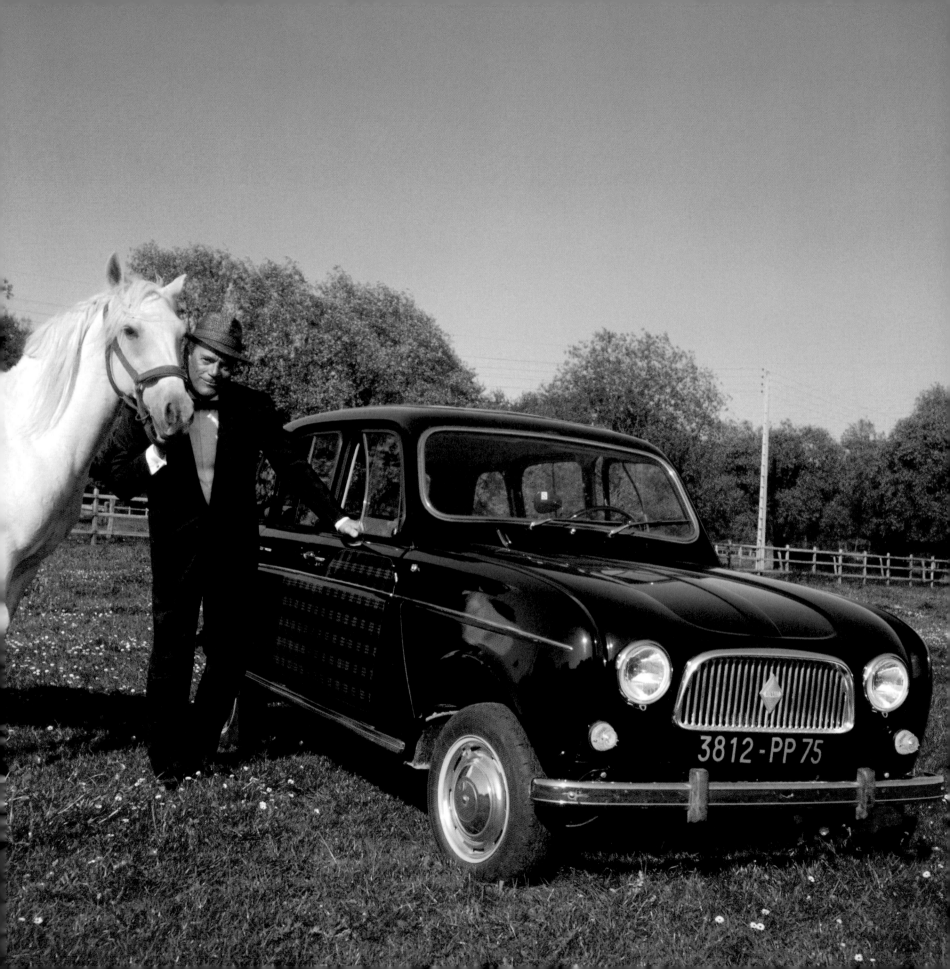

Collecting Vintage Cars

During the summer of 2006, Tony Nourmand contacted me due to my long involvement with vintage cars and Christie's International Motor Car department. Tony had accumulated a huge number of images from various sources and we worked together, laying them out in some kind of order to represent the most notable cars owned by stars from the early days of cinema up to the rock and pop stars of the 1970s.

As a central part of modern life, cars have long surpassed their practical use as a means of transport. Rather, they represent an extension of the owner's persona. Cars create a powerful sense of identity, be they elegant and classic, fast and ferocious, or lavishly ostentatious. It's perhaps not surprising, then, that cars have always been part of the celebrity lifestyle. Whether in their films or in real life, stars have always wanted to be seen in the latest and best makes and models. Throughout the last century, stars often chose either the most expensive or the sportiest cars of the day. If money was no object, why wouldn't you choose the most sumptuous Duesenberg or the fastest Ferrari on the market?

Early Hollywood stars loved to own thoroughbred cars. Charlie Chaplin's Minerva and Rudolph Valentino's Voisin both featured sleeve-valve engines which were prized for their quiet running, while Al Jolson's super-charged Mercedes-Benz S was known for its high performance and luxury, as was Clark Gable's fabulous Duesenberg SJ. Some were chauffeur-driven, but many were driven by the stars themselves.

In the later, post-war years, English stars such as Diana Dors and Cliff Richard wanted to live the American dream and chose Cadillacs or Chevrolet Corvettes to show their credentials. Meanwhile, European cars such as Ferraris and Aston Martins were favoured by American stars like Michael Landon and Clint Eastwood, who is known to have an impressive collection of cars from this era.

The Rock 'n' Roll years roared into life in 1951 with Jackie Brenston singing 'Rocket 88' – a song about the joys of the Oldsmobile model of the same name – and Eddie Cochran, Chuck Berry and Little Richard soon followed suit, singing the praises of their favourite cars. The trend continued well into the 1960s with bands such as The Beach Boys singing songs like 'Little Deuce Coupe' and name-checking the famous T-bird in 'Fun Fun Fun'. Soon, the car itself became the star of many feature films such as *Grand Prix* (1966), *Bullitt* (1968), *The Italian Job* (1969) and *Le Mans* (1971).

As passionate speed freaks, actors such as Steve McQueen and James Dean were very much associated with cars. McQueen drove them, cherished them, starred alongside them, raced them and collected them. The young James Dean liked to race, too, but his passion was eventually to claim his life when he died

in his favourite Porsche Spyder. Other notable enthusiasts such as Italian film director Roberto Rossellini and actors Jackie and Gary Cooper also bought cars to race in; all of these men had an eye for a great motor, choosing cars simply for their outstanding performance. At the other end of the spectrum, some stars, such as Serge Gainsbourg, chose instead to drive cars that dictated the fashion of the time, like the microcars and Austin Minis of the sixties.

Often pop stars such as Tom Jones and Marvin Gaye, who came from relatively modest backgrounds, chose the most luxurious cars; a polished Rolls-Royce (or a Cadillac, if you were Elvis Presley) was a fine symbol of their success, a statement that they'd finally made it. In the race to be noticed, members of the Rat Pack in the 1960s often tried to outdo each other with their choice of cars. Flying to Italy to order Lamborghini Miuras to their own specification with such luxuries as boarskin upholstery, Dean Martin and Frank Sinatra weren't put off by the waiting list or the shipping costs. Other stars had cars custom built and would then choose the entire shape and style of the car, creating a complete one-off. Sonny and Cher opted for his-and-hers Ford Mustangs, while Bobby Darin's futuristic, finned Dream Car took seven years of planning and was said to have crushed diamond dust in the paintwork.

Many of these cars still exist in museums or private collections and, if ever offered at auction, create a huge amount of interest among buyers, especially if presented in their original, un-restored condition. Imagine sitting in Steve McQueen's Jaguar XKSS or Frank Sinatra's 1956 Ford Thunderbird, which recently fetched $150,000. Sinatra's 1989 Jaguar XJS, offered at auction in 1998, sold for even more – a cool $160,000. No ordinary XJS would ever be worth this much, which just goes to show that cars with famous ownership often far exceed their book value. The star's attachment to the car gives the object itself another dimension, magnifying its allure with a touch of fantasy and a bewitching sense of identity.

Nicholas Benwell

Having worked at all the Christie's car sales worldwide since 1994, Nicholas has been personally involved with many rare and famous cars, including several that had originally been owned by famous people. He now owns the famous Phoenix Green Garage and specialises in the restoration and preservation of pre-war sports cars.

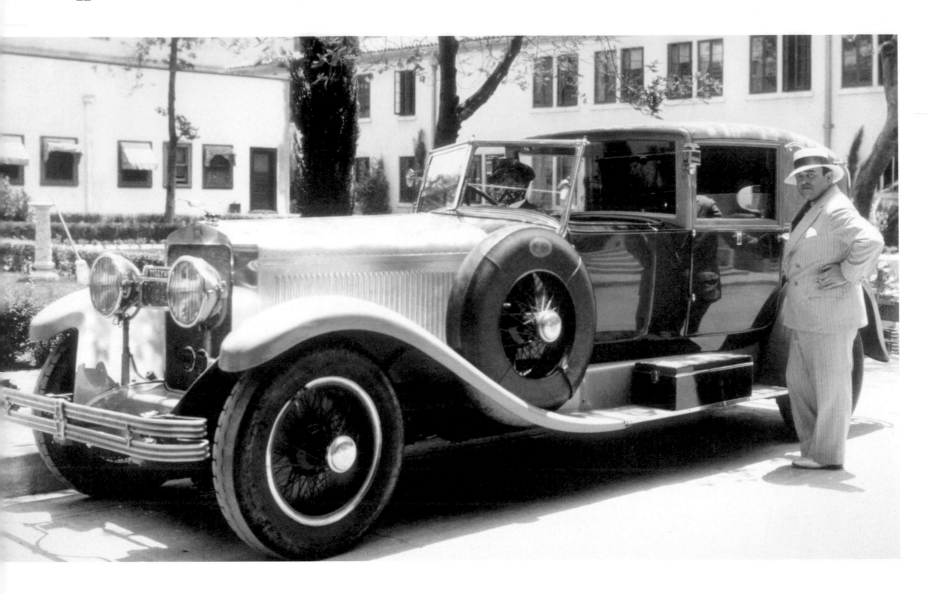

Above: George Fitzmaurice, director of over eighty classic silent movies including *The Son of the Sheik* (1926) with Rudolph Valentino and *Mata Hari* (1932) starring Greta Garbo.
Here he is with his magnificent c.1927, 6-cylinder Delage Limousine. These high-quality cars were manufactured in France.
Opposite: Roscoe 'Fatty' Arbuckle, at the height of his career, in his 1920 Pierce-Arrow. This huge touring car, which cost $25,000 ($280,000 in today's money) was designed and built to complement his personal stature – the wheelbase was 147.5 inches and the fuel tank had a 32-gallon gas-guzzling capacity. Arbuckle's personal touches included his signature engraved on the radiator badge.

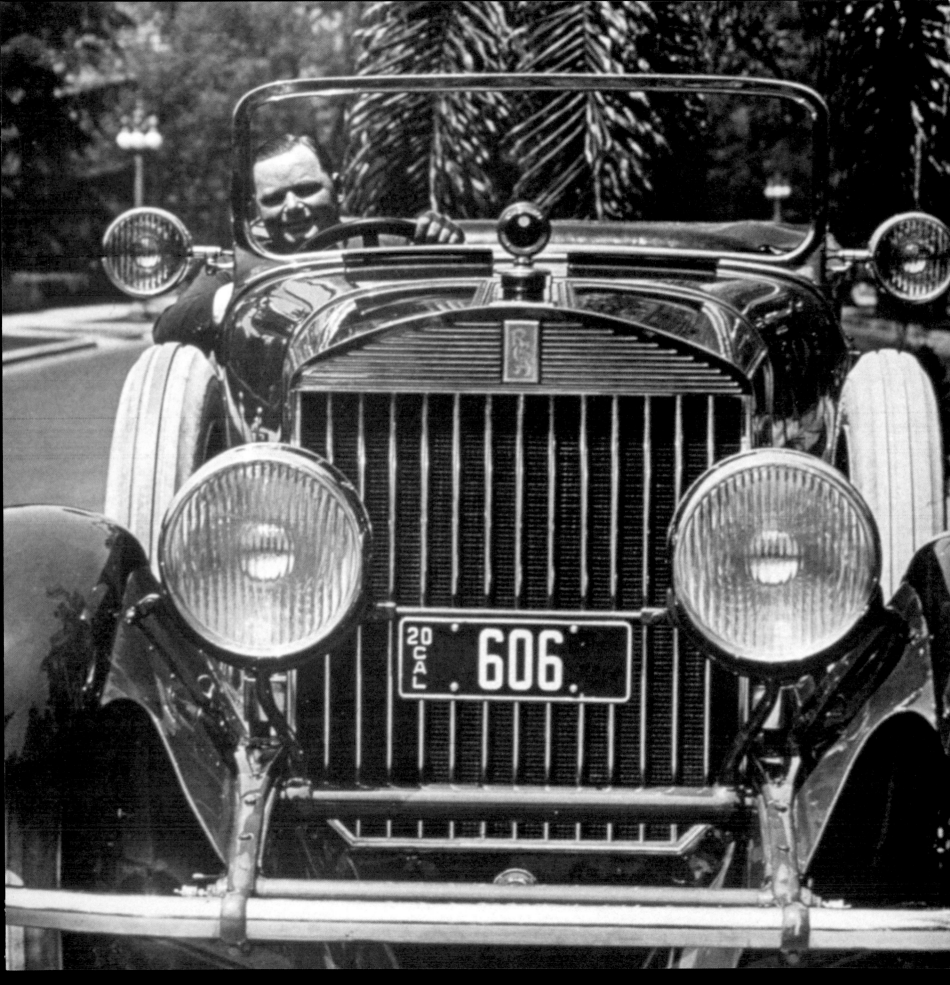

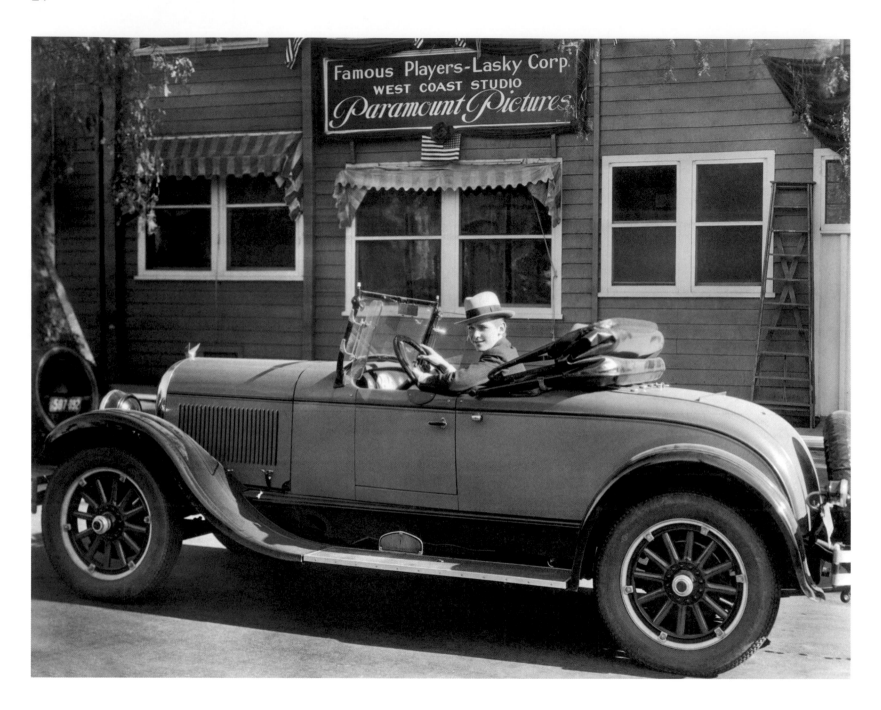

Above: Douglas Fairbanks Jr outside his studio's offices in a 1924 Chrysler roadster, acclaimed by many as the first modern car.

Opposite: Jack Dempsey, the hugely popular World Heavyweight Boxing Champion from 1919 to 1926, liked to mingle with the stars and at one time shared an apartment with Charlie Chaplin and Douglas Fairbanks. His 1924 McFarlan roadster cost as much as $9,000 new ($100,000 in today's money) and was known as the 'American Rolls-Royce'.

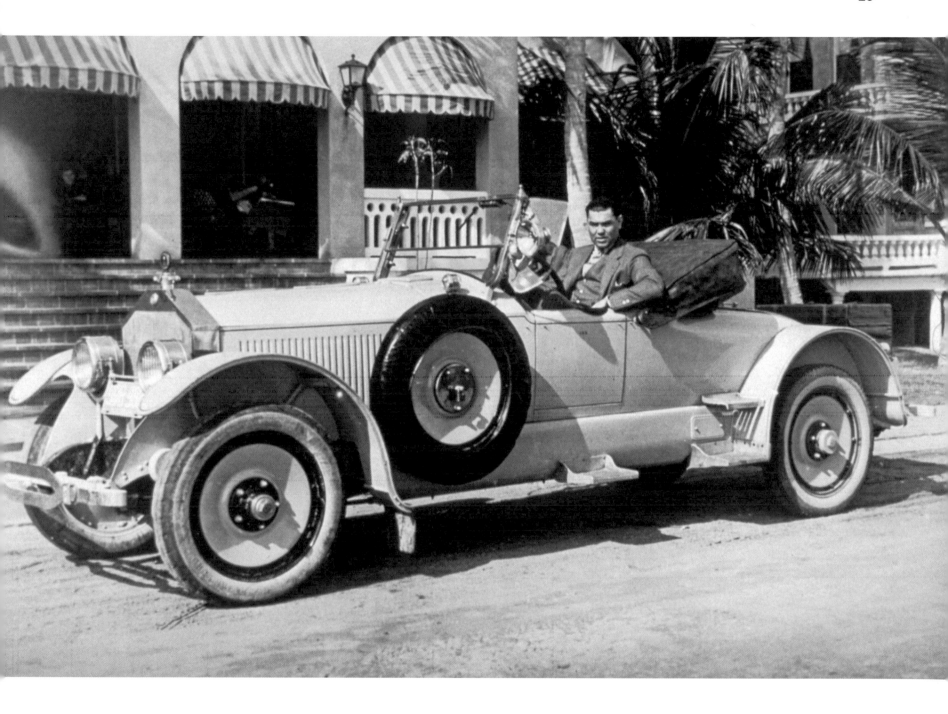

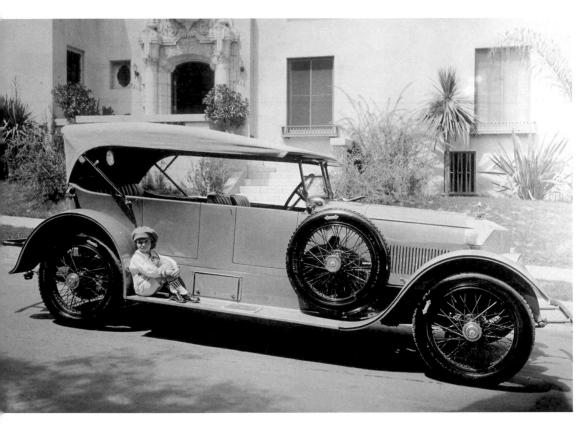

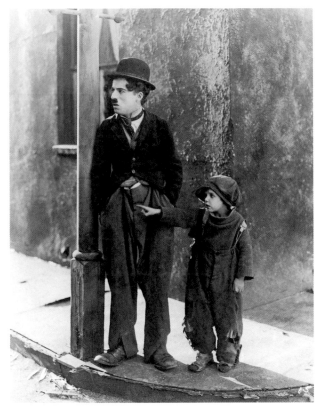

Above left: Child star Jackie Coogan sits on the running board of his c.1925 Austro-Daimler – a very rare car, especially in the US.

Above right: Charlie Chaplin and his co-star Jackie Coogan in a scene from *The Kid* (1921).

Opposite: Chaplin's c.1925 Minerva, with very unusual coachwork that included protection from the weather for rear passengers only.

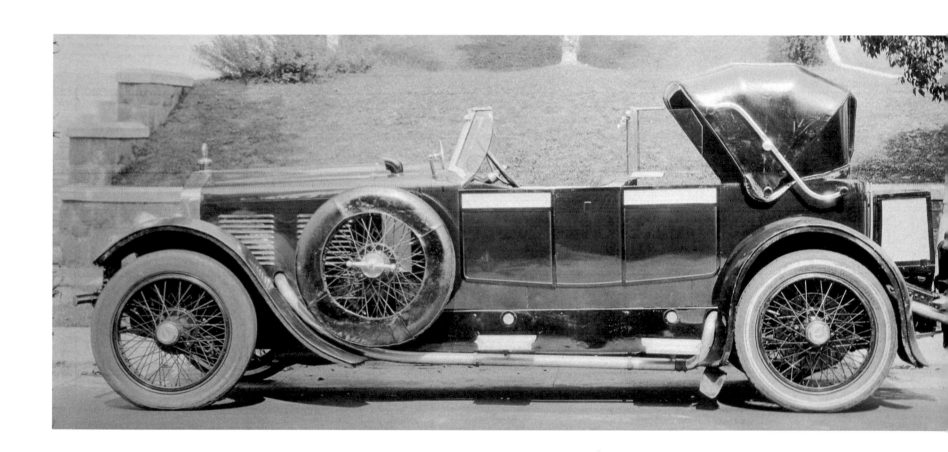

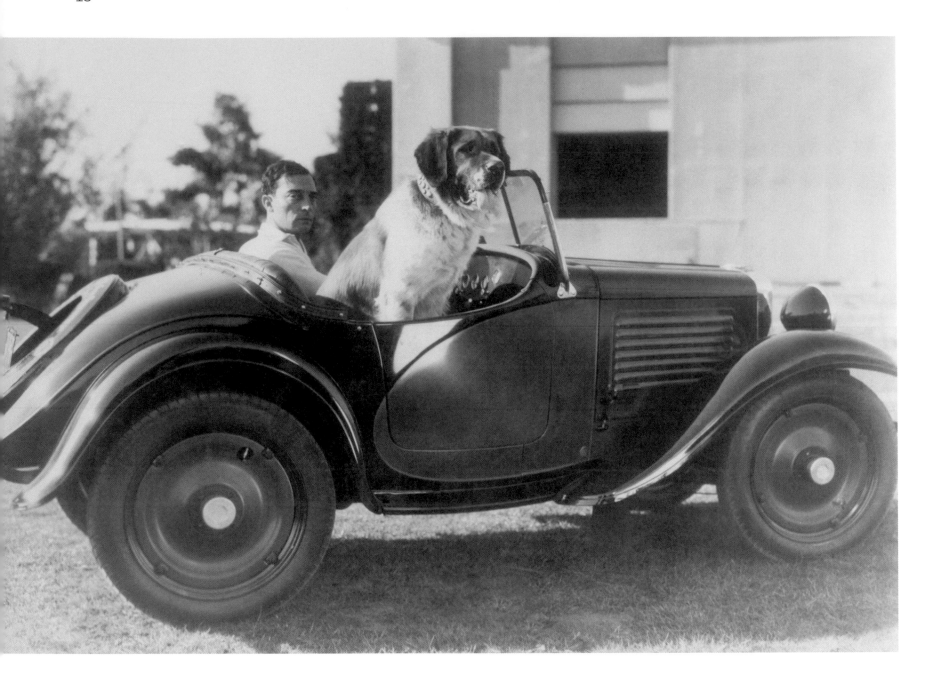

Above: Buster Keaton – with his dog, Consentido – in his c.1931 Bantam roadster, a car built by the American Austin company under licence to the English Austin.

Opposite: Dolores Del Rio in a very early English Austin Seven sports model, c.1924. Del Rio, who was dubbed 'the female Valentino' as her fame grew in the 1920s, was the first Mexican movie star to gain international appeal. She went on to star in over sixty films and was famously linked with Orson Welles, who later referred to her as 'the most exciting woman I have ever met'.

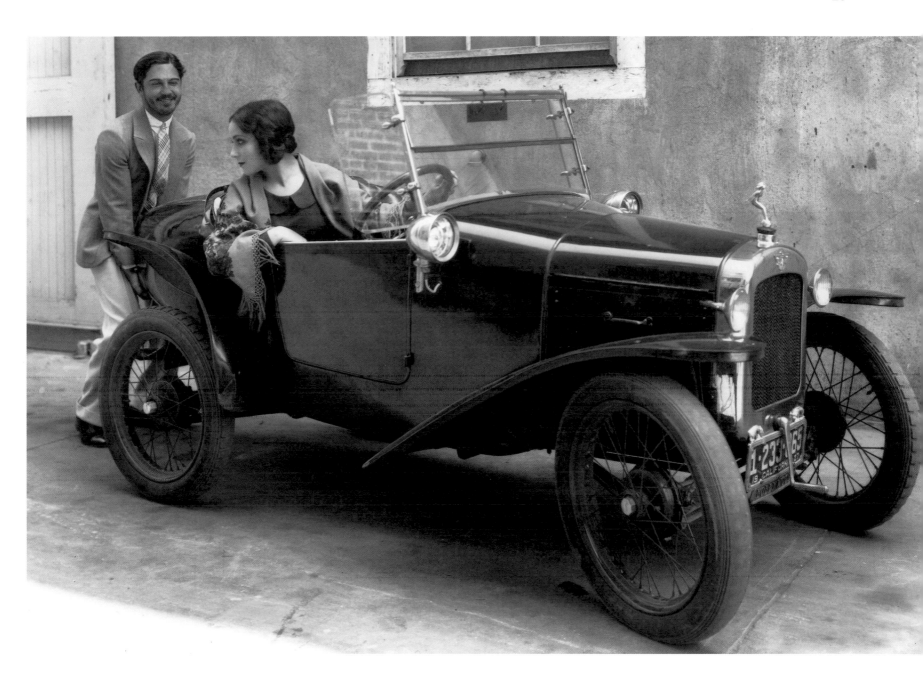

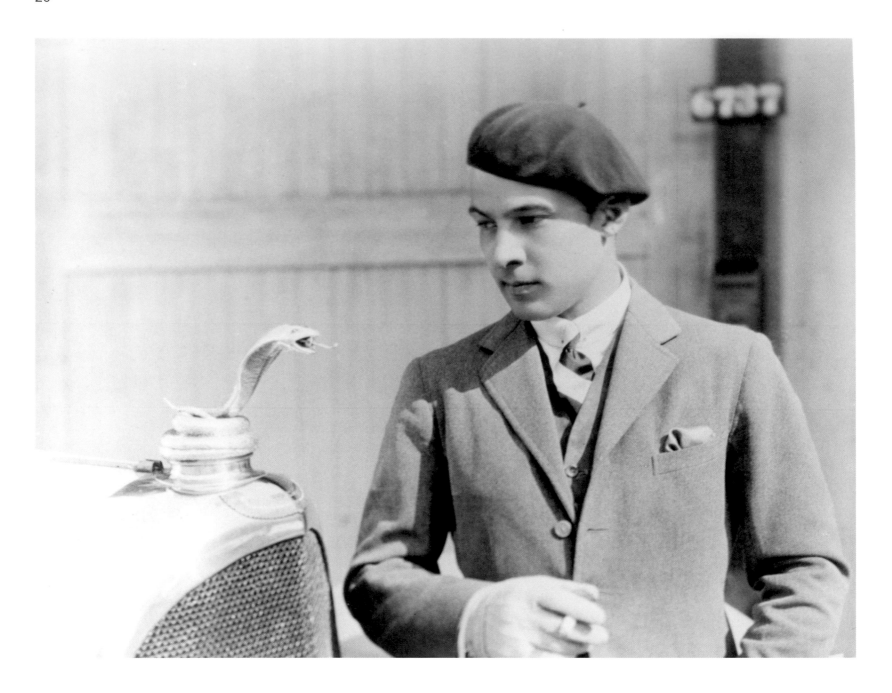

Above: Screen icon Rudolph Valentino seems mesmerized by his custom-made cobra radiator mascot. Perhaps most famous for his lady-killing role in *The Sheik* (1921), Valentino's second-to-last movie was actually called *The Cobra* (1925), a film in which he plays Rodrigo, a sex-obsessed man who becomes bored with women coming on to him all the time (and vice versa!).

Opposite: Valentino outside Falcon Lair, his 8-acre home in the Hollywood Hills. The car is his 1923 Voisin, a rather eccentric French model created by aircraft designer Gabriel Voisin.

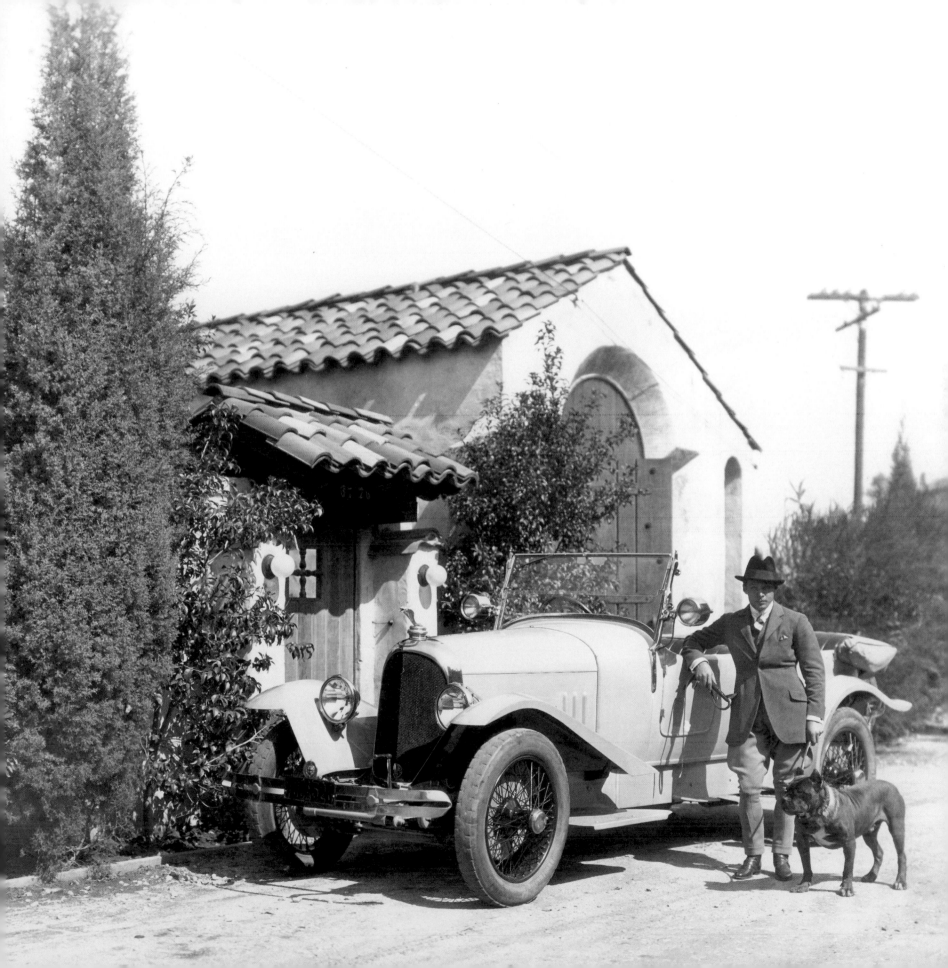

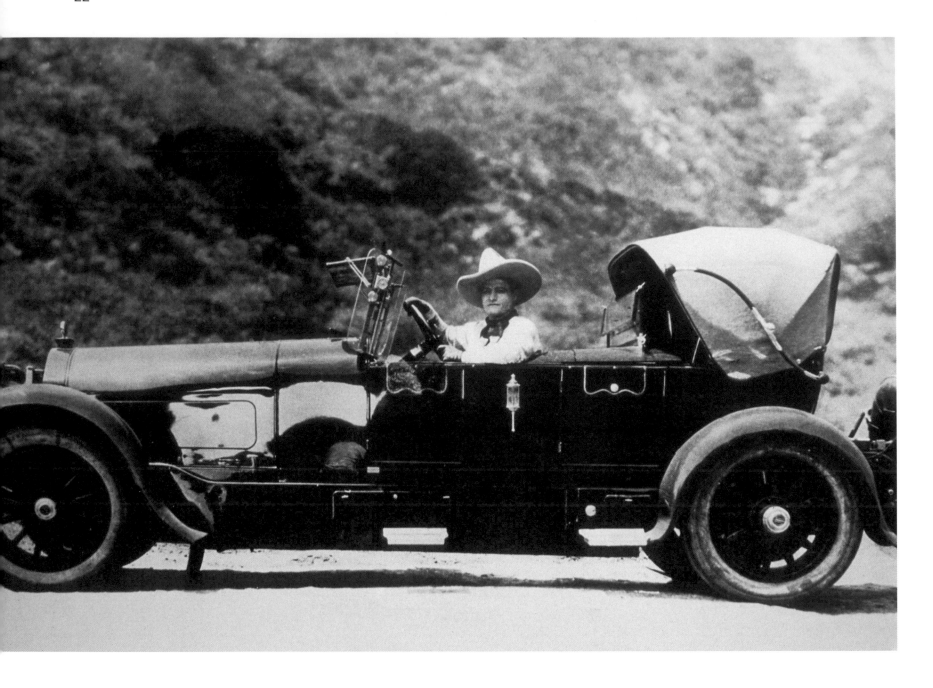

Above: Actor Tom Mix, 'King of the Cowboys', for once without his famous and talented horse Tony. Instead he drives a huge, early 1920s Locomobile Model 48, a very powerful American touring car.

Opposite: Another legendary cowboy star, Buck Jones (remember his horse called Silver?) and his c.1928 Packard roadster – a very popular make of car amongst stars of this era.

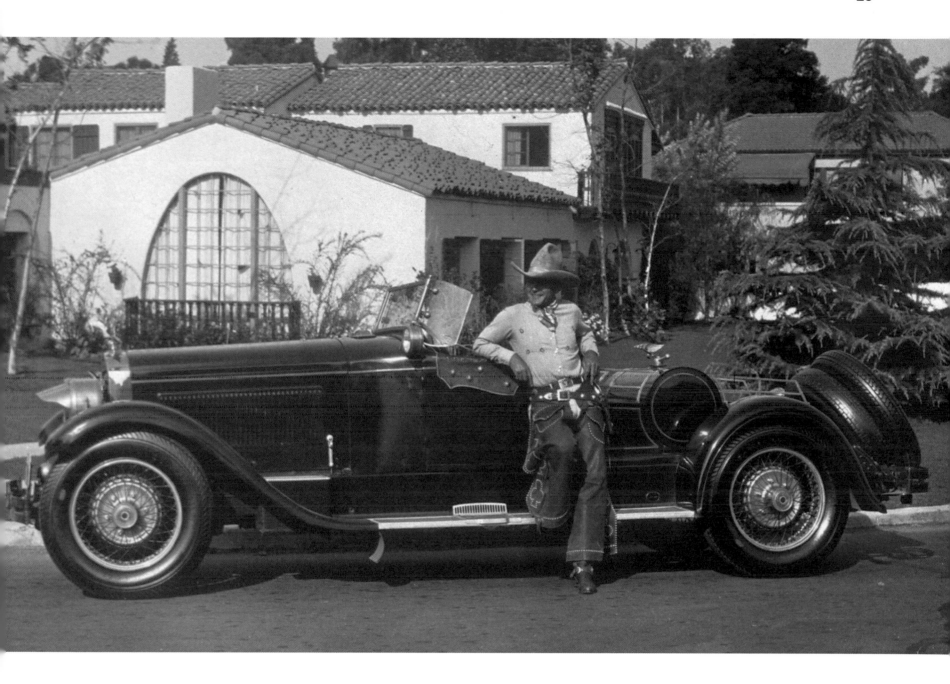

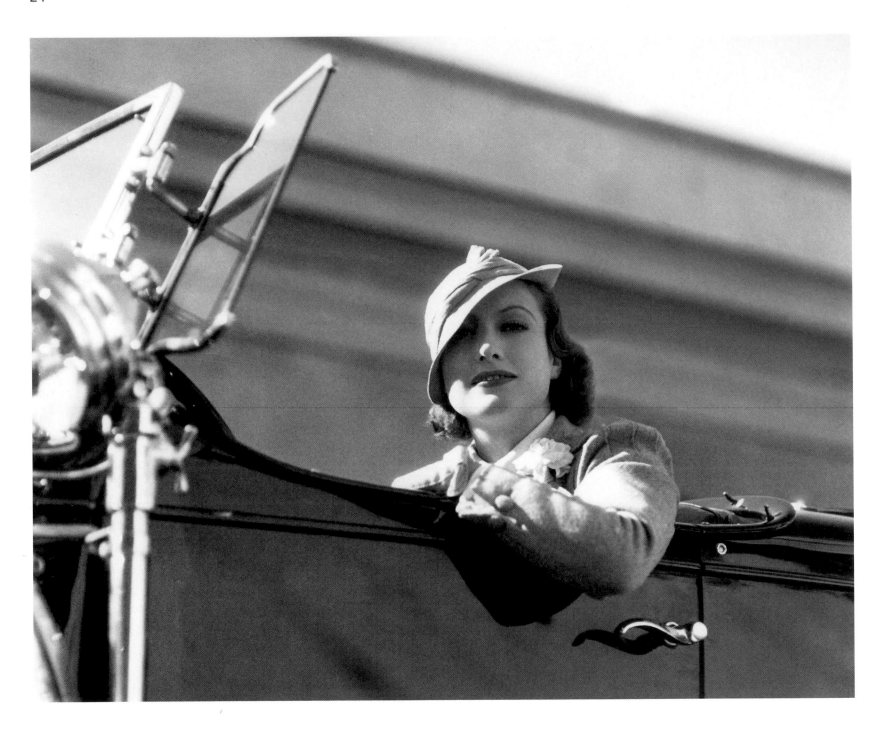

Above: Joan Crawford at the wheel of her 1932 Cadillac Phaeton.

Opposite: Greta Garbo, perfectly poised and chicly dressed, sitting in a 1920s tourer ready for driving in the fast lane.

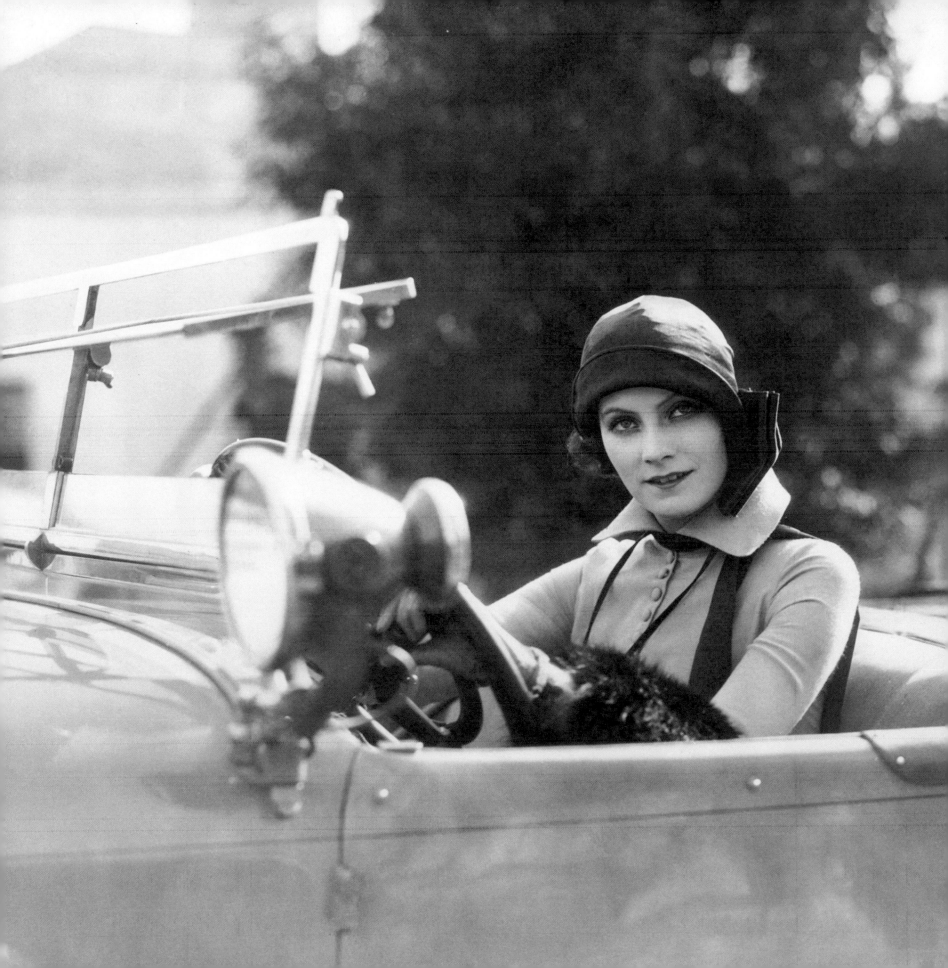

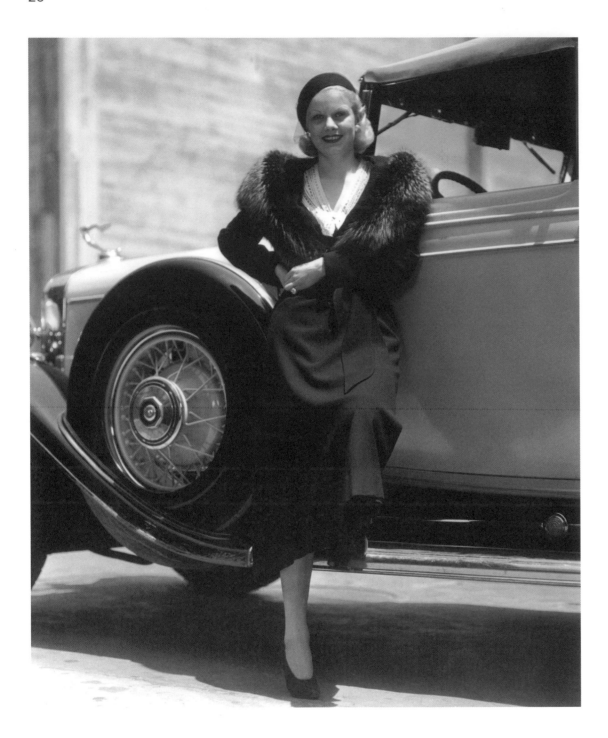

Above: Jean Harlow poses in front of her c.1931 Packard Phaeton. Packard prefaced much of their promotion and advertising with the following lavish statement: *'As modish as Matisse in painting, as late as Georg Jensen in silver, as modern as an architectural design by Frank Lloyd Wright, as recent as Debussy in music and as new as Brancusi in sculpture.'*

Opposite: Only the very best for Marlene Dietrich, seen here with her luxurious c.1929 Rolls-Royce Phantom I convertible sedan, with coachwork by Hibbard and Darrin. Thomas L. Hibbard and Howard 'Dutch' Darrin were two American coachbuilders living in Paris, whose work is characterized by great craft and flair. Dual windshields were provided for added comfort during top-down motoring.

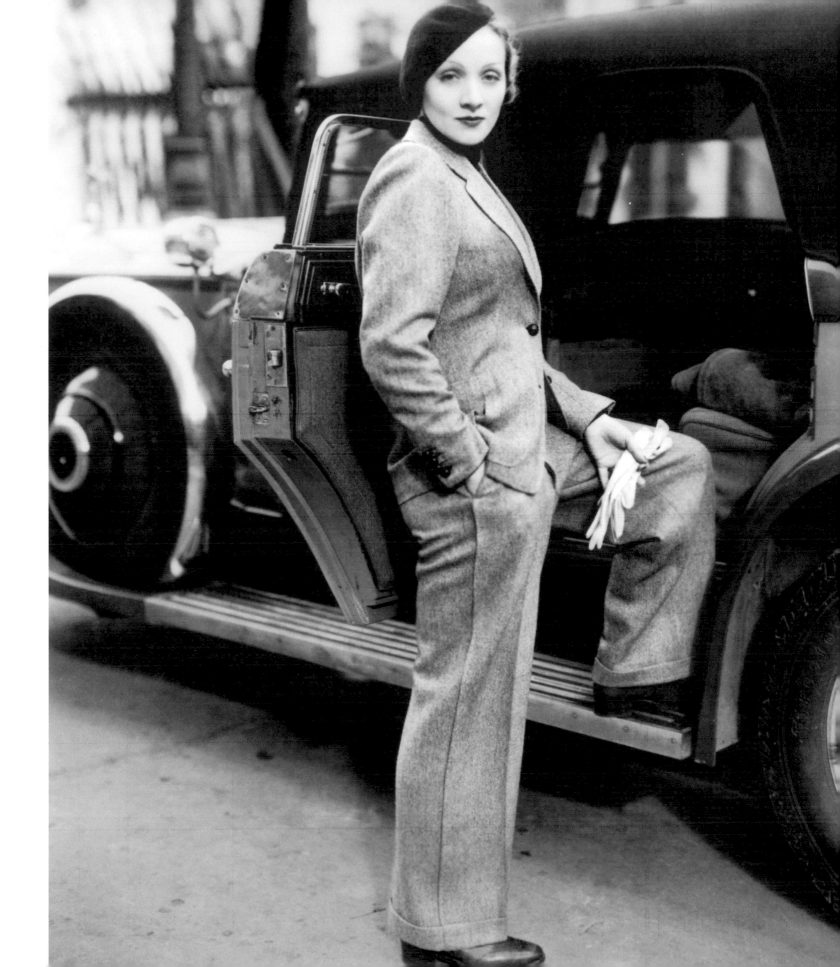

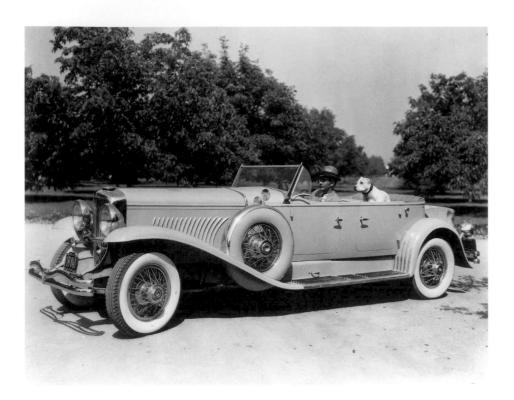

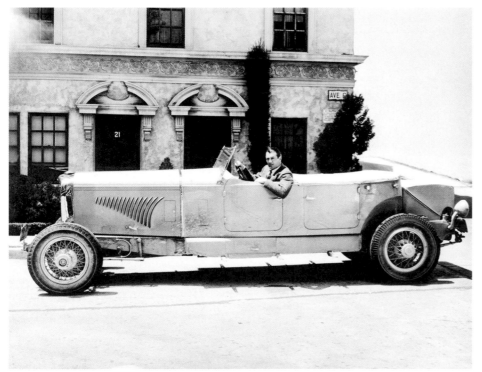

Top: Gary Cooper in his Duesenberg, in full touring trim.

Bottom: Cooper in the same car stripped for racing, with fenders, running boards and spare tyre removed.

Opposite: Cooper, sitting casually on the fender of his DeSoto coupé in 1937.

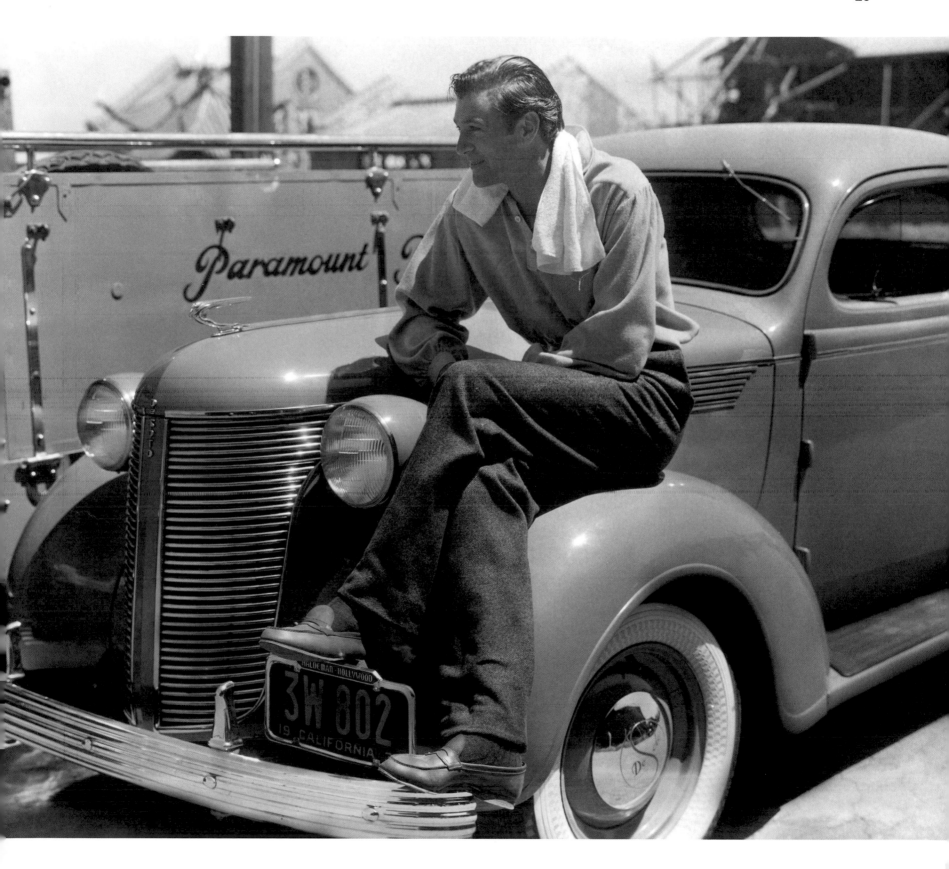

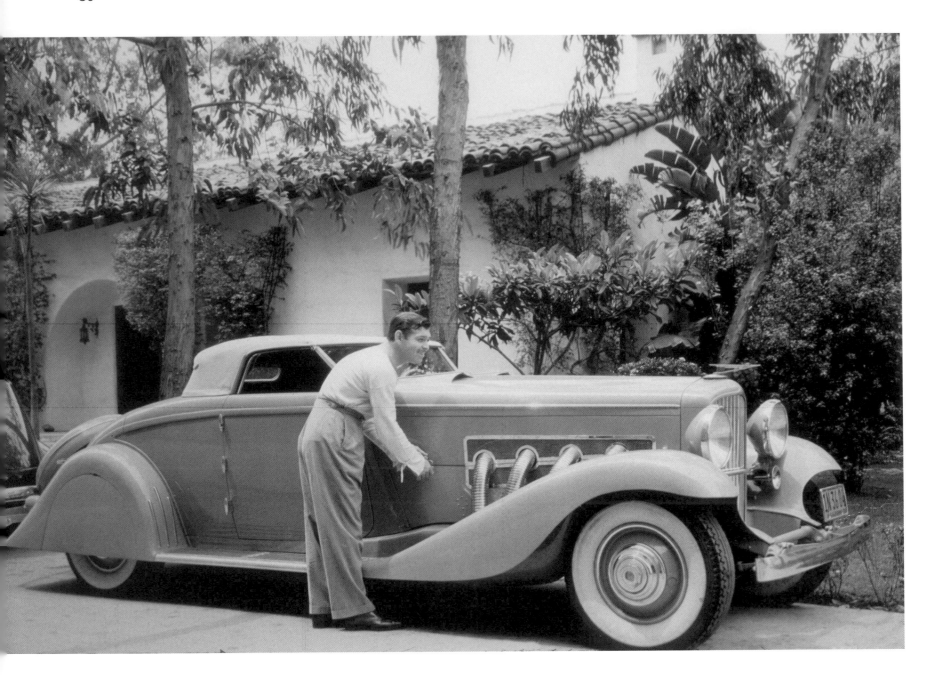

Above: Clark Gable with his fabulous c.1935 Duesenberg SJ. The most famous US automotive marque from the classic era, as the 1929 catalogue stated:

'It is a monumental answer to wealthy America's insistent demand for the best that modern engineering and artistic ability can provide... Necessarily, its appeal is to only a very few. Any masterpiece can only be appreciated by those who understand the principles upon which its greatness is based. Therefore the ownership of a Duesenberg reflects discernment far above the ordinary...'

Opposite: Raoul Walsh, the legendary Hollywood director whose career spanned five decades and more than 130 films, including *The Thief of Baghdad* (1924) with Douglas Fairbanks, *The Big Trail* (1930) with John Wayne and *White Heat* (1949) with James Cagney. His majesterial c.1934 Duesenberg perfectly reflected his status in Hollywood.

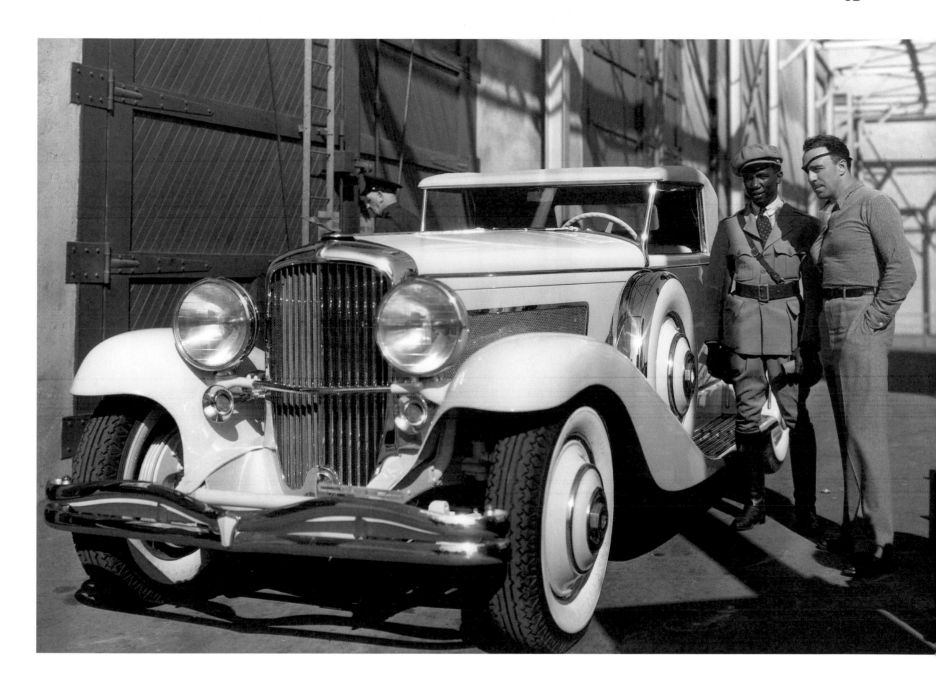

Above left: On- and off-screen lovers Clark Gable and Carole Lombard – a wonderfully glamorous couple, here shown in a publicity still from the MGM film *No Man of Her Own* (1932).

Above right: Their image extended to their choice of cars: Lombard with her elegant c.1932 Packard convertible roadster and *opposite:* Gable with his powerful Packard Twin Six.

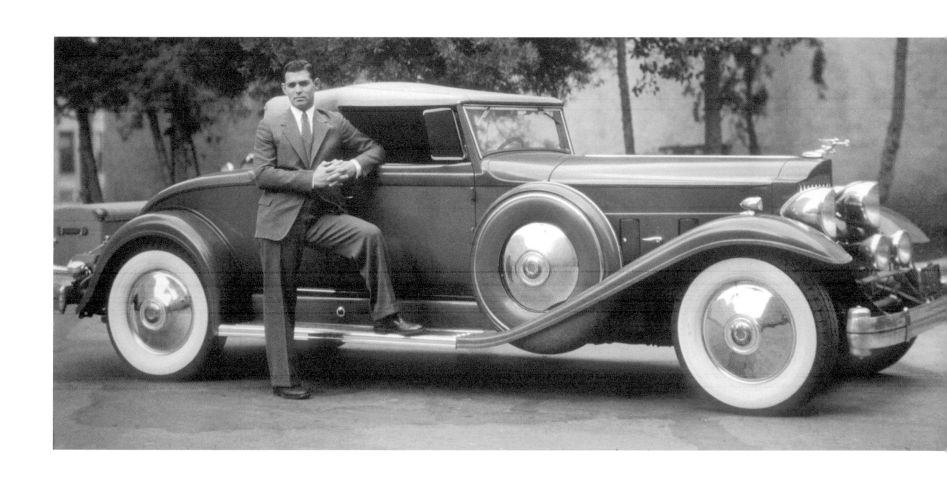

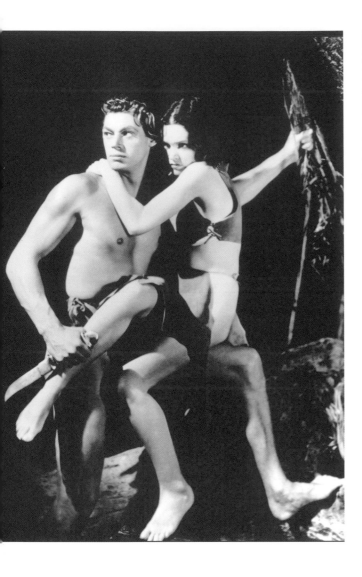

Above left: Johnny Weissmuller and Maureen O'Sullivan, creatively posed for a publicity shot from the MGM film *Tarzan and His Mate* (1932) – the most famous of all the Tarzan films.
It was considered rather risqué at the time, and the nude underwater scenes were cut from the final prints after intervention from film censors.

Above right: O'Sullivan, fashionably dressed, with her massive Duesenberg.

Opposite: Weissmuller, also sartorially elegant with his more modest Chevrolet roadster.

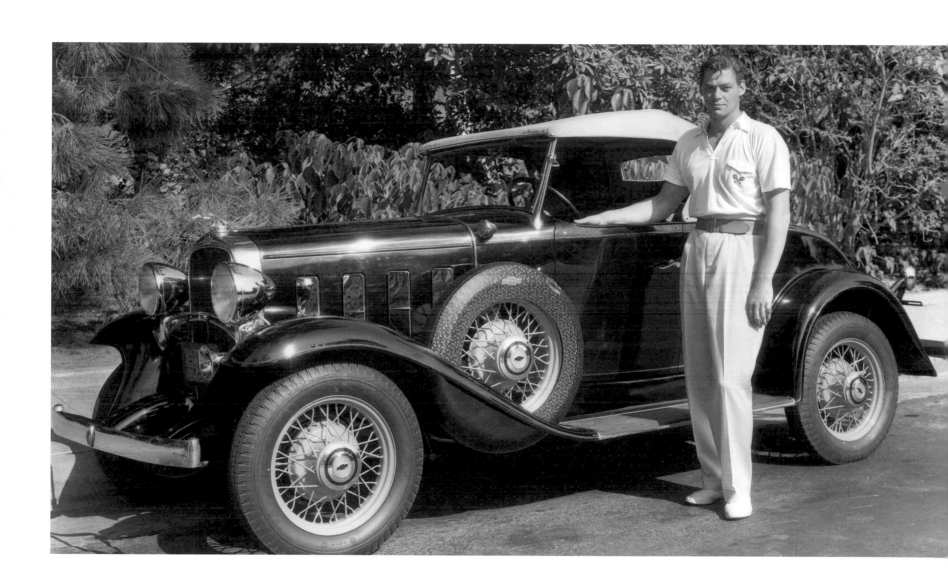

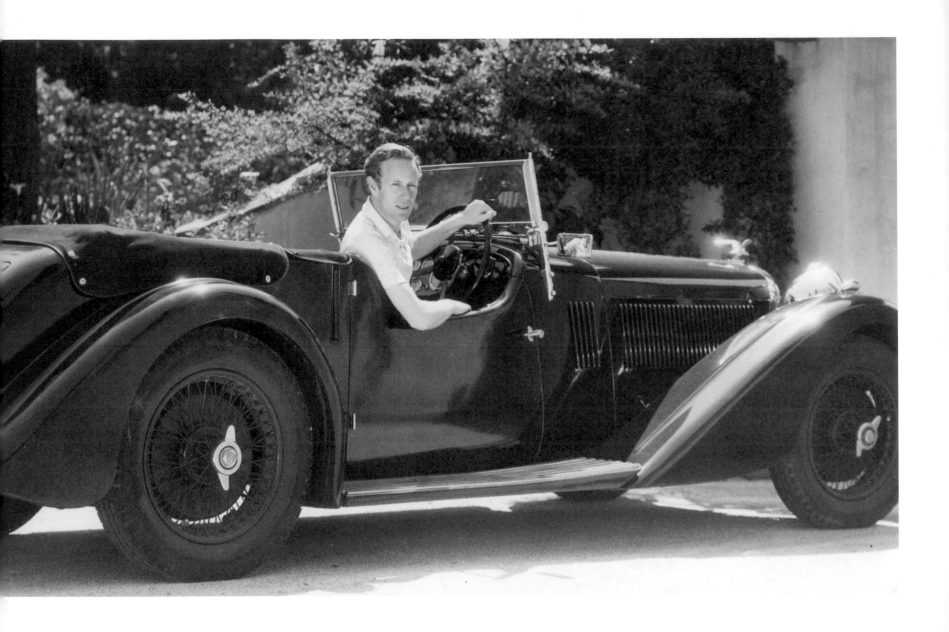

Above: Actor Leslie Howard, who moved from London to Hollywood in 1930, became known as the perfect Englishman – slim, tall, intellectual and sensitive – a part he played in many movies and which made him hugely popular with female moviegoers around the world. His most famous roles were in *Pygmalion* (1938), *Intermezzo* (1939) and *Gone With the Wind* (1939). Here we see him enjoying his success in a suitably English car, his refined c.1935 Derby Bentley – a model so called because it was the first Bentley produced under the ownership of Rolls-Royce from its factory in Derby, England.

Opposite: Actor Robert Montgomery behind the wheel of his c.1935 Derby Bentley. Nicknamed 'the silent sports car', Derby Bentleys were in a class of their own and exhibited some of the finest coachbuilding work of the 1930s. This model displays a more sporting and less formal Bentley radiator, allowing the designers to develop flowing lines of unsurpassed beauty.

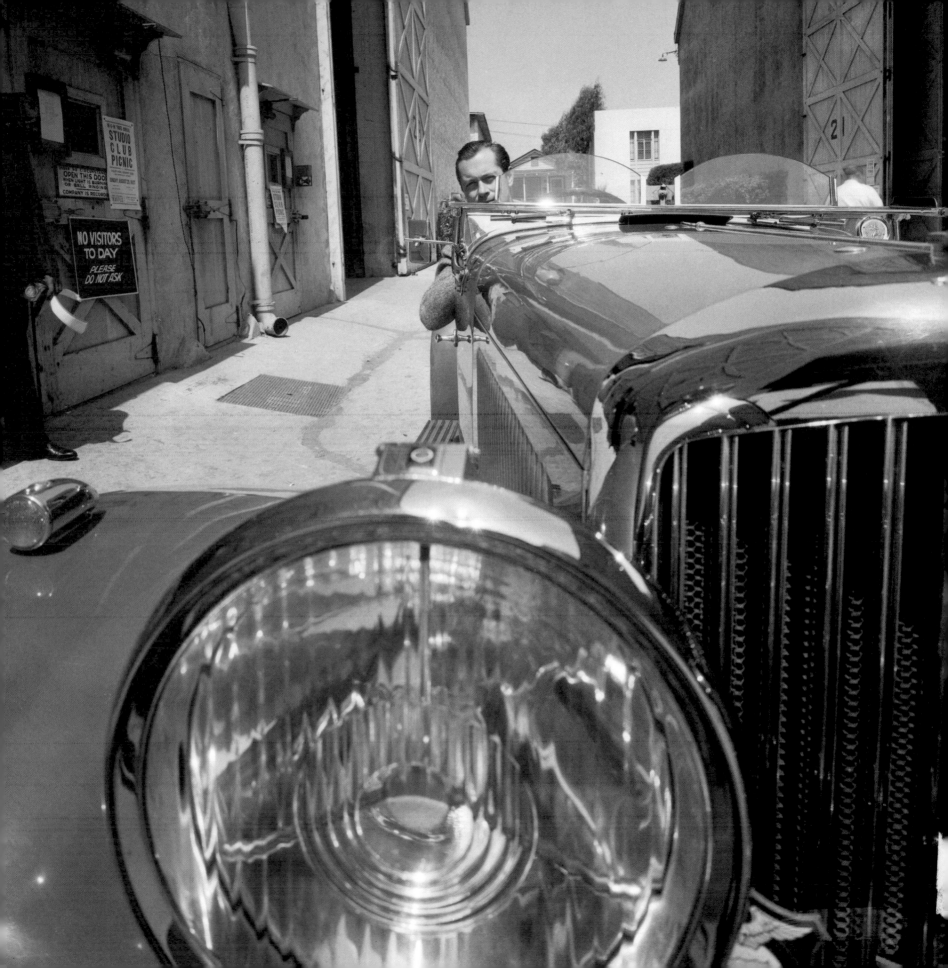

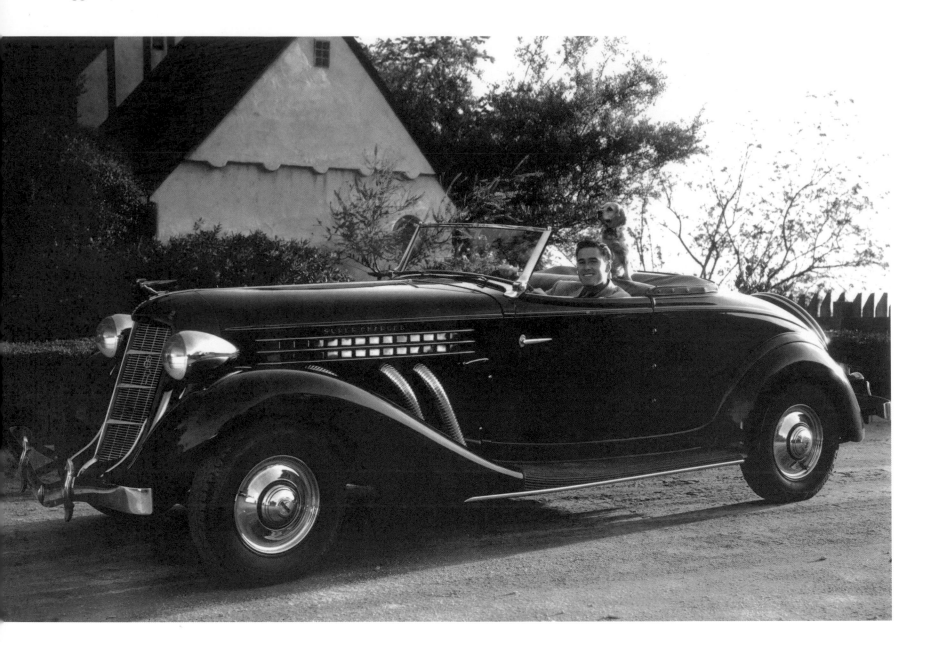

Above: Errol Flynn, swashbuckling star of *Captain Blood* (1935) and *The Adventures of Robin Hood* (1938), with his c.1935 Auburn Speedster. Auburn Speedsters did not just look fast; for their time they *were* fast. Very fast. To prove this, famed racing driver Ab Jenkins sat behind the wheel of an 851 Speedster and was the first American to record an average speed of 100 m.p.h. for a twelve-hour period. As a result, each Speedster built carried a dash plaque bearing Ab Jenkins's signature, attesting to its l00 m.p.h.+ capability.

Opposite: Flynn in his c.1937 AC, an English car built in Thames Ditton, Surrey. AC were famous for building their cars to individual order specifications. Almost any type of bodywork modifications or trim could be ordered, so keen were they to offer more than the other, mass-produced sports models of the day. In fact, the advertising slogan they loved to use was 'Thames Ditton, the Saville Row of Motordom'.

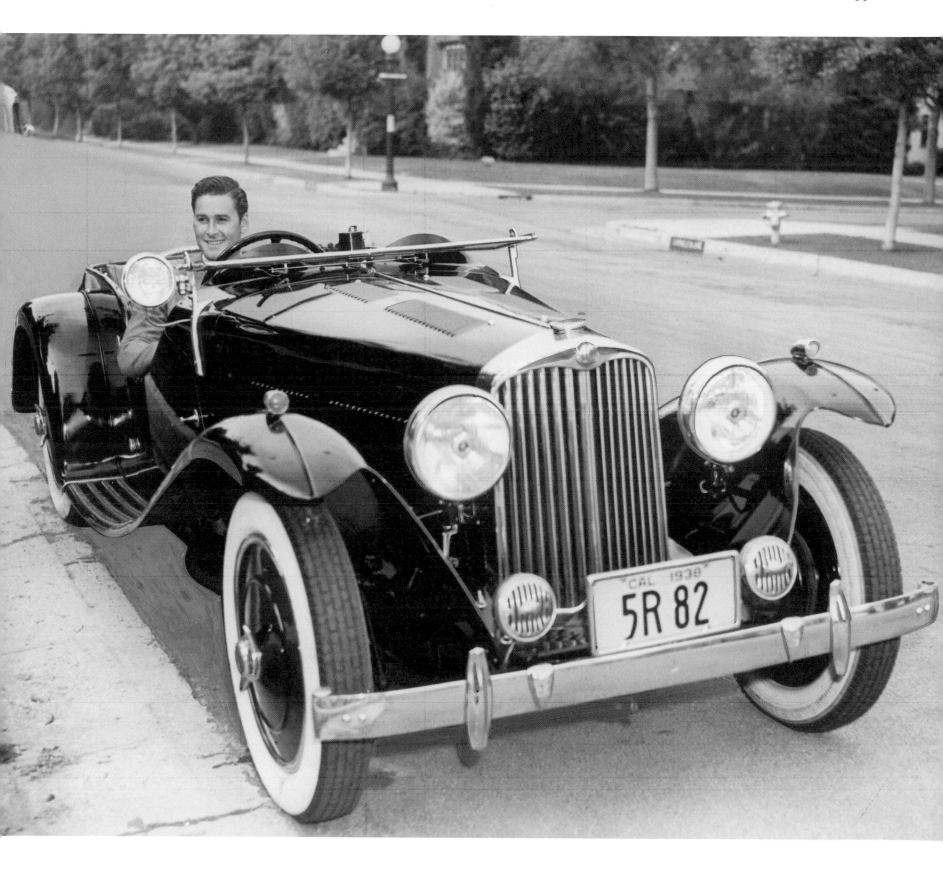

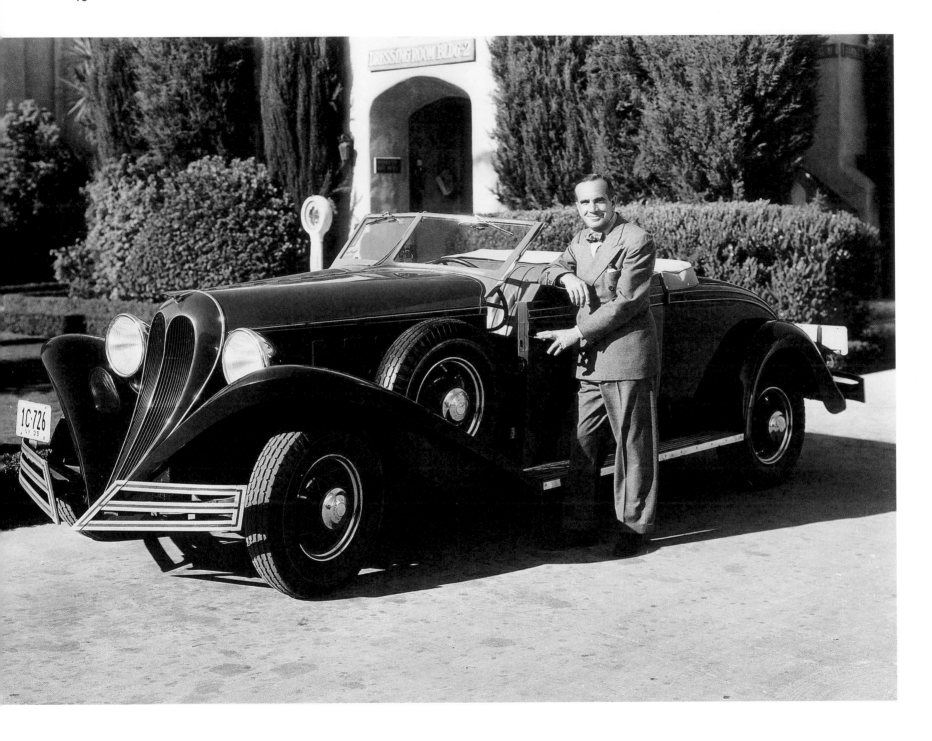

Above: Performer Al Jolson – who starred in the first ever talking movie, *The Jazz Singer* (1927) – with his 1935 Brewster roadster. A limited-production car built on a Ford V8 roadster chassis, the Brewster was sold at Rolls-Royce showrooms.

Opposite: Cecil B. DeMille with actress Marsha Hunt and his Cord Phaeton, a very advanced car for its time, with front-wheel drive and retractable headlights.

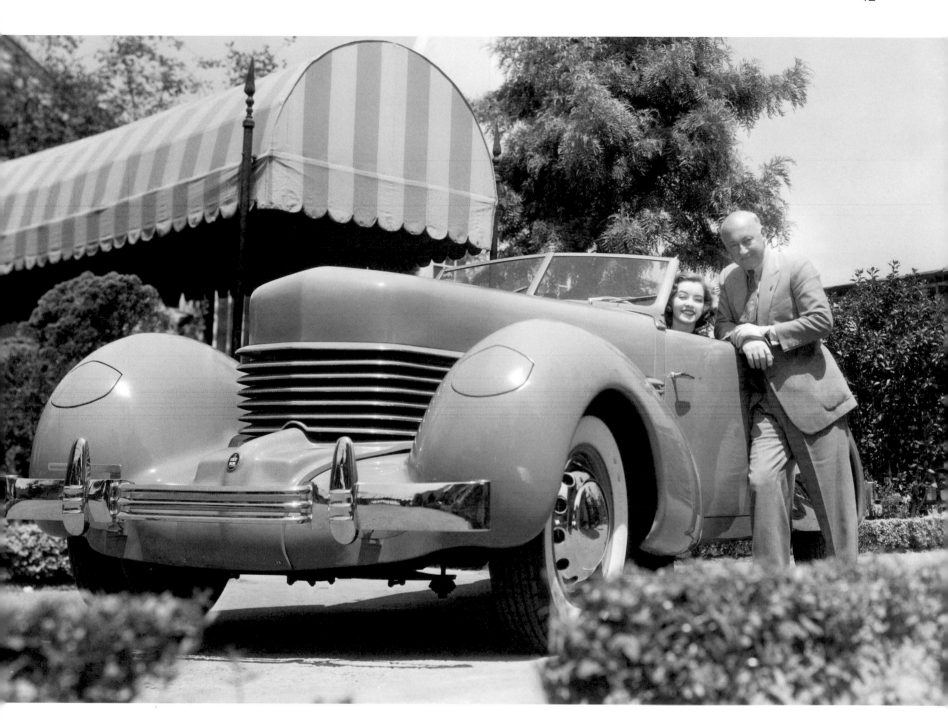

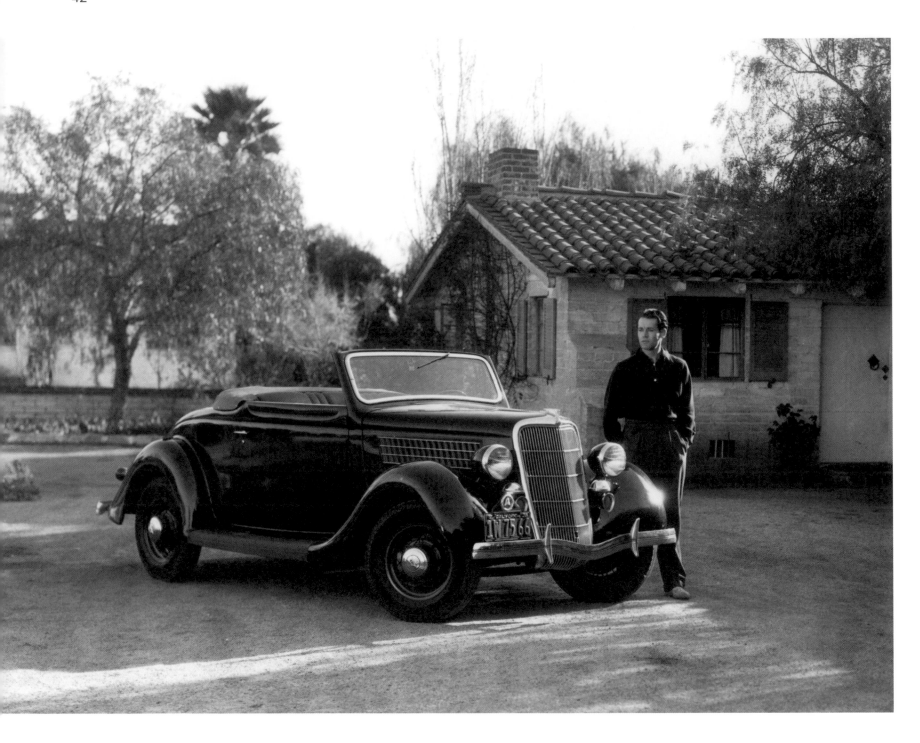

Above: A young Henry Fonda stands alongside his perfectly proportioned 1935 Ford roadster.

Opposite: James Stewart leans elegantly against his classic 1936 Plymouth coupé.

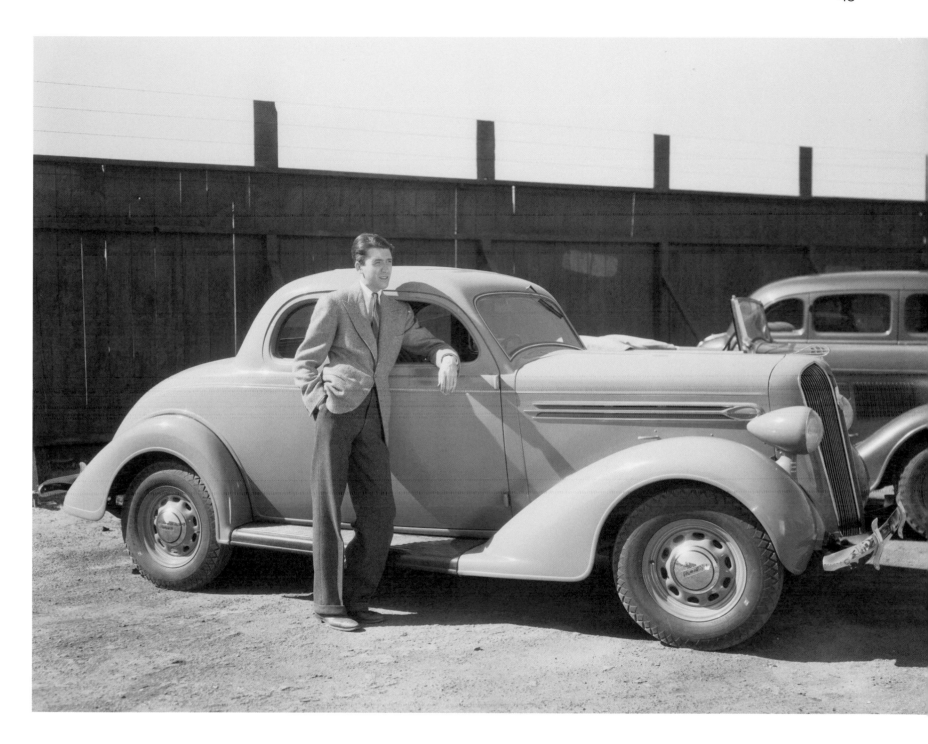

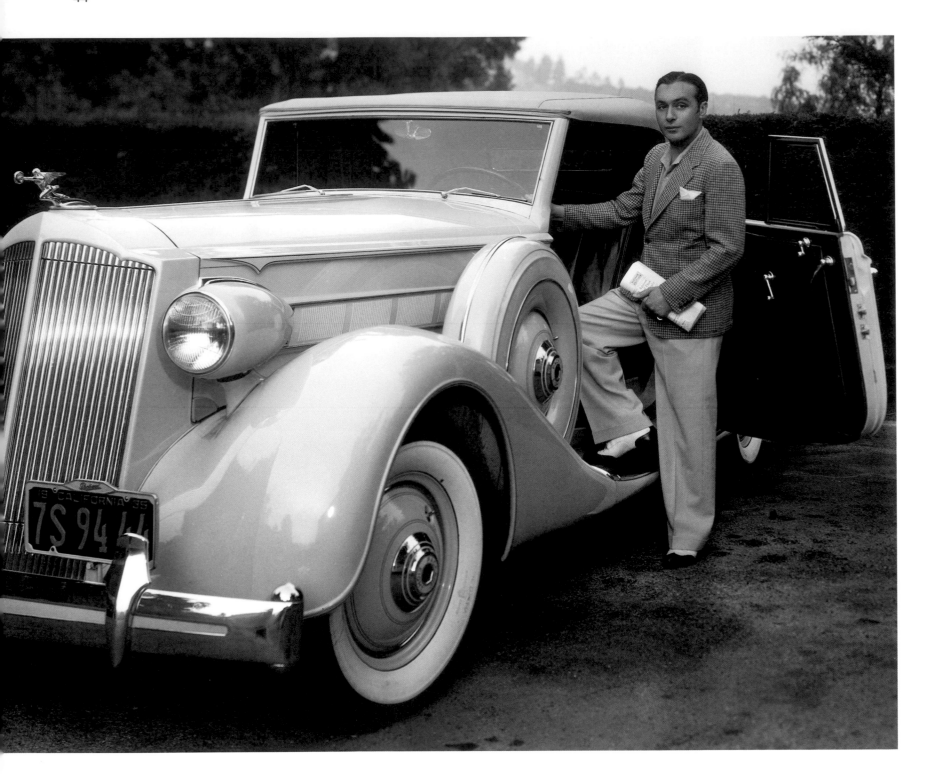

Above: French actor Charles Boyer, famous as a romantic lead, climbs aboard his 1935 Packard convertible.

Opposite: Actor Robert Taylor (star of *Quo Vadis* [1951] and *Ivanhoe* [1952]) lovingly polishes his 1935 Packard.

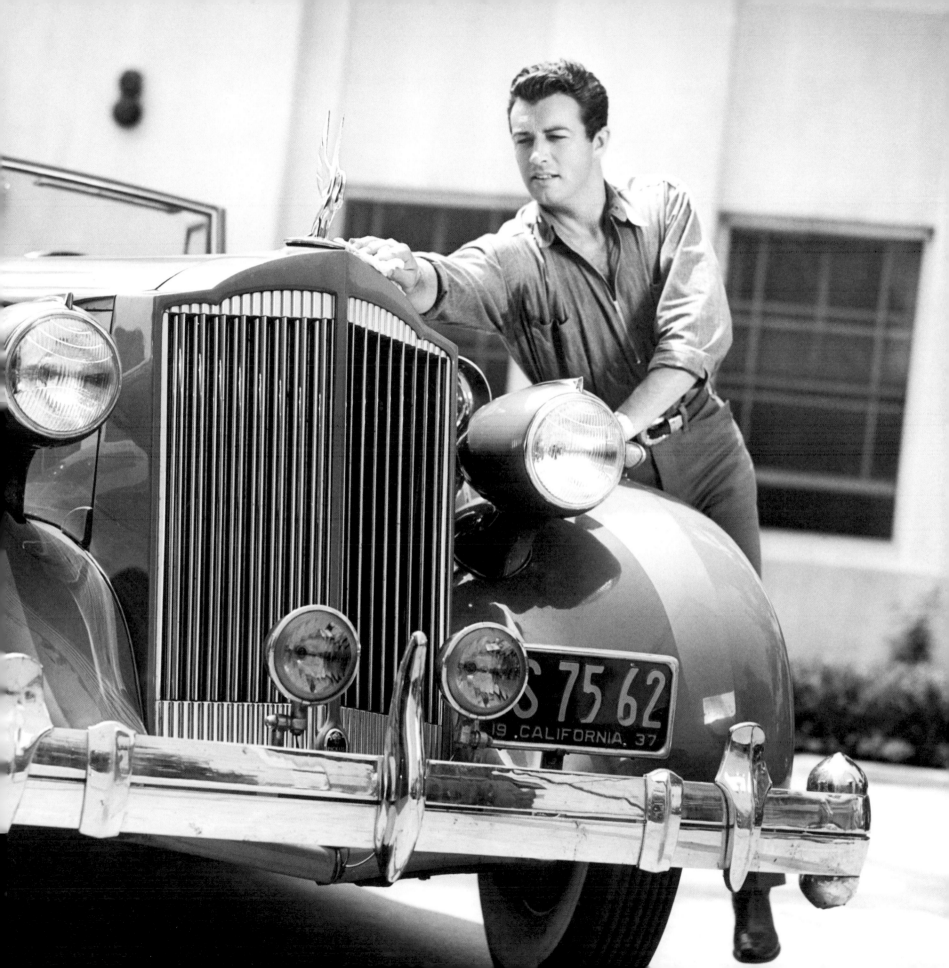

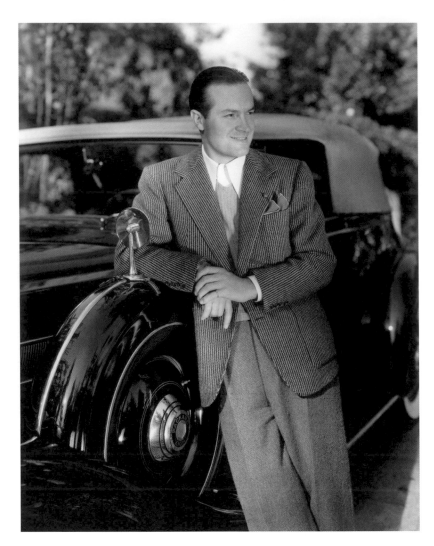 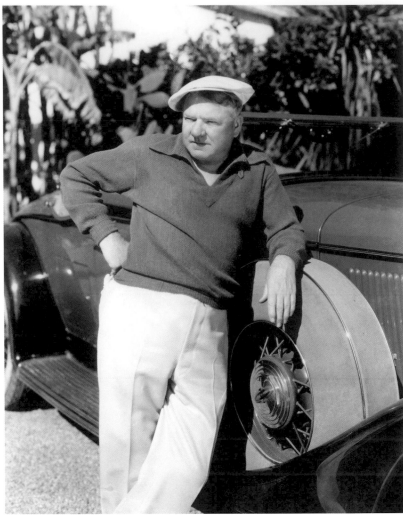

Above left: Comedian Bob Hope, in relaxed mode, poses against his 1934 Packard convertible.

Above right: W.C. Fields leans grumpily against his c.1932 Lincoln roadster.

Opposite: Actor Don Ameche, dressed for tennis with his c.1936 Packard sedan.

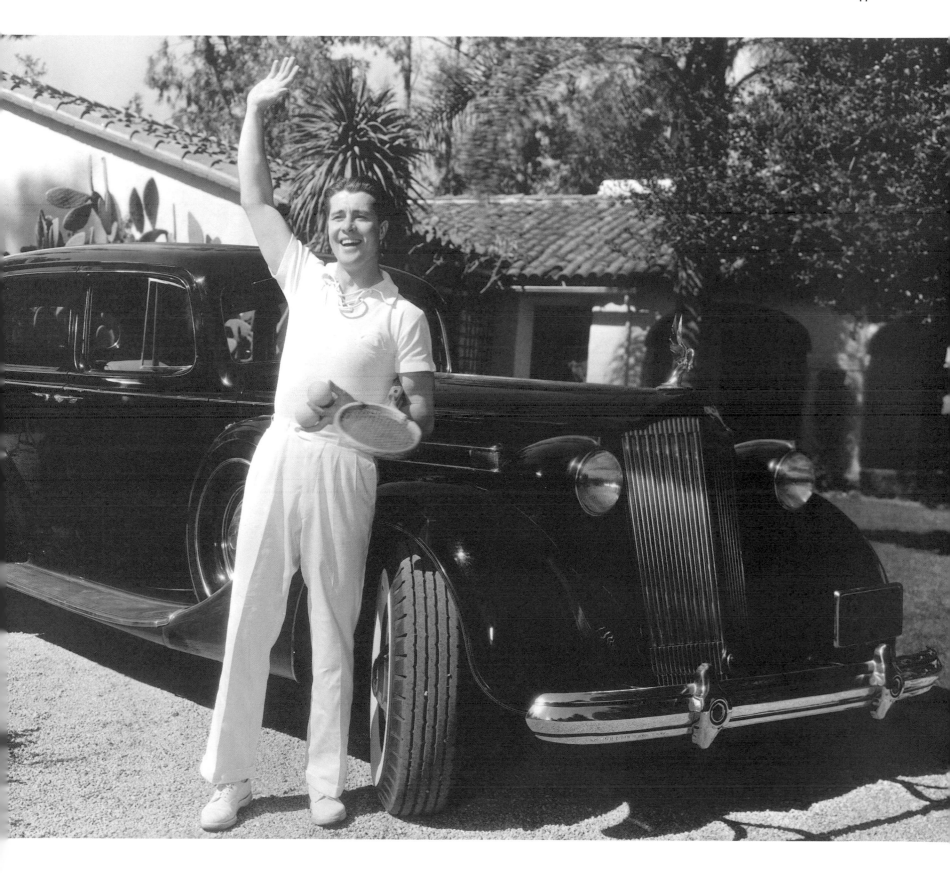

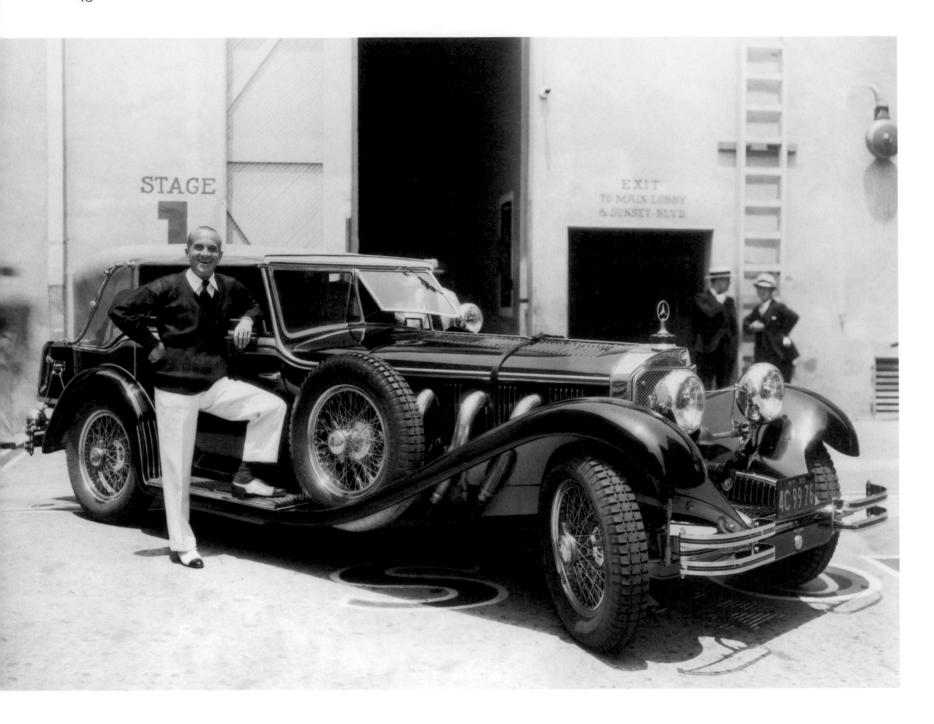

Above: Al Jolson with his 1930 Mercedes-Benz S on the Warner Brothers lot. The S was, in its time, the ultimate supercar. Fitted with two- and four-seat open coachwork from Sindelfingen, home of some of Europe's finest coachbuilders, the Mercedes-Benz S was a sports car for select, successful owners who prized quality, flair and performance above all else.
Opposite: Actress Joan Bennett doesn't go in much for driving – preferring to be chauffeured by her husband, Gene Markey, in their Mercedes-Benz S.

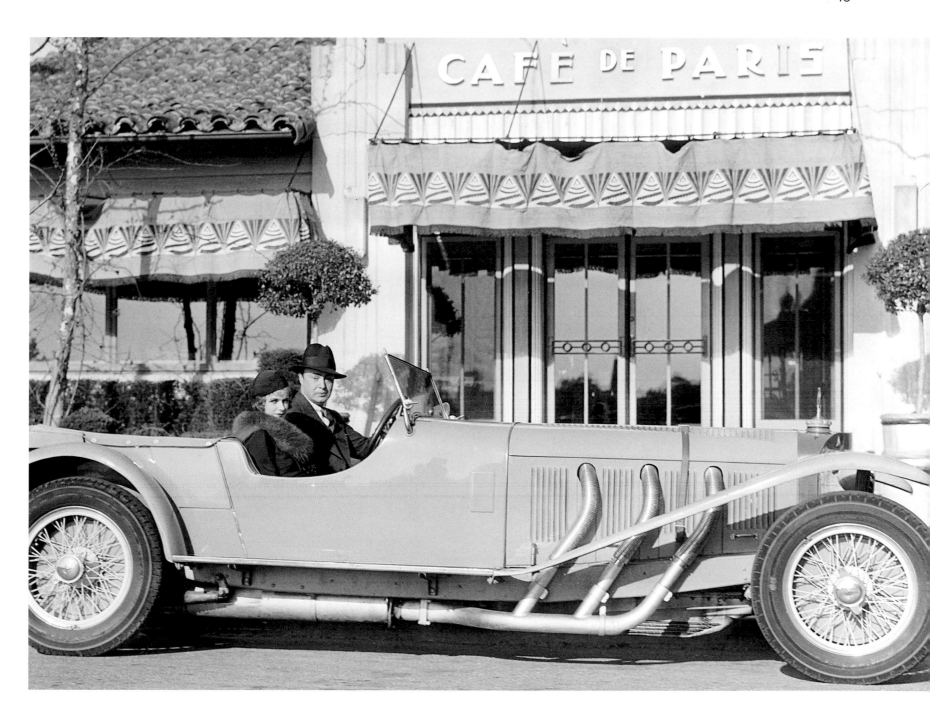

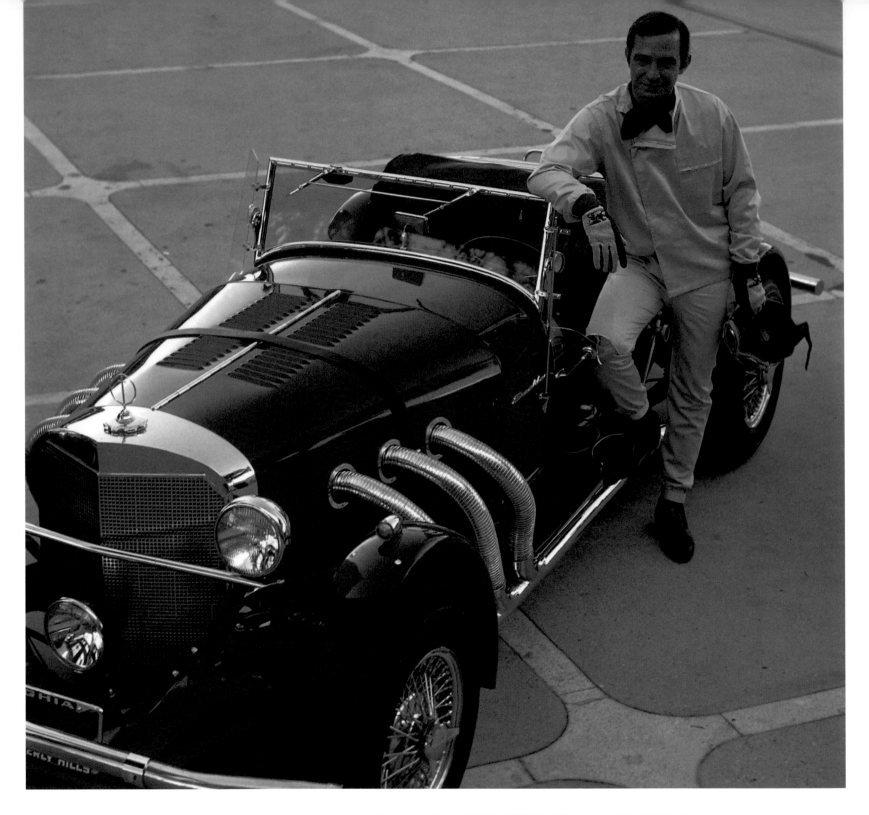

Above: Actor Ben Gazzara, who has had a long career stretching from such classics as *Anatomy of a Murder* (1959) to 2003's *Dogville*, stands with his 1966 Excalibur, a car driven by only the coolest Hollywood stars.

Opposite: Steve McQueen and his wife Neile Adams in their 1967 Excalibur. These cars were built as replicas of the famous late-Twenties Mercedes-Benz and were purchased by many famous people at the time, including Frank Sinatra, Tony Curtis, Dean Martin, Jackie Gleason, Roberto Duran and Paul Harvey.

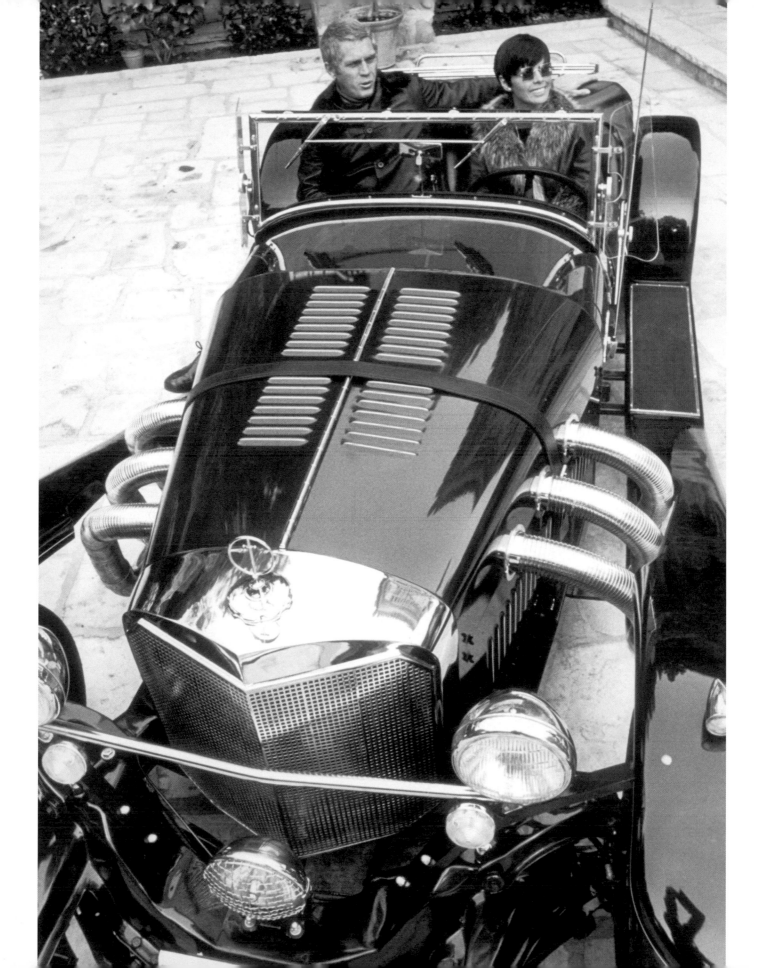

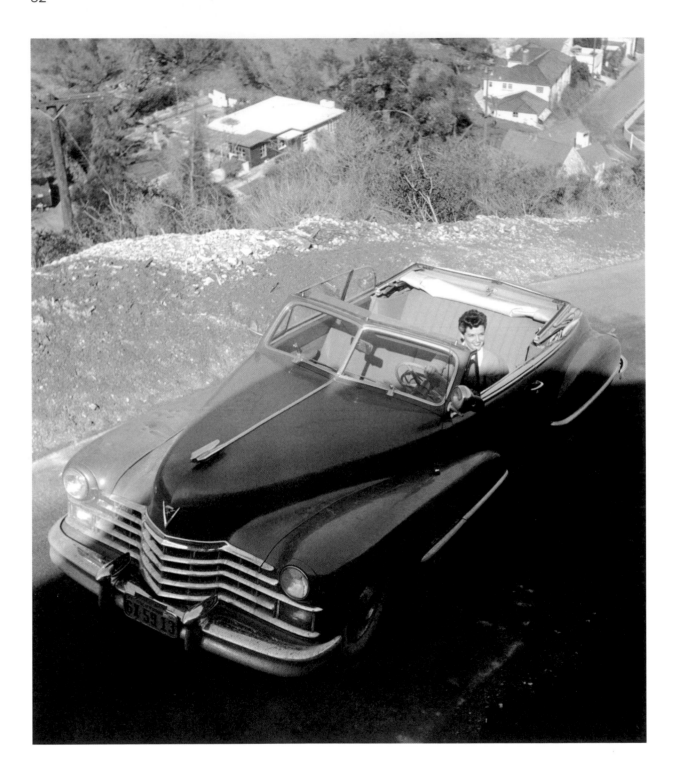

Above: Jane Russell at the wheel of her glamorous Cadillac convertible in the driveway of her home in the Hollywood Hills, 1949.

Opposite: Actress and film-maker Ida Lupino poses alongside her 1941 Buick 8 convertible.

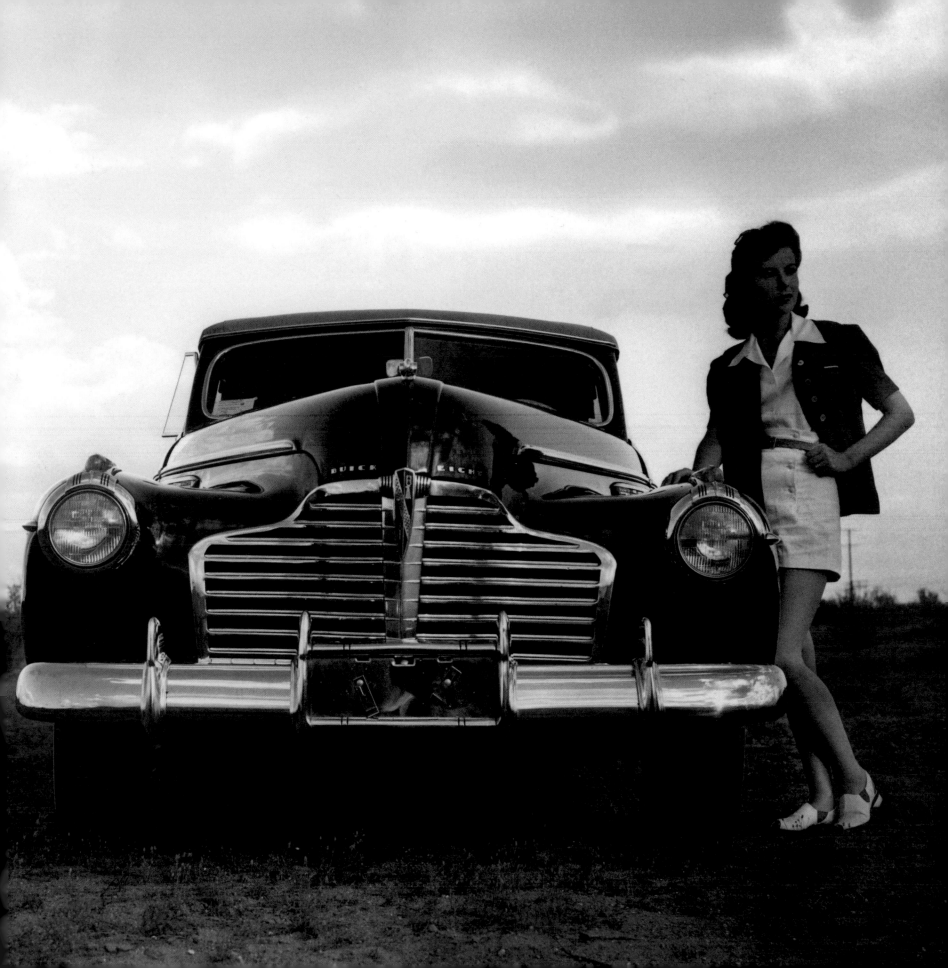

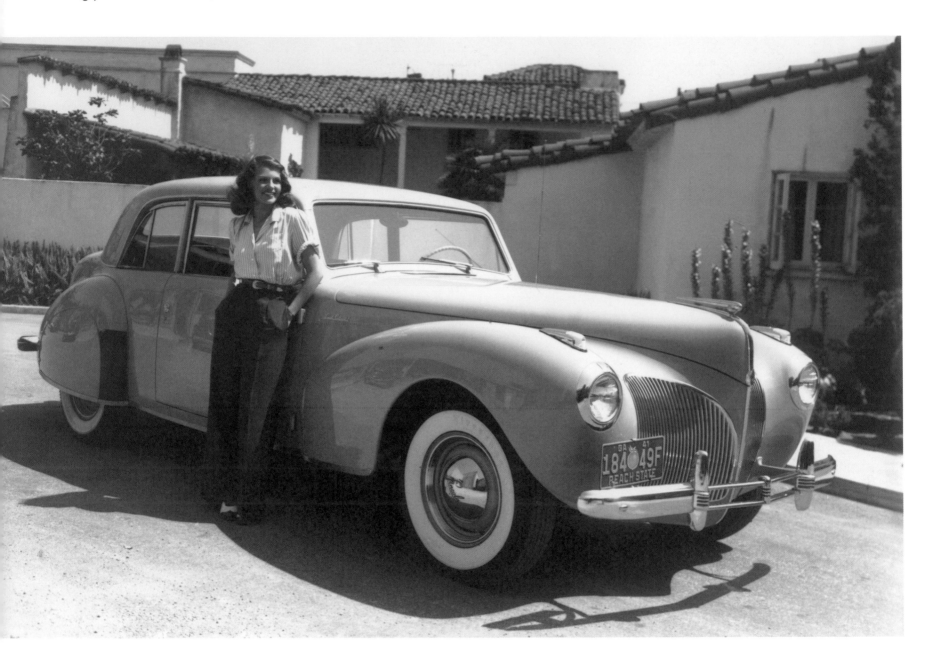

Above: Rita Hayworth leaning against her curvy new 1941 Lincoln Continental sedan. When Ford Motor Company President Edsel Ford returned from a European vacation in September 1938, he asked designer E. T. 'Bob' Gregorie for a special car that would be 'strictly continental' in appearance. Clean uncluttered lines, elegant styling and a nod to art deco were the result.
Opposite: Oscar-winning actress Anne Baxter in a swimsuit with her handsome 1949 Lincoln Cosmopolitan convertible. The Cosmopolitan featured 4-speed manual transmission and a 5.5 litre V8 engine.

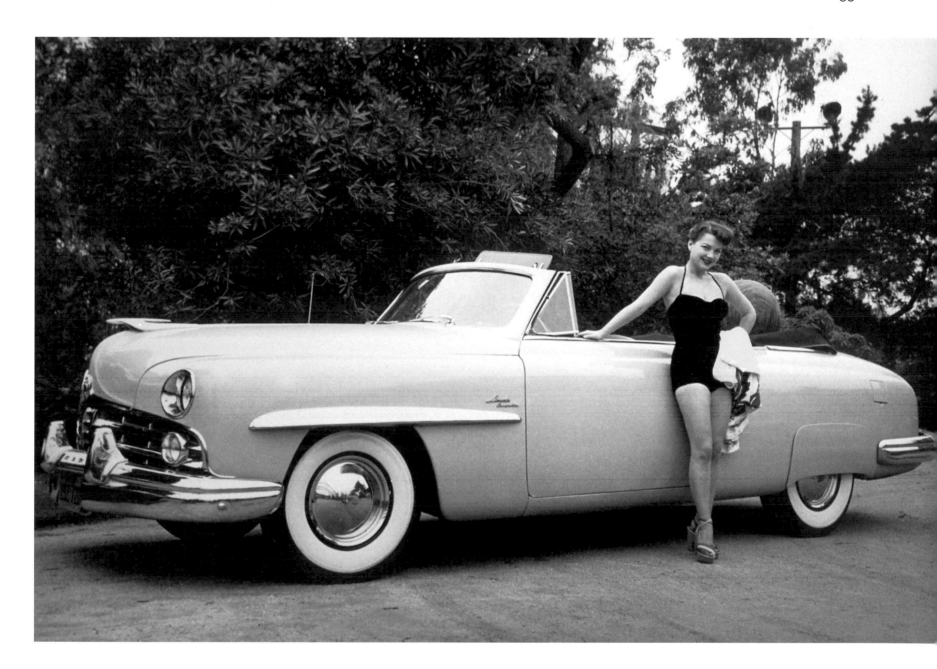

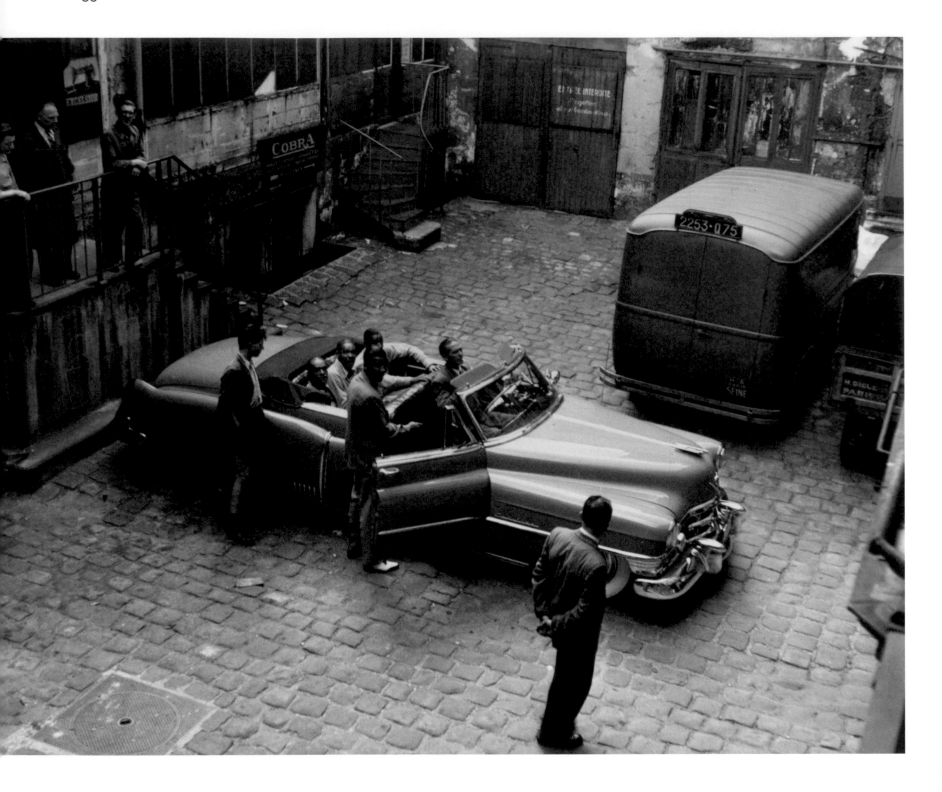

Above: Boxing legend Sugar Ray Robinson enjoys his brand-new 1951 Cadillac convertible during some time off training in Paris, prior to his bout with British boxer Randolph Turpin.

Opposite: Cassius Clay, soon to be known as Muhammad Ali, sitting, deep in thought, on the bonnet of his brand-new 1963 Cadillac convertible at his parents' house in Louisville, Kentucky.

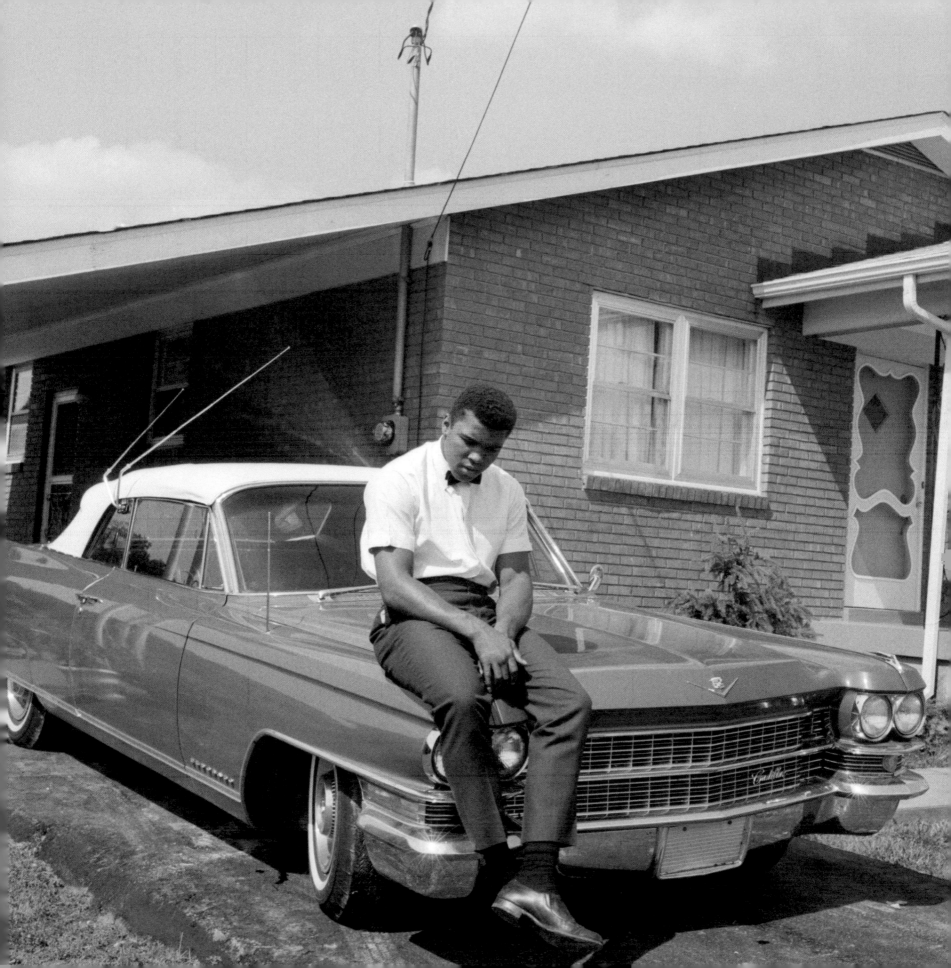

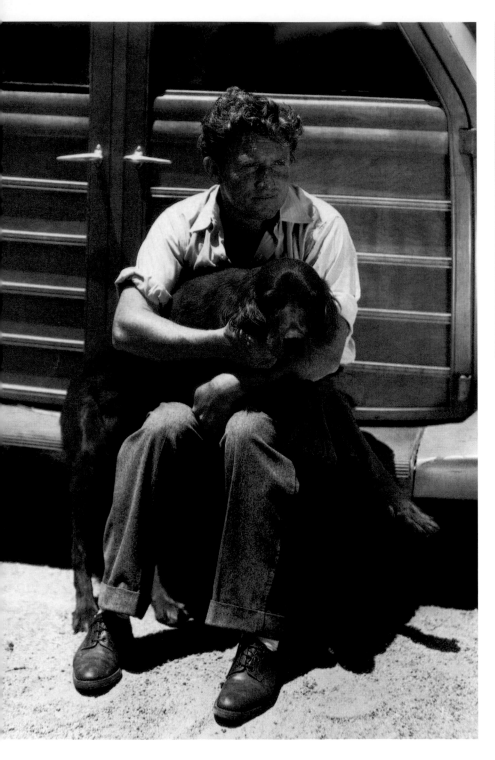

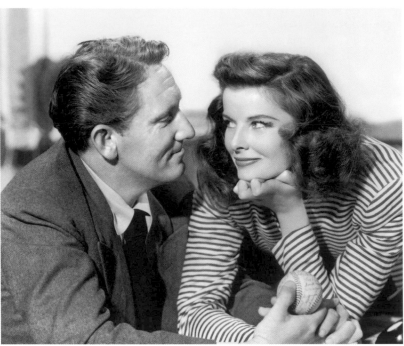

Above left: Spencer Tracy, in homely mood with his Red Setter, sits on the running board of his 'Woodie', an early make of American station wagon.

Above right: Spencer Tracy and another redhead, Katharine Hepburn, in a publicity shot from *Woman of the Year* (1942).

Opposite: Katharine Hepburn driving an English Singer roadster along the waterfront with Irene Mayer Selznick in Montego Bay, Jamaica, 1953.

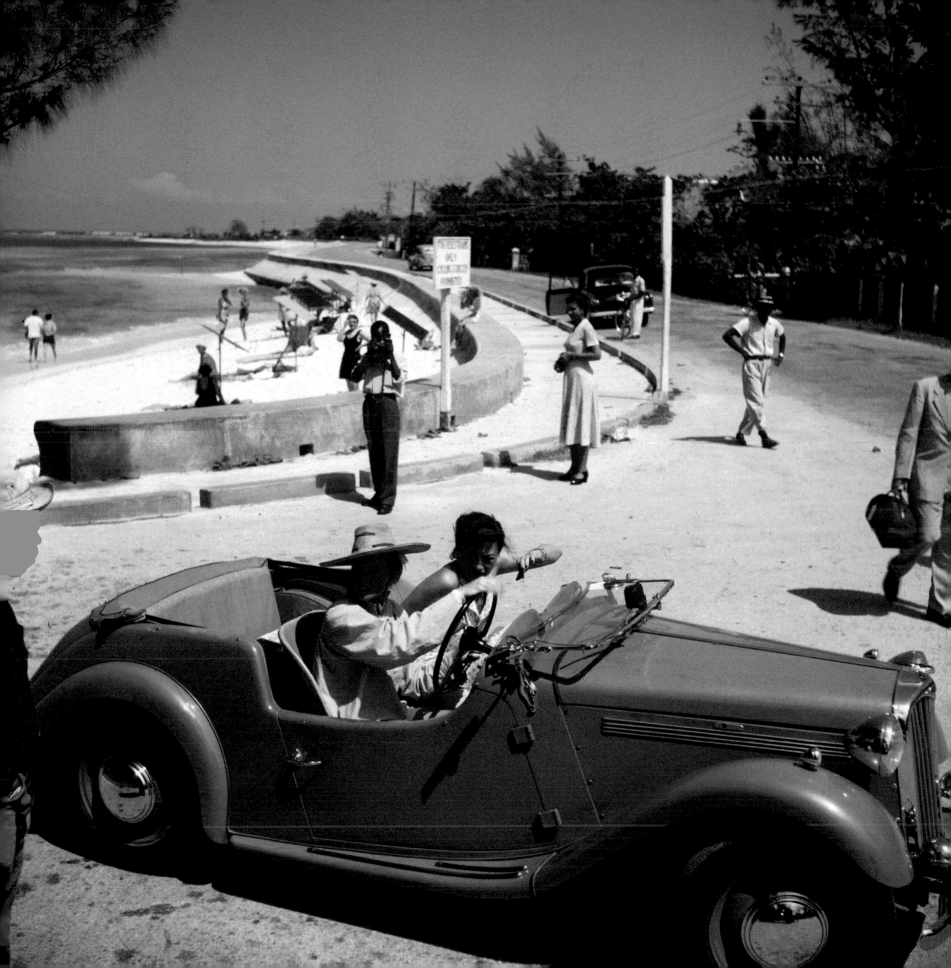

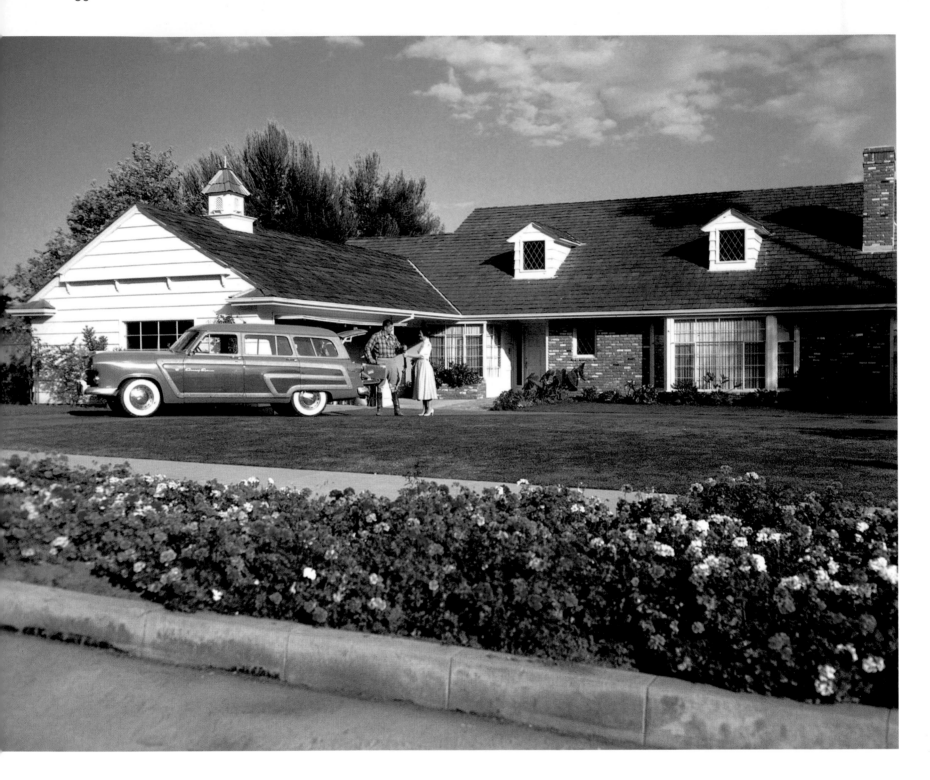

Above: Ronald and Nancy Reagan outside their home in California with their brand-new 1952 Ford station wagon.

Opposite: A youthful Ronald Reagan poses shirtless with a shovel alongside his 1948 Buick convertible.

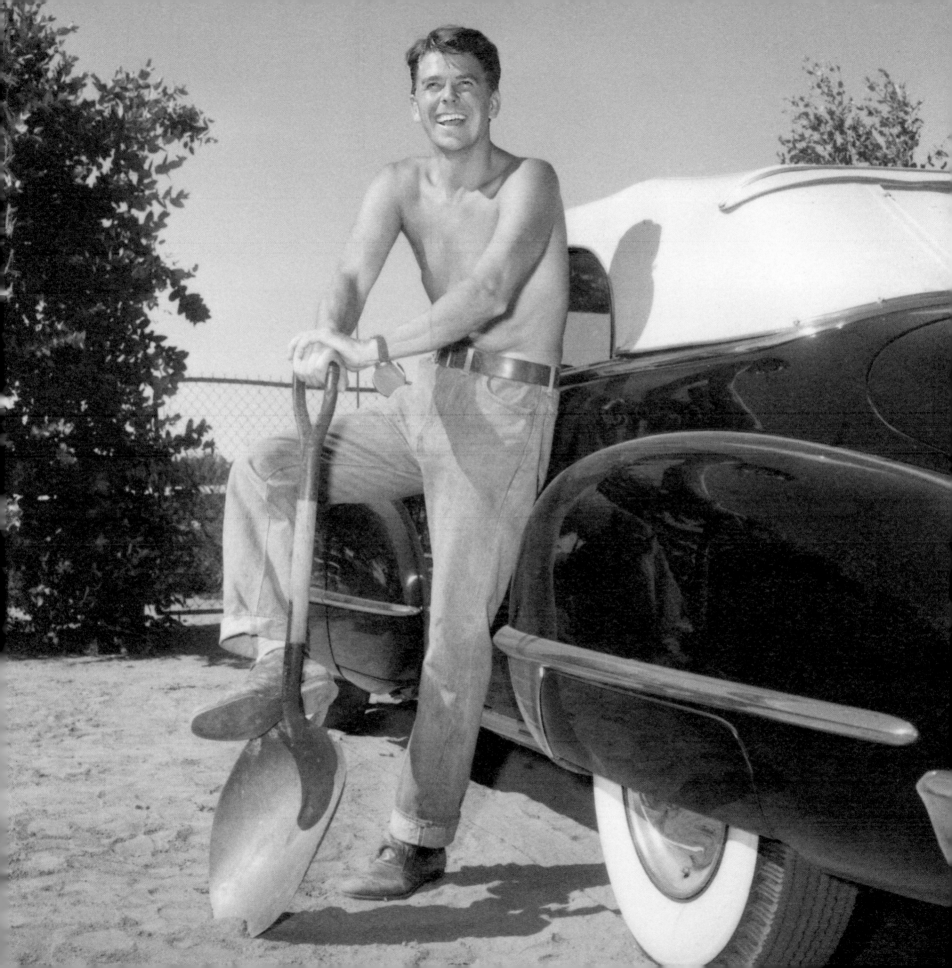

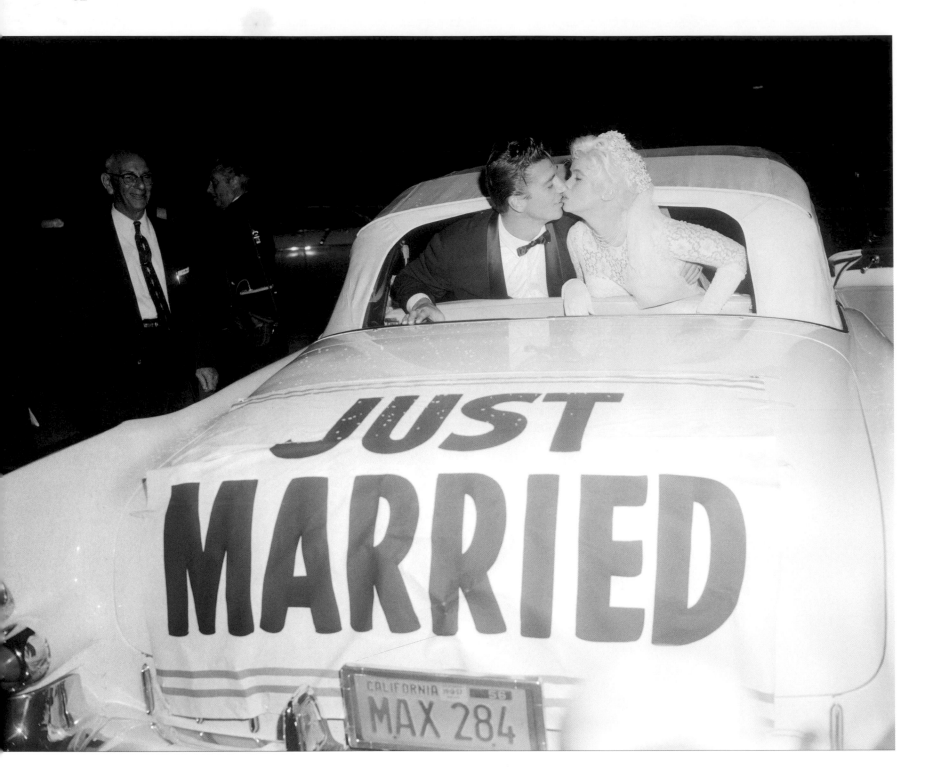

Above: Jayne Mansfield receives a kiss from her bridegroom, Mickey Hargitay, in the back of her 1955 Cadillac Eldorado convertible. The couple married in Palos Verdes, California on 15 January 1958.

Opposite: Marilyn Monroe waves from Arthur Miller's Ford Thunderbird convertible as the newlyweds leave their Roxbury, Connecticut home for a picnic in June 1956.

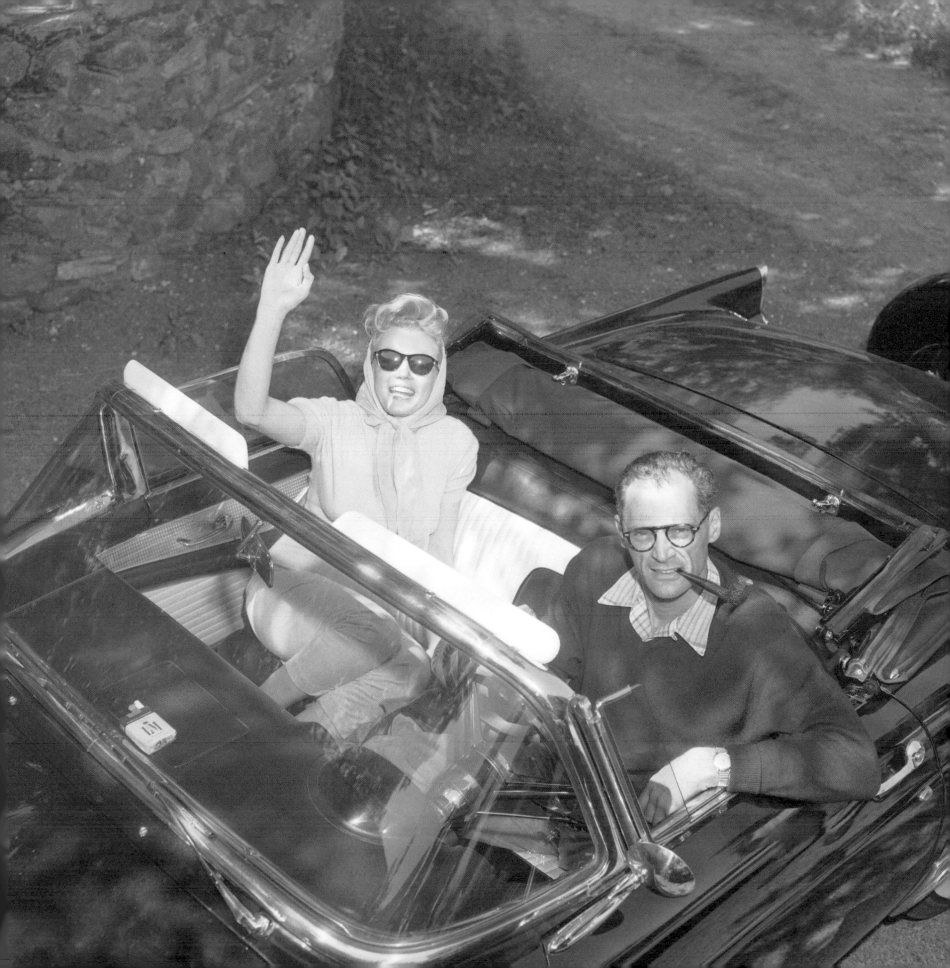

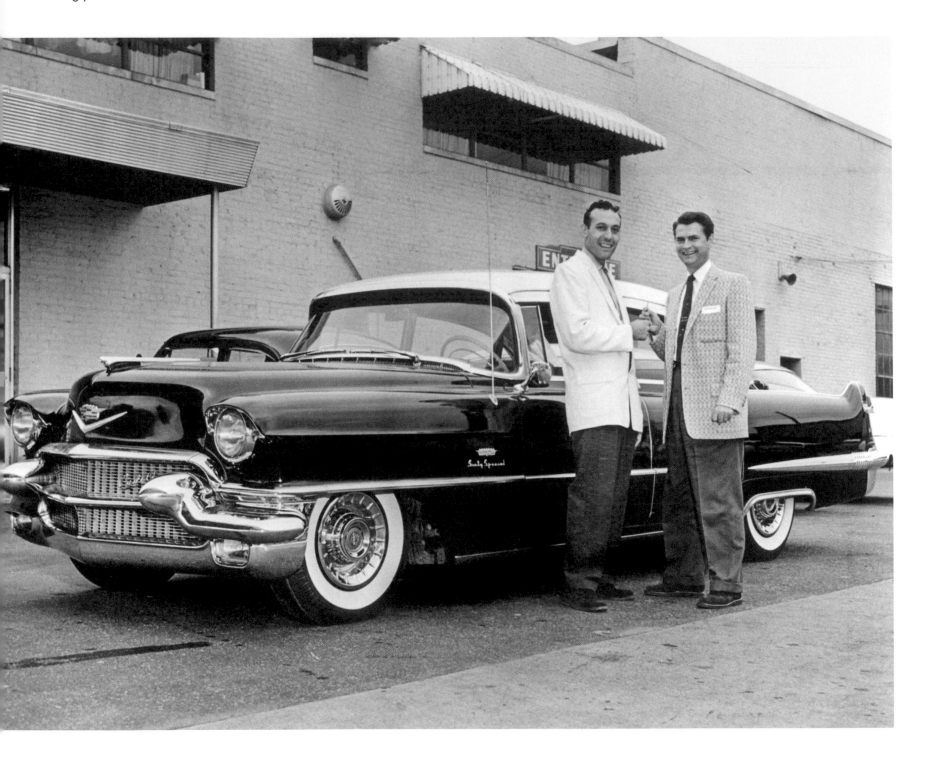

Above: Rockabilly legend Carl Perkins receiving the keys for his new Cadillac from Sun Studios owner Sam Phillips in November 1956.

Opposite: Elvis Presley leans against his 1956 Continental Mark II, a car of understated beauty when compared to some of the flashier American designs of the day, with their acres of chrome, two-tone paint and sharp styling cues. The Mark II cost $10,000 new, equivalent to a Rolls-Royce at the time. Famous owners have included Frank Sinatra, Louis Prima, Dwight Eisenhower, Spike Jones, Nelson Rockefeller and even the Shah of Iran.

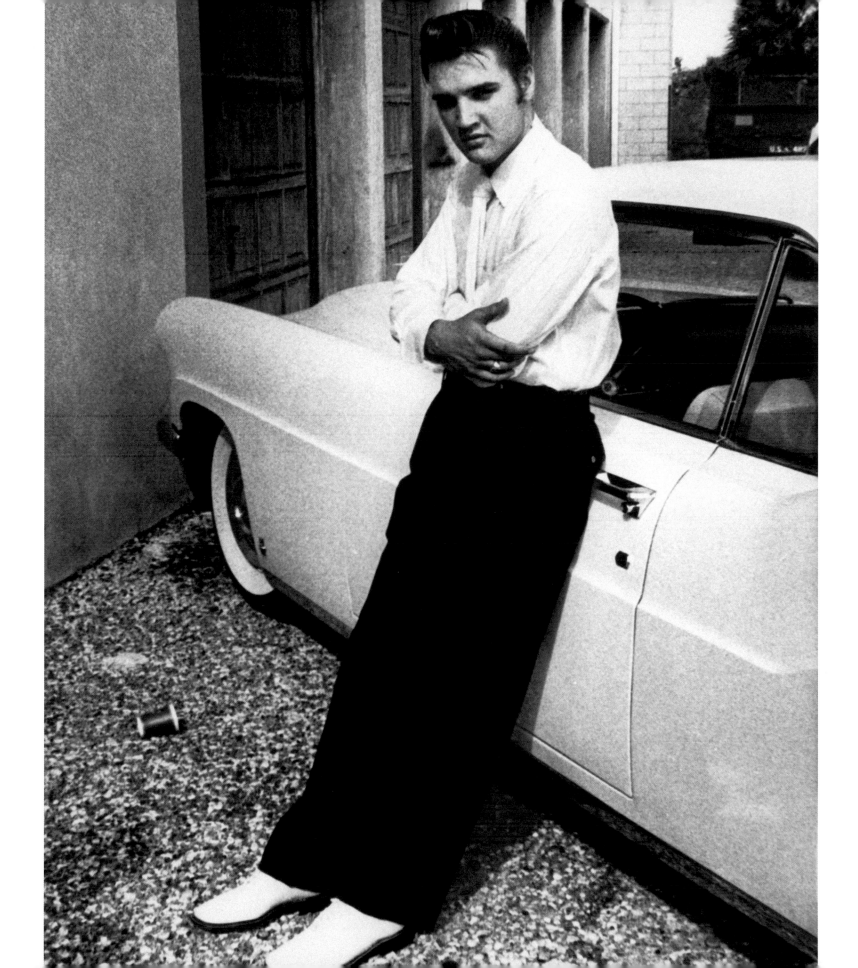

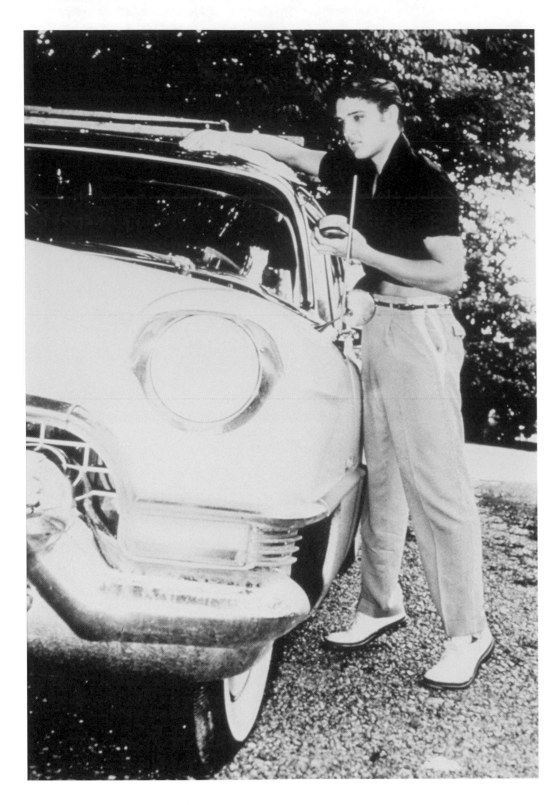

Above: Elvis Presley polishes the roof of his Cadillac, c.1956.

Opposite: Elvis makes a fast getaway from over-zealous autograph hounds.

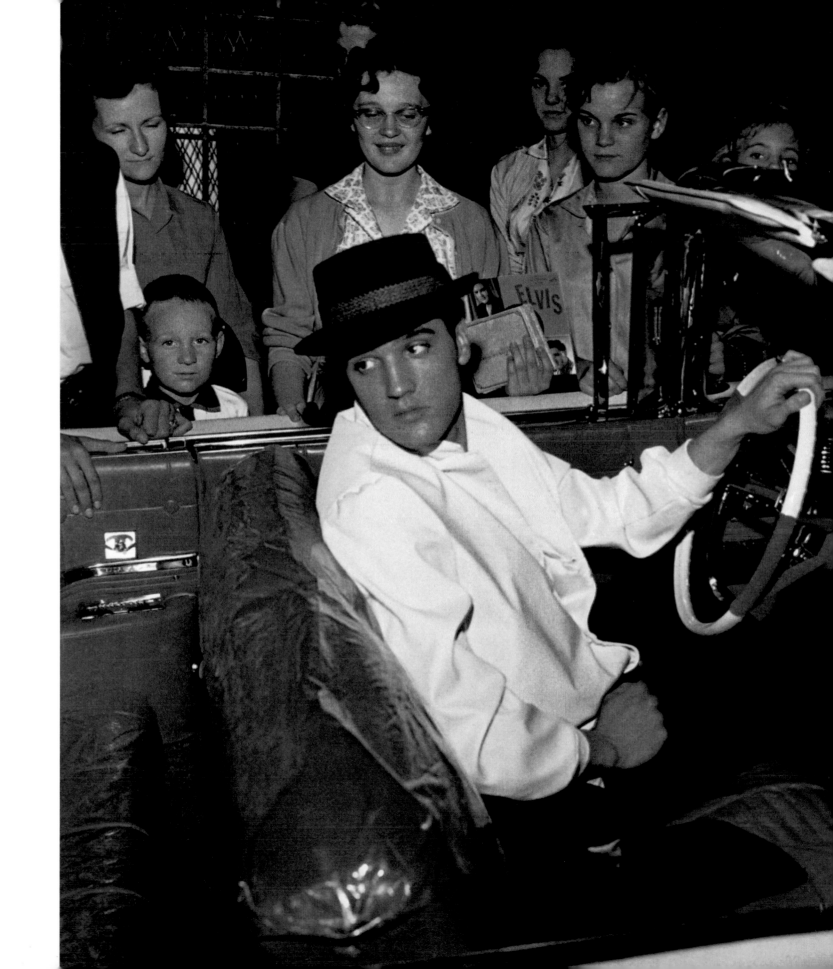

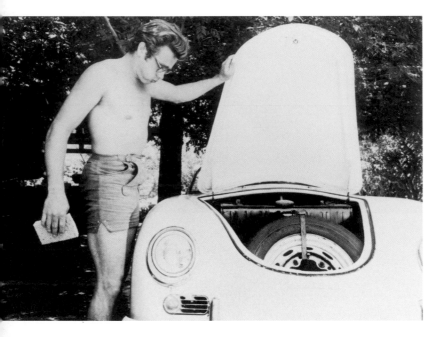

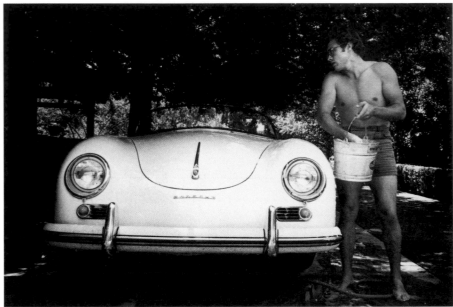

James Dean's passion for racing cars resulted in a tragically short life.

Above: With his beautiful Porsche Speedster in 1955.

Opposite: Dean, photographed by Sandford Roth just days before the fatal accident, with his Porsche Spyder – the car in which he lost his life.

Overleaf: James Dean cruises the streets of Los Angeles in his Porsche Speedster.

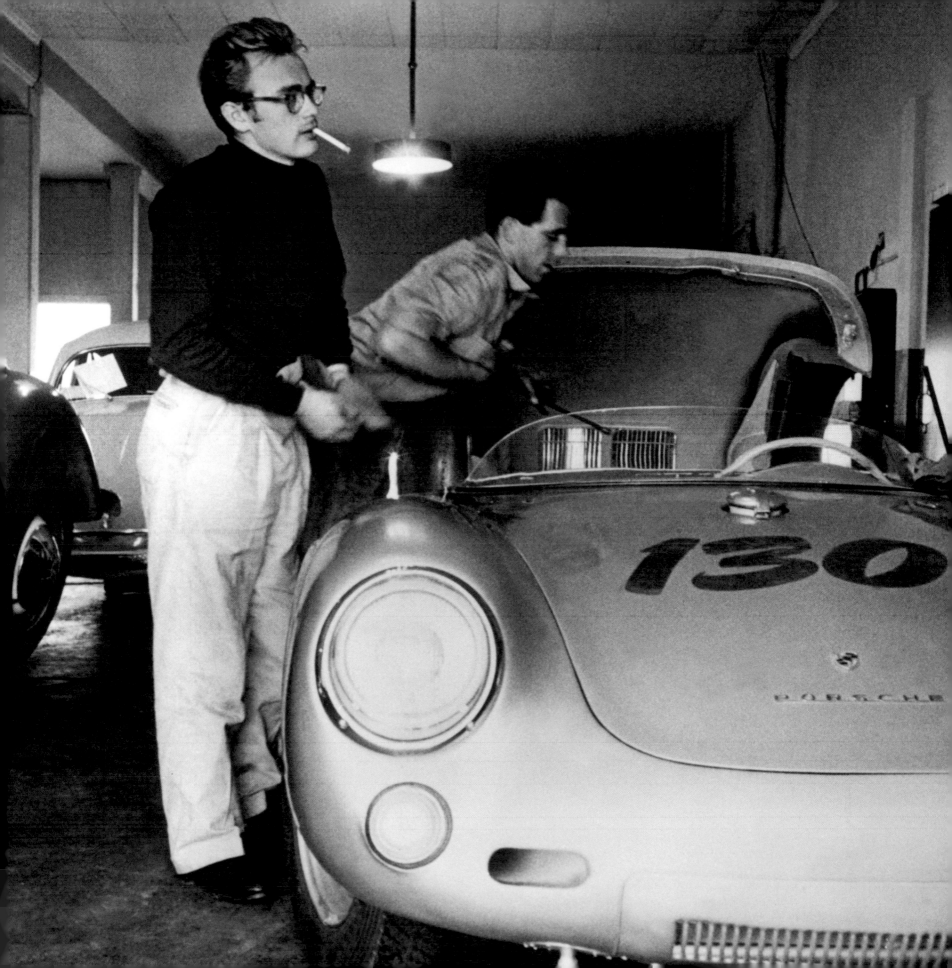

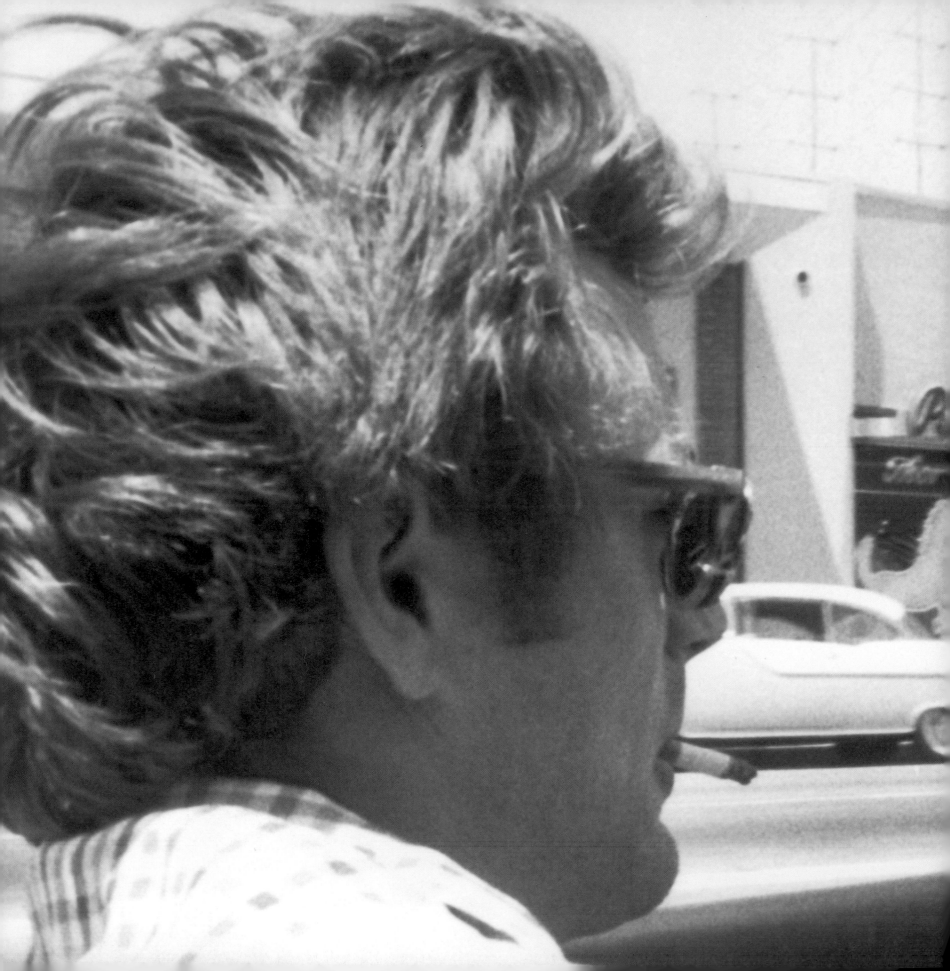

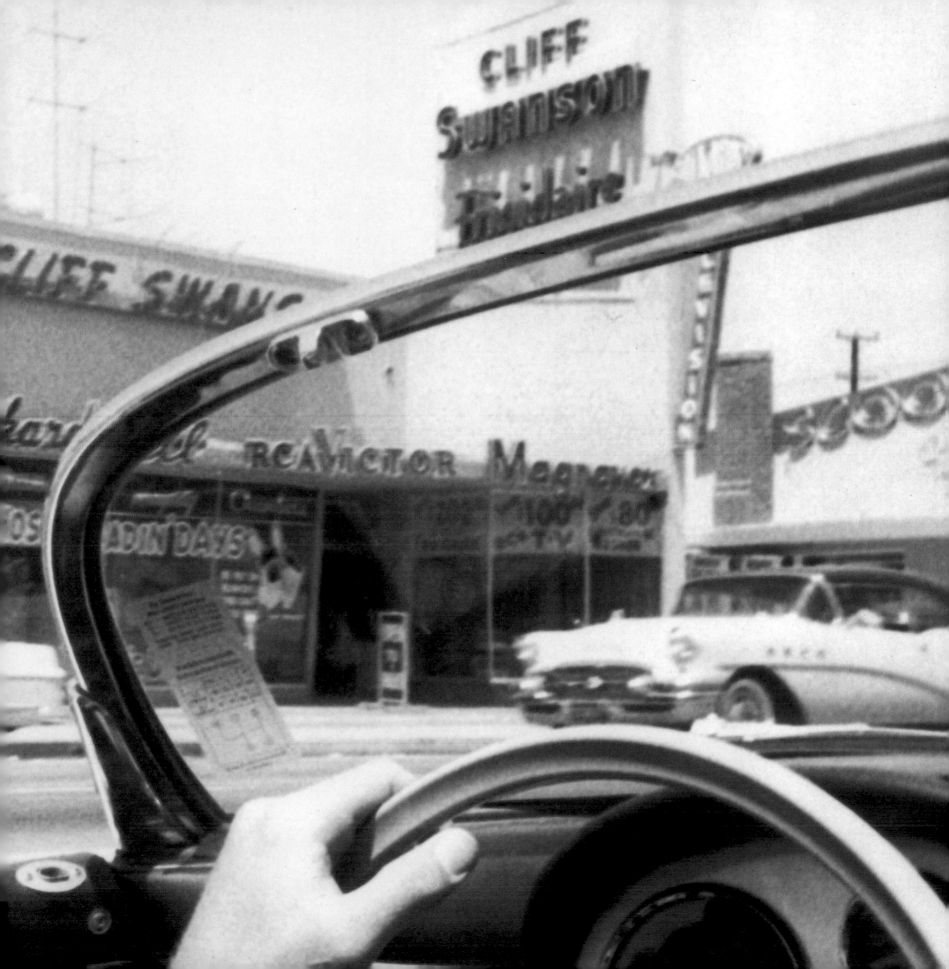

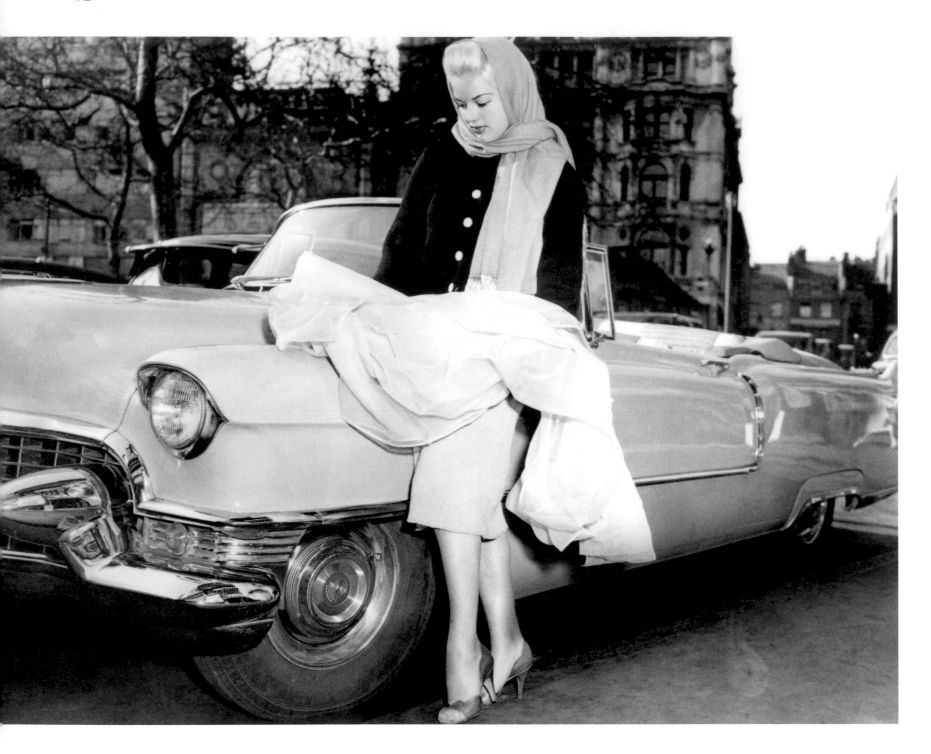

Above: Diana Dors, the British starlet, arriving at the Cannes Film Festival with her sexy Cadillac convertible. These mid-Fifties Cadillacs featured Dagmar bumpers, also known simply as Dagmars, a slang term for the artillery shell-shaped styling elements found on the front bumpers. (The word was actually a direct reference to 'Dagmar' [born Virginia Ruth Egnor], an early 1950s television personality who was famous for her pronounced cleavage.)

Opposite: Singer Cliff Richard poses for the cameras at the wheel of his Chevrolet Corvette on 27 August 1963. Dors and Richard were considered to be Britain's answers to Marilyn Monroe and Elvis Presley.

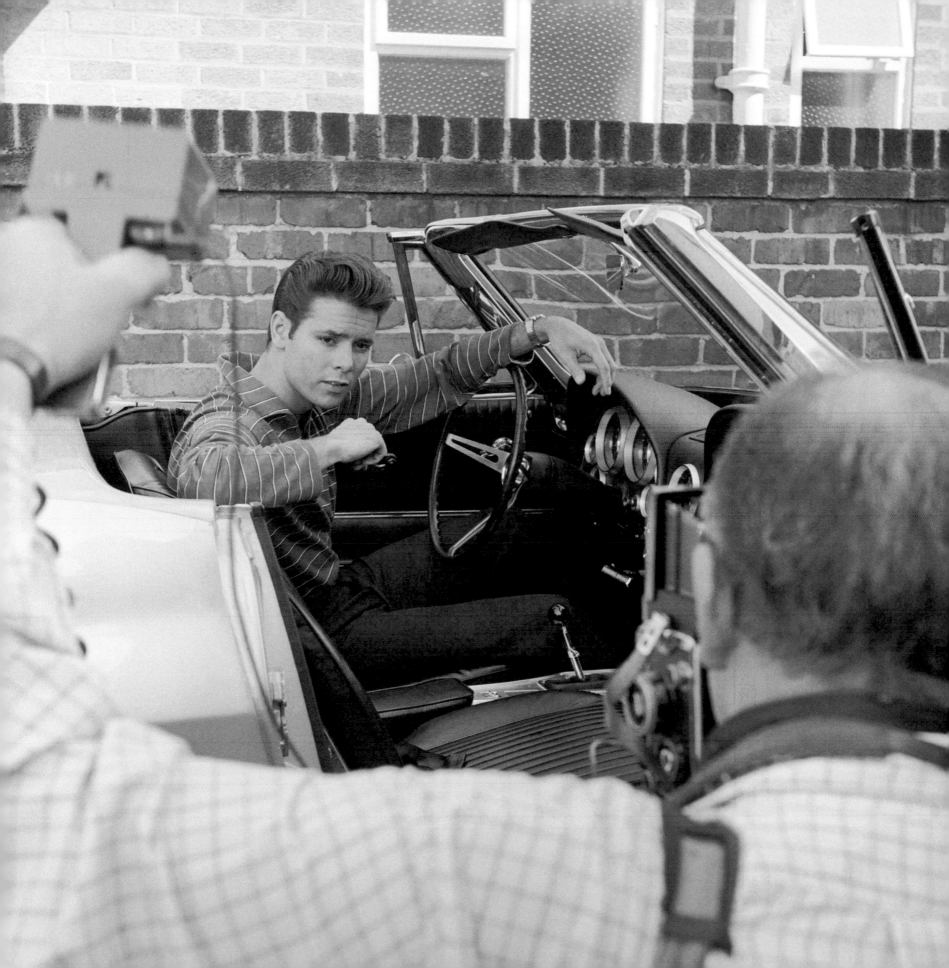

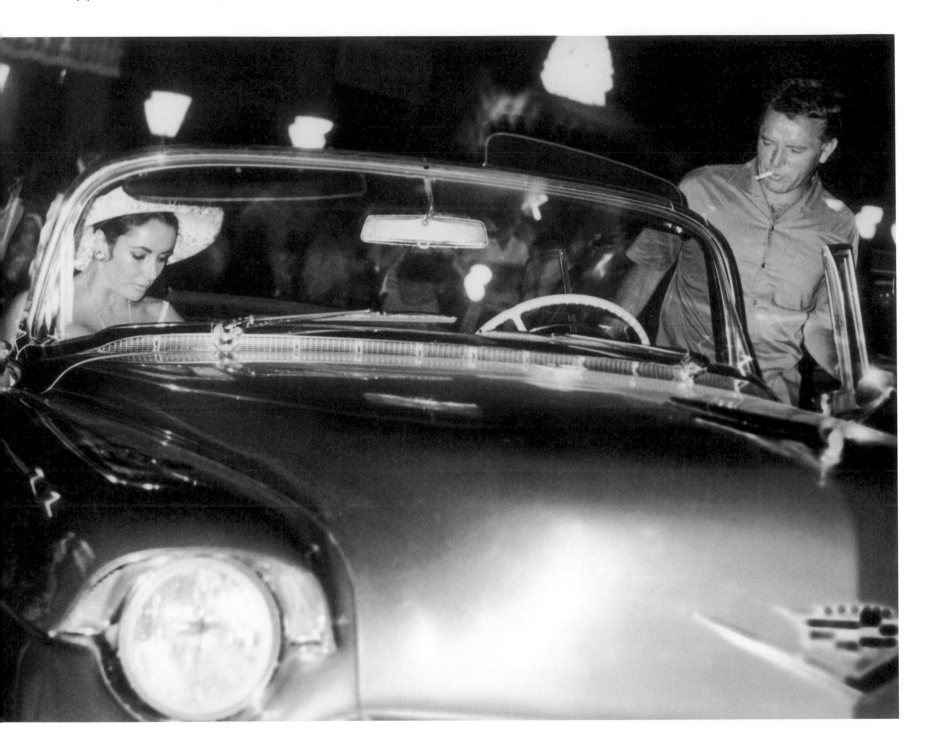

Above: Elizabeth Taylor and Richard Burton leave the Tre Scalini restaurant in Piazza Navona, Rome in Burton's 1955 Cadillac convertible.

Taylor had just returned from a family holiday in Switzerland, while he had arrived from Egypt, after filming the final scenes of *Cleopatra* (1963).

Opposite: Burton poses alongside his Cadillac.

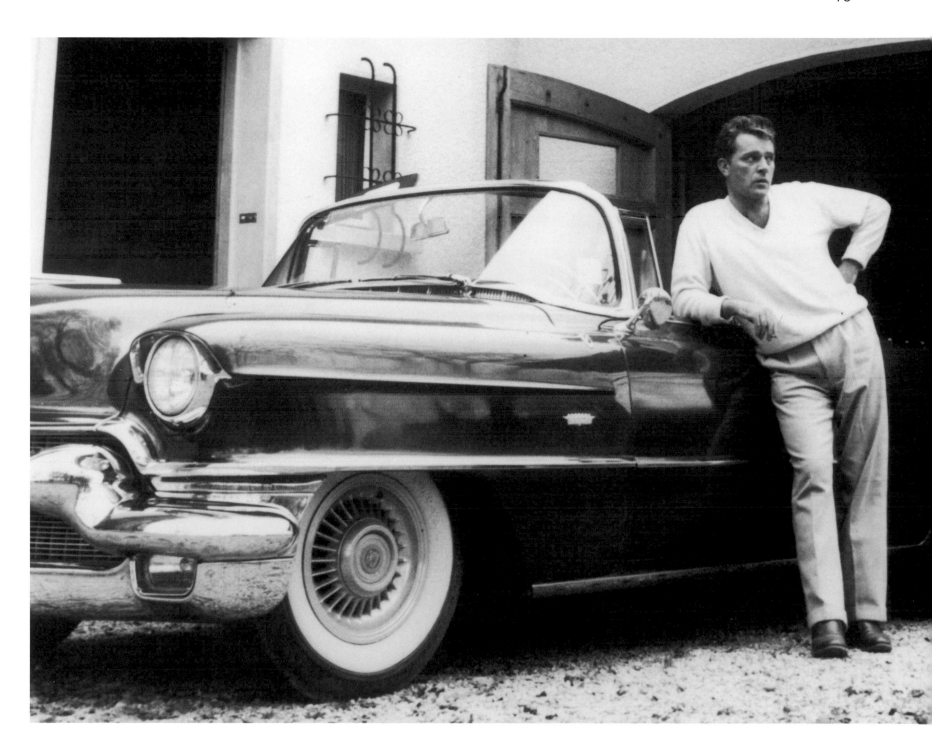

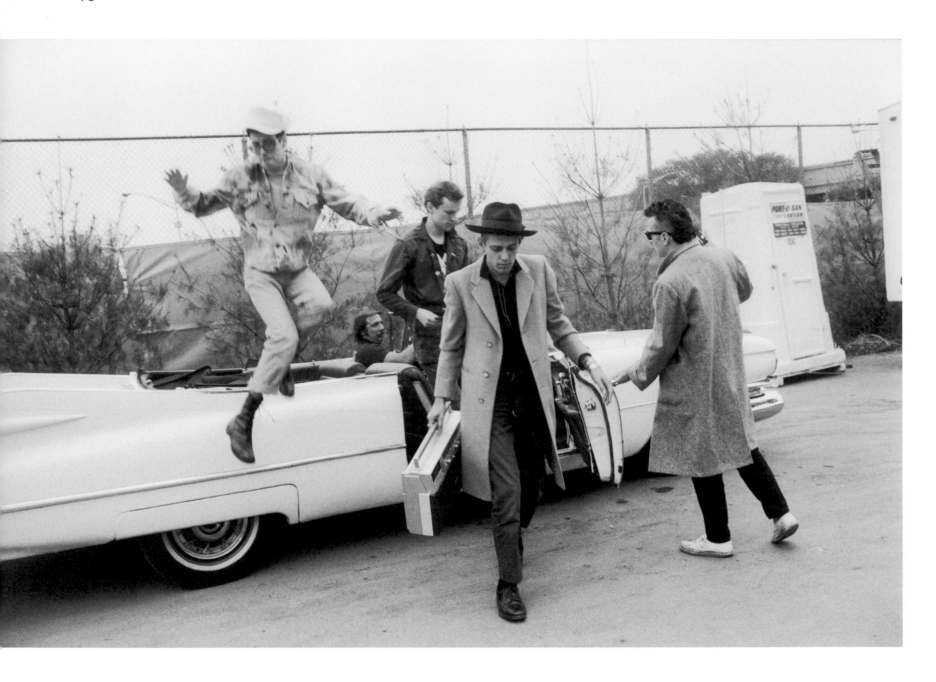

Above: Members of the Clash getting out of a 1959 Cadillac convertible, the ultimate 1950s car with the biggest fins of them all.

Opposite: Jayne Mansfield in her 1959 Cadillac convertible.

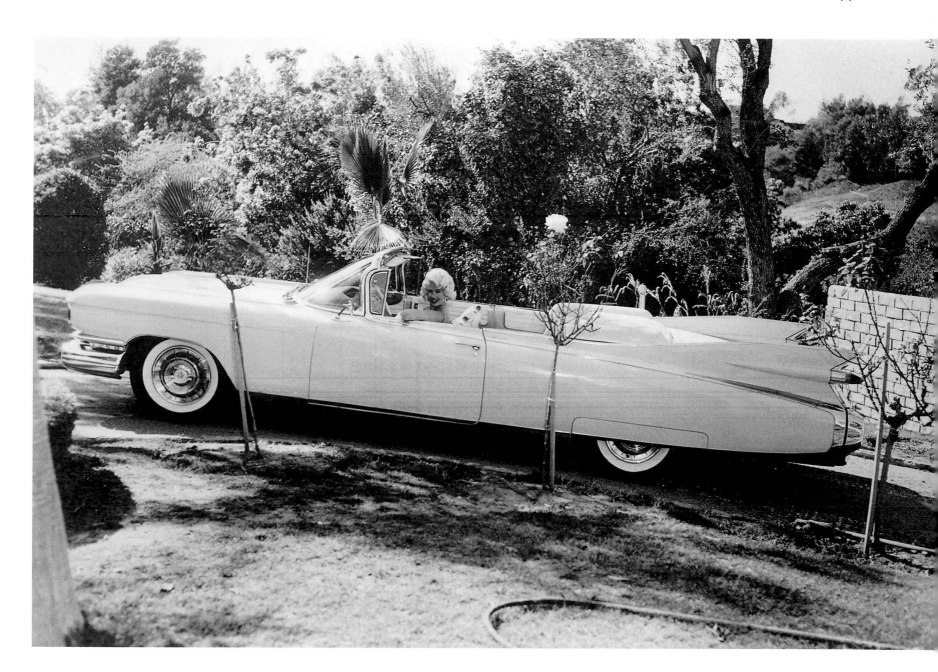

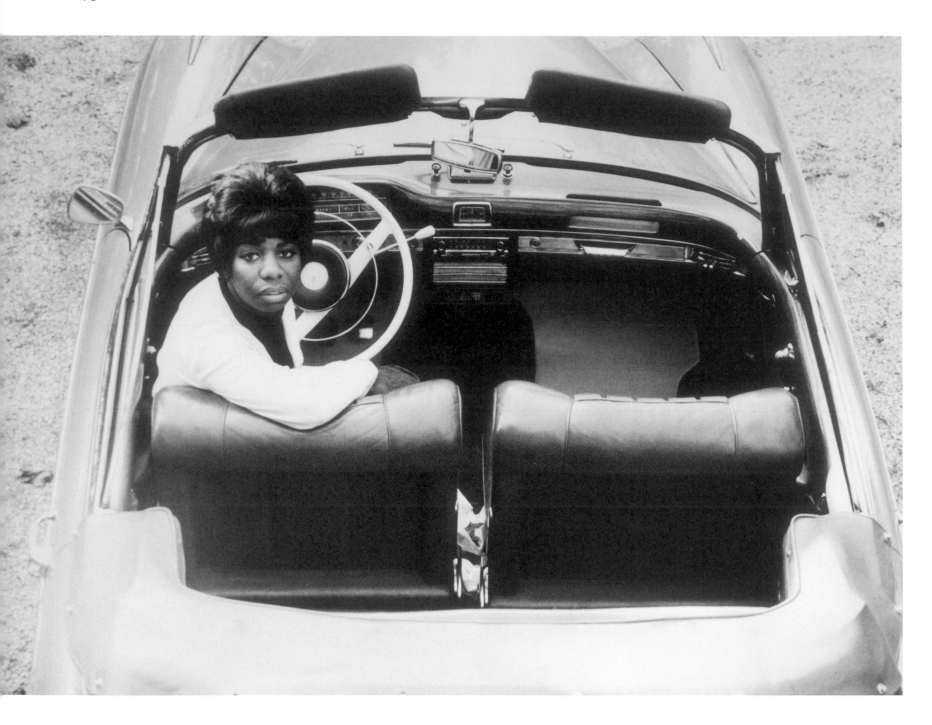

Above: Nina Simone looks up from the driver's seat of her Mercedes-Benz convertible.

Opposite: Piano duo Buck Whittemore and Jack Lowe with their 1953 Cadillac convertible. Note the personalized licence plate, '88-WL'.

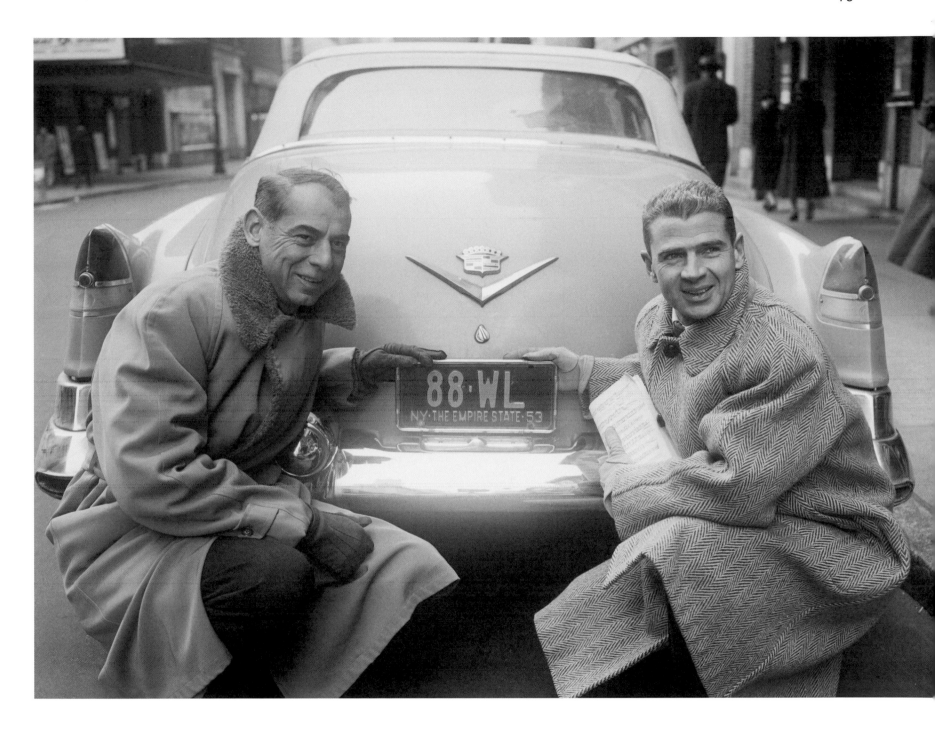

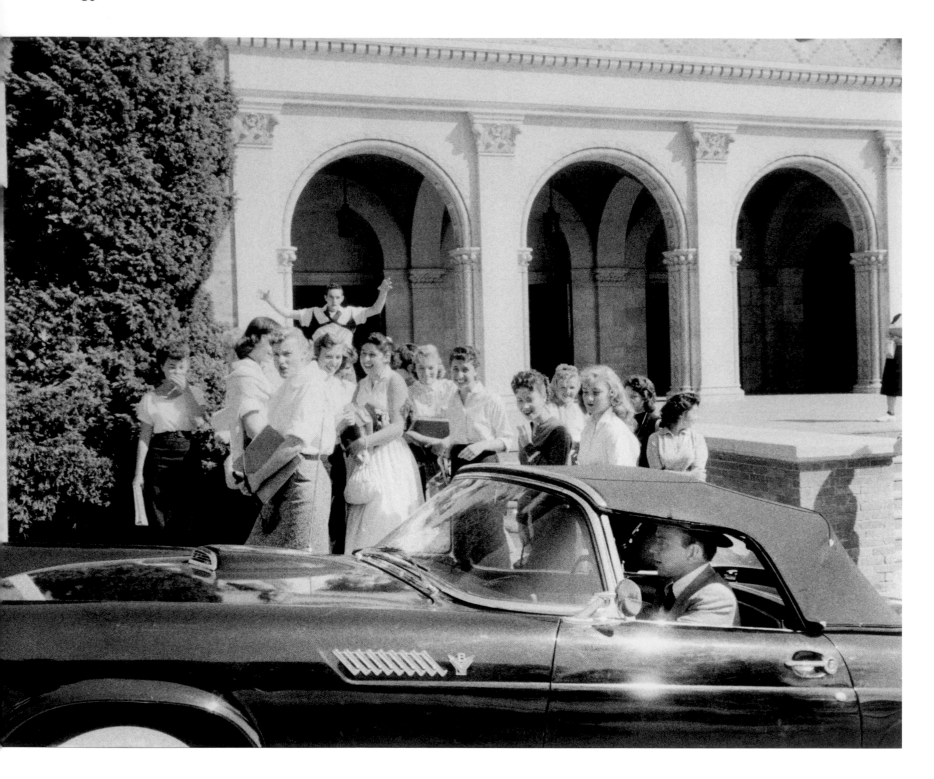

Above: Frank Sinatra leaving his daughter Nancy's high school after a performance, in a 1955 Ford Thunderbird.

Opposite: Frank Sinatra with his Dual Ghia, known as America's first four-passenger sports car. Original owners of these rare cars included Sammy Davis Jr, Debbie Reynolds, Peter Lawford and big-band leader Hoagy Carmichael.

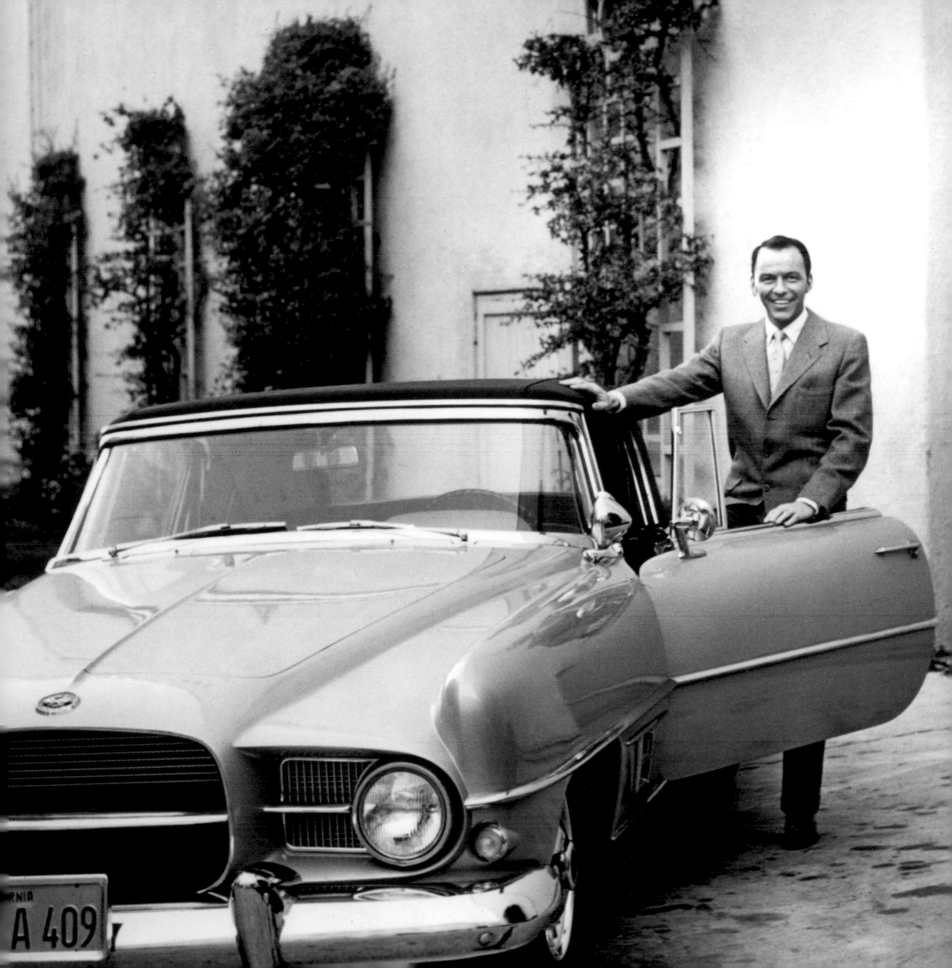

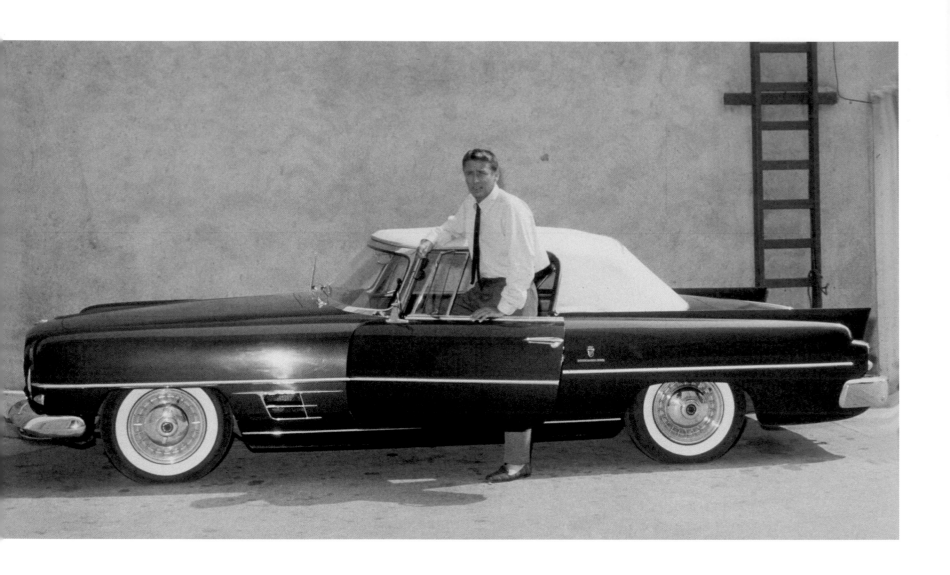

Above: Rat-Pack star Peter Lawford with his 1957 Dual Ghia.

Opposite: Dean Martin gets out of his 1961 Facel Vega, a luxurious French-built car with V8 power courtesy of American Chrysler.

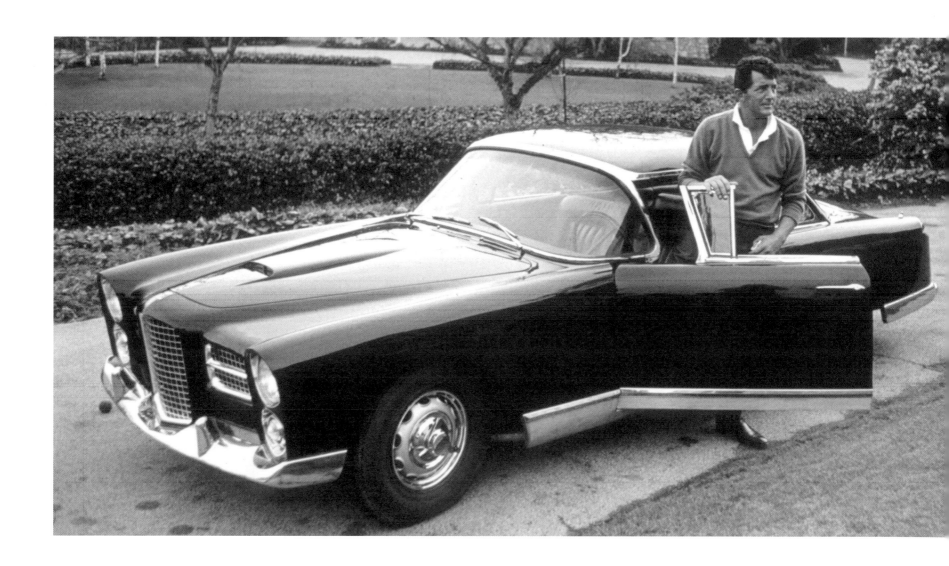

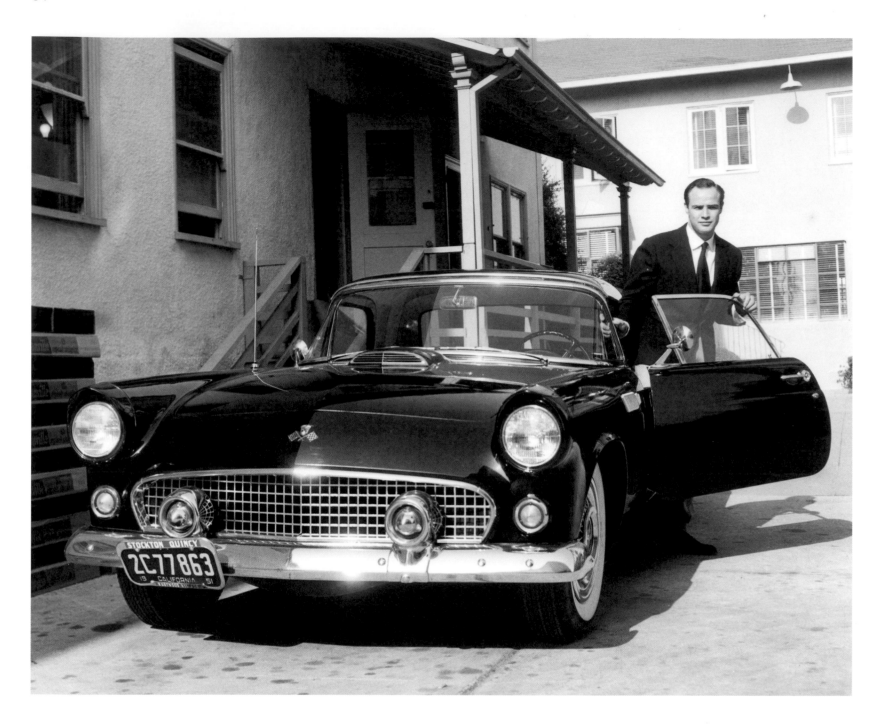

Above: Marlon Brando at a studio lot with his 1956 Ford Thunderbird.

Opposite: Brando steps into his 1950 Ford convertible outside his home in Hollywood, California.

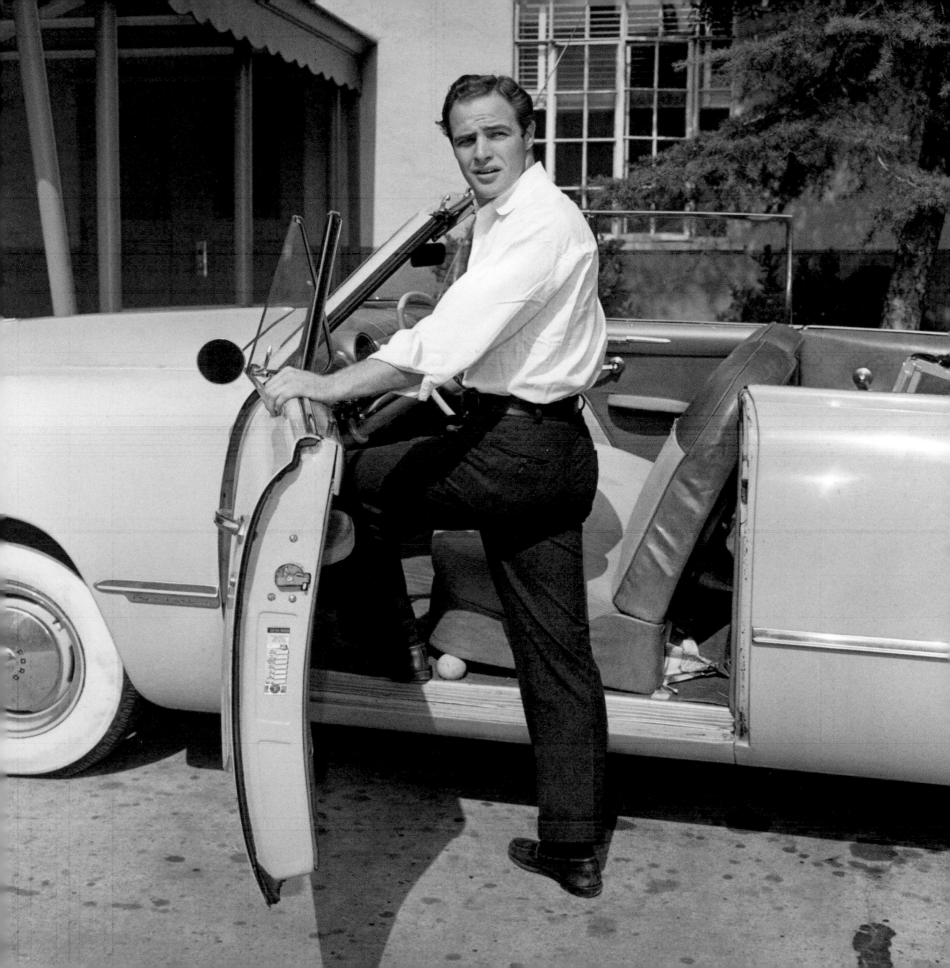

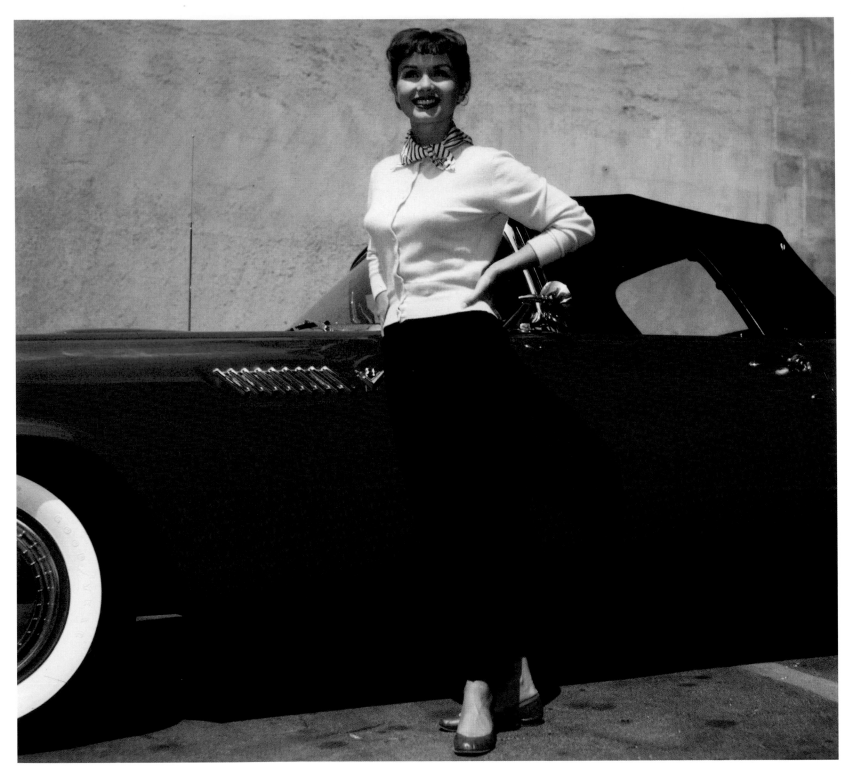

Above: Debbie Reynolds with her classy 1955 Ford Thunderbird.

Opposite: Reynolds outside Bob's Big Boy diner, again with her 1955 Ford Thunderbird. Although only a two-seater, the Thunderbird was never sold as a full-blown sports car, Ford instead choosing to describe it as a 'personal luxury car'.

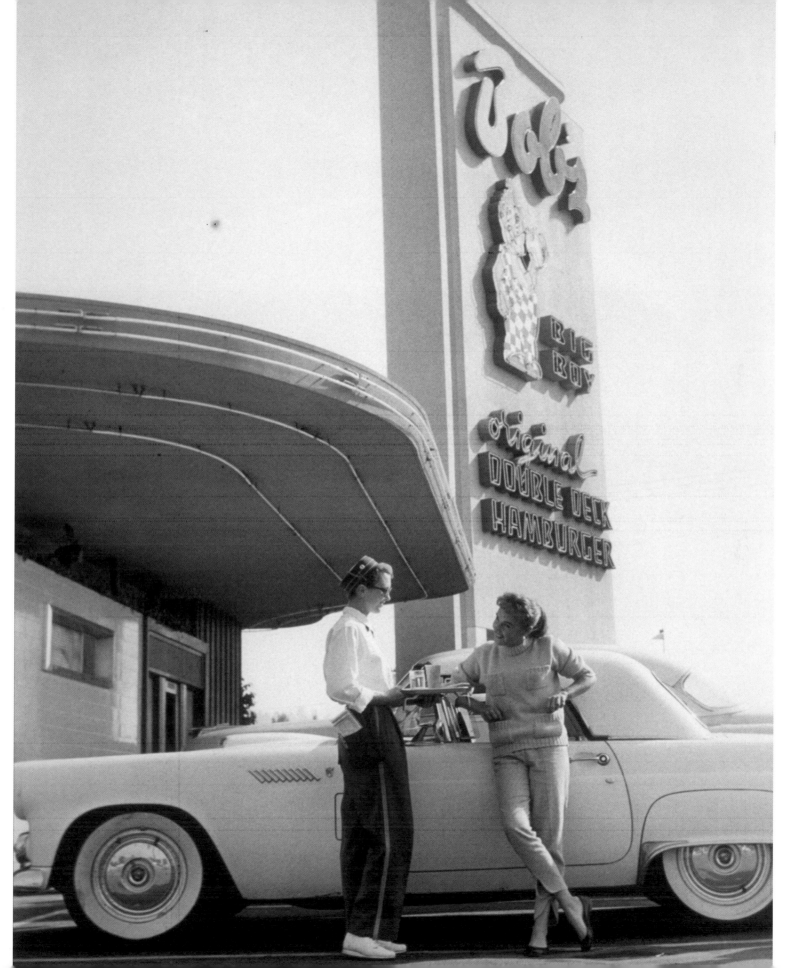

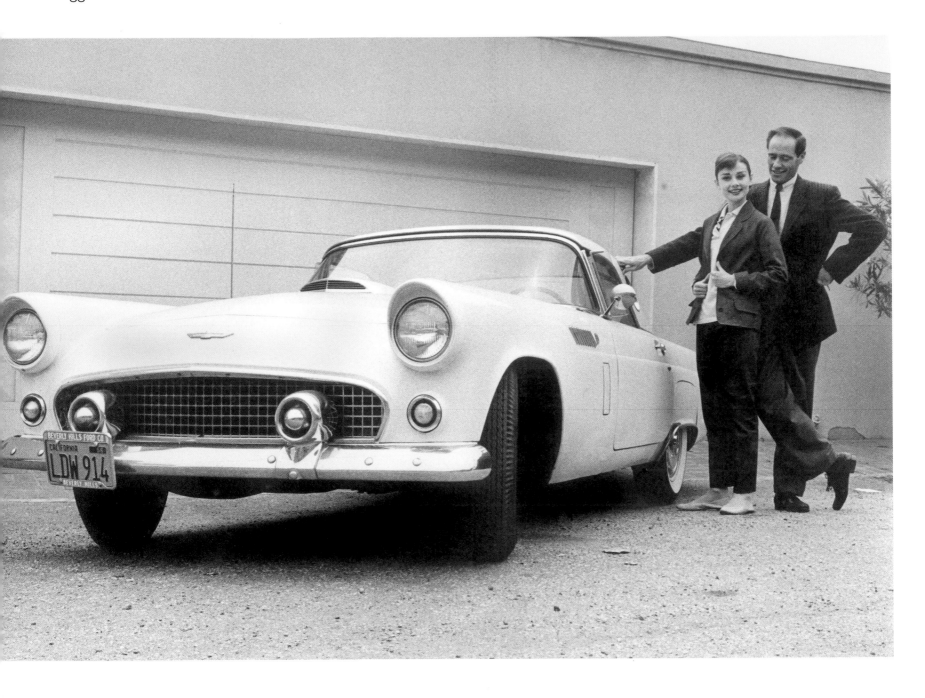

Above: Audrey Hepburn and her husband Mel Ferrer stand alongside their brand-new 1956 Ford Thunderbird at their home in Beverly Hills, California.

Opposite: Hepburn poses with a Ferrari 250 PF cabriolet in Rome in March 1961.

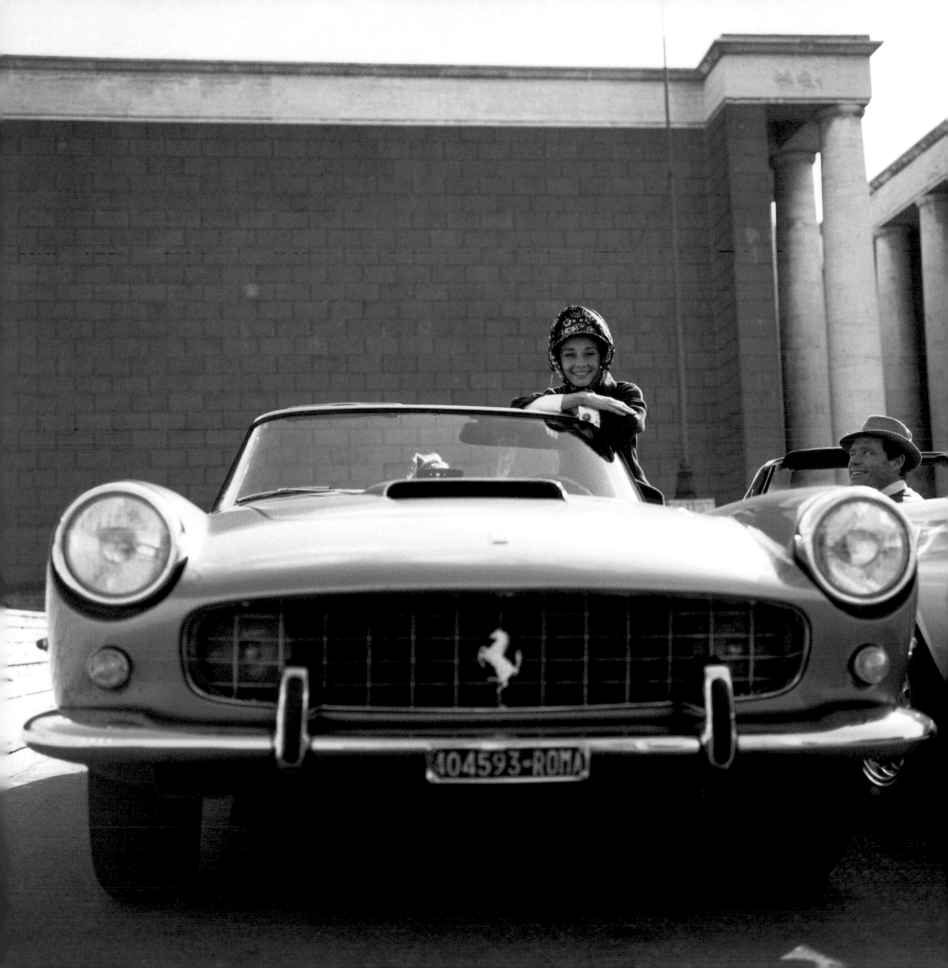

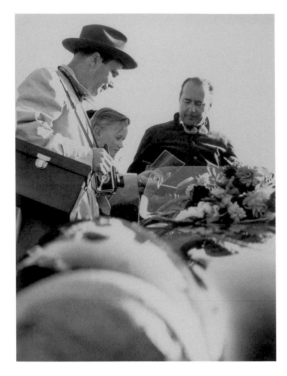
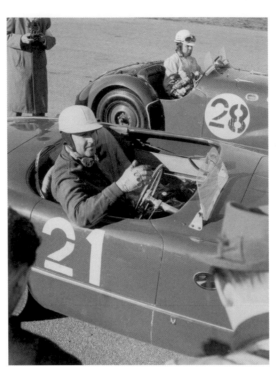
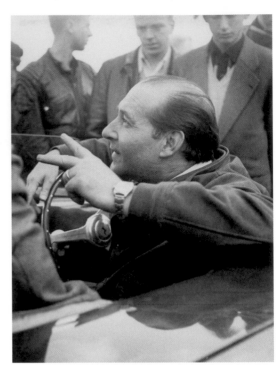

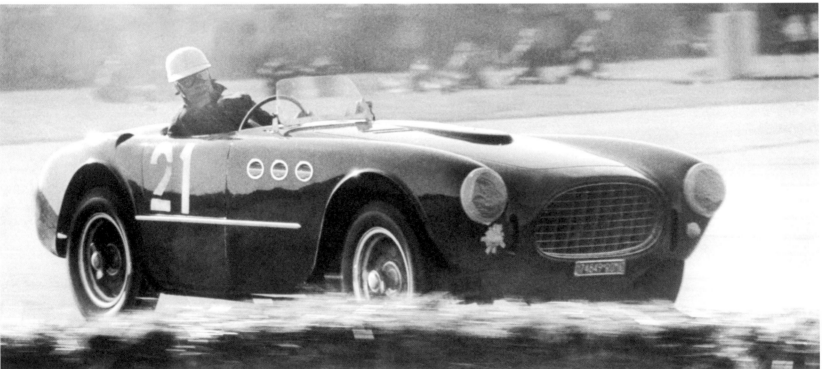

Above: Italian director Roberto Rossellini racing his Ferrari to fourth place in 1955, and signing autographs afterwards.

Opposite: Rossellini and his wife, Ingrid Bergman, on their way home from the set of their film *Voyage to Italy* in 1953.

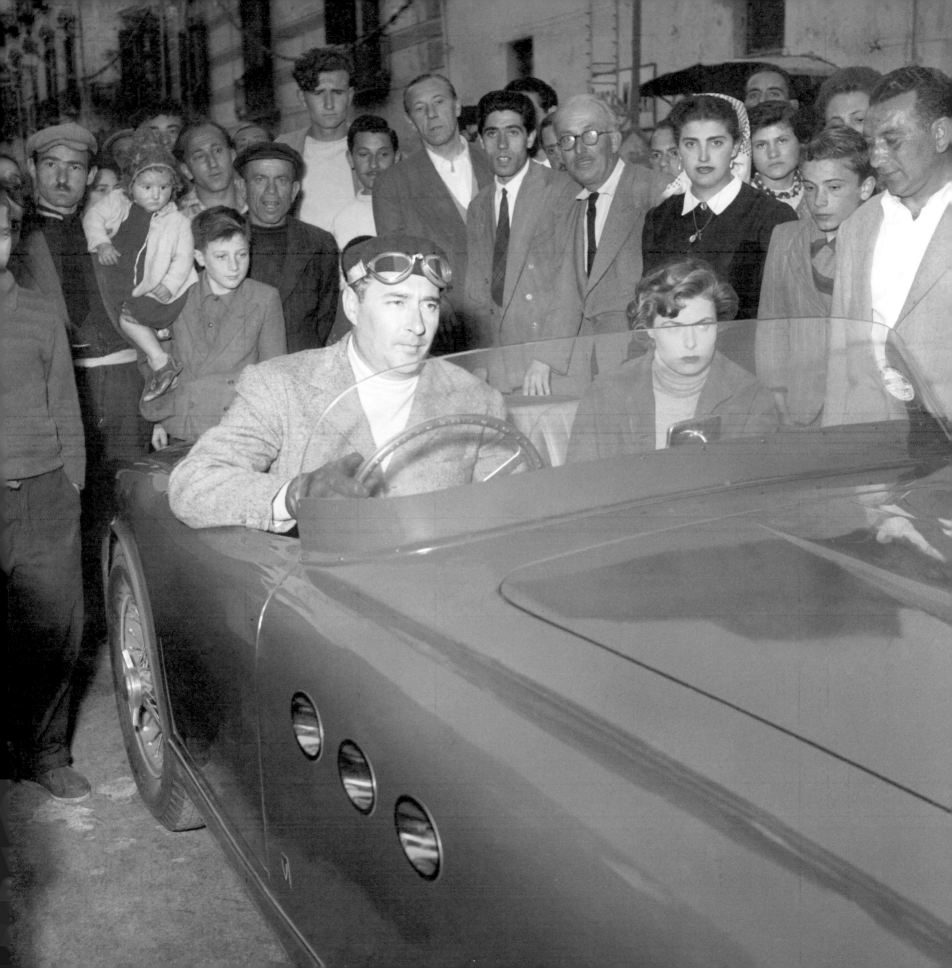

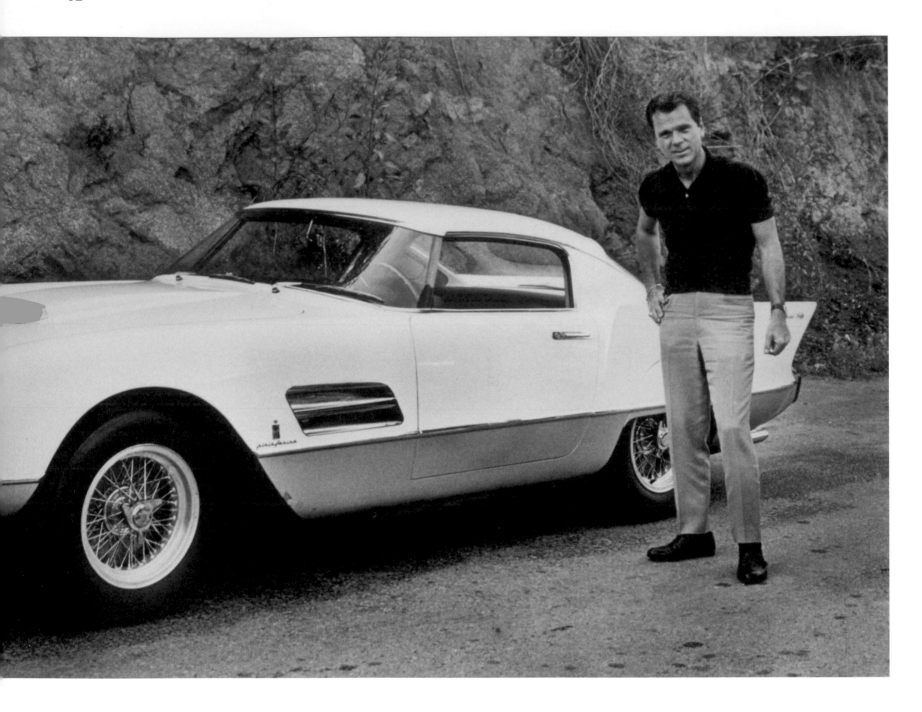

Above: Jackie Cooper with his 1956 Ferrari Superfast. Ferrari's elite clientele demanded sophistication, power and visual distinction.

The ultimate expression of such qualities was the Superfast, a series of only thirty-seven automobiles of the highest possible performance, luxury and presence.

Opposite: Cooper takes the Ferrari for a spin.

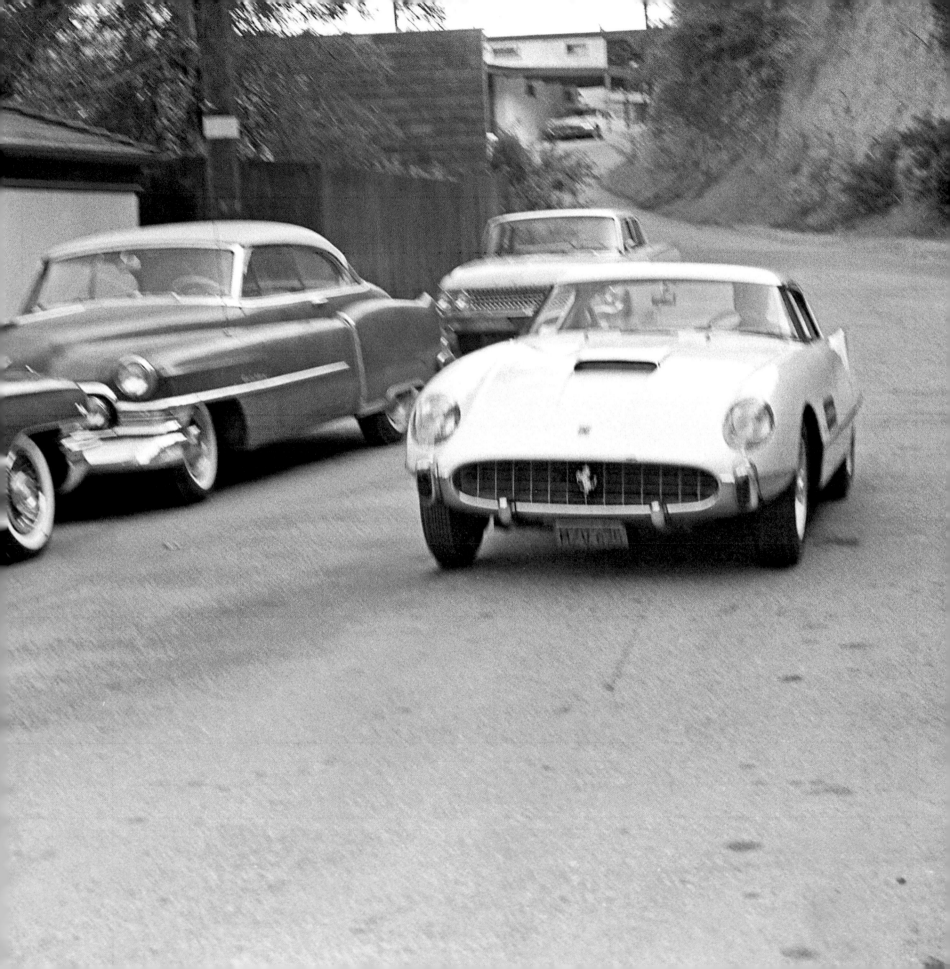

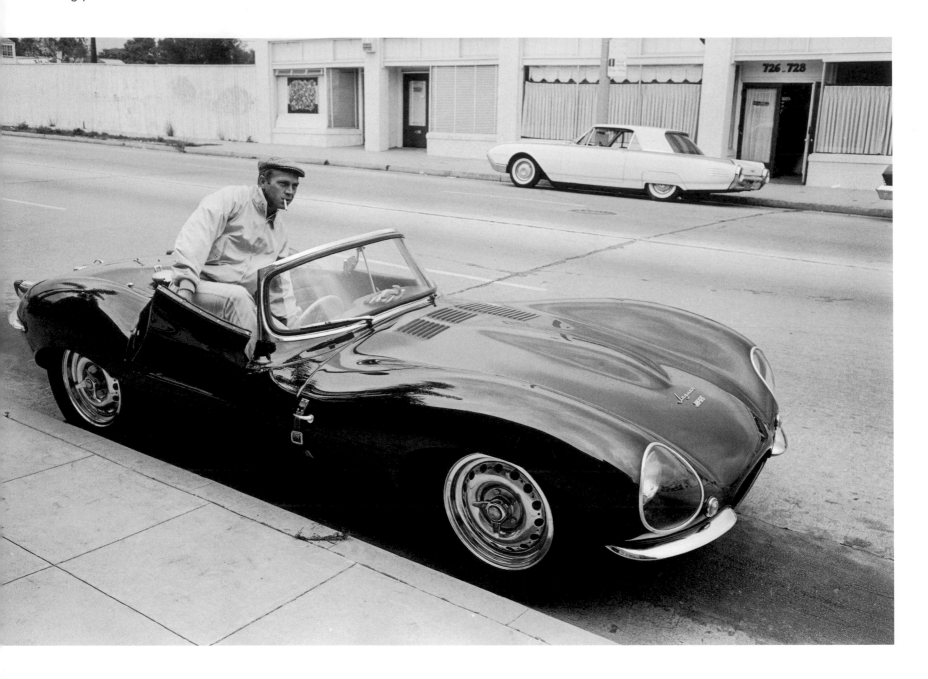

Above: Only sixteen of these beautiful Jaguar XKSS were ever made, the majority of which were sold to private American buyers. (Two went to Canada, one to Hong Kong and the final car to the UK.) Among the owners of this rare model was Steve McQueen, a motor-racing fan who appeared in *Le Mans* (1971) – a documentary film of the famous 24-hour race – but who was best known as the star of cult movies such as *The Great Escape* (1963), *Bullitt* (1968) and *The Thomas Crown Affair* (1968). Here McQueen climbs into his Jaguar in Los Angeles, California in 1963.

Opposite: McQueen stands next to his Lola at the Riverside Raceway in California, 1966.

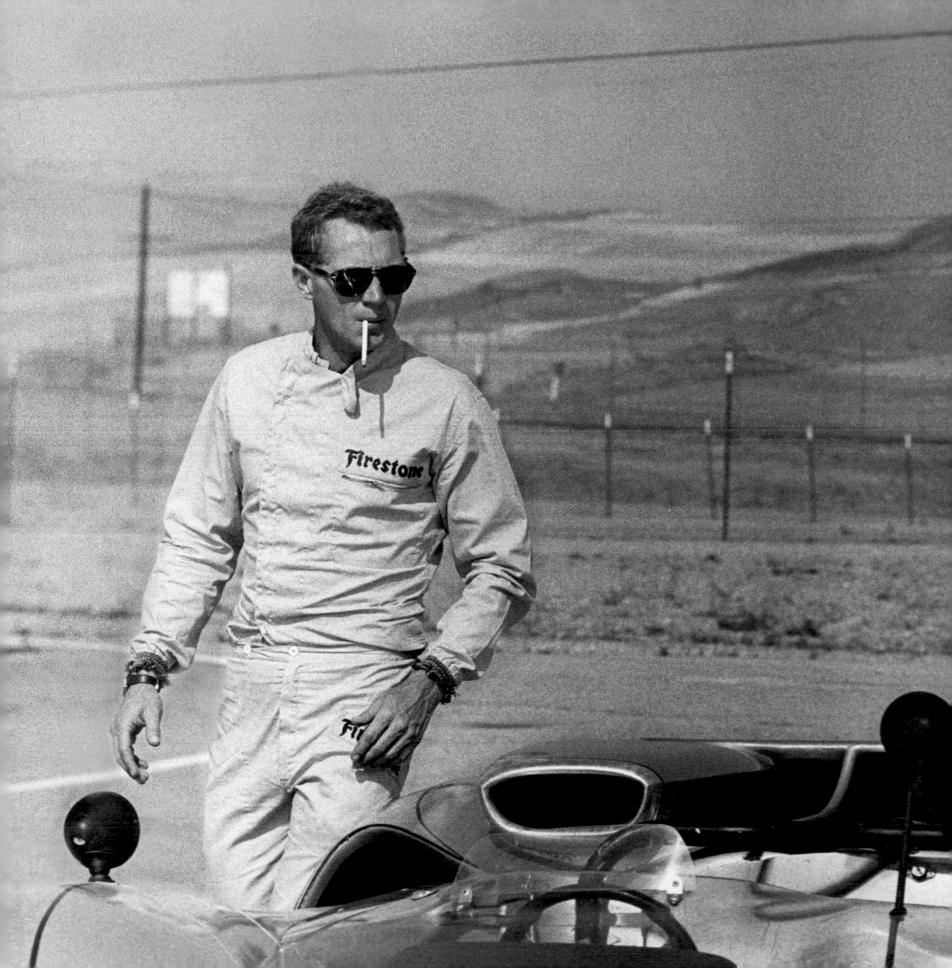

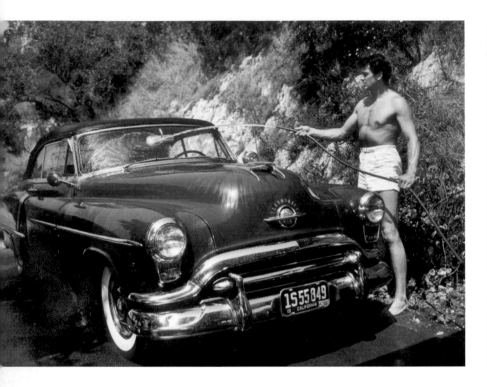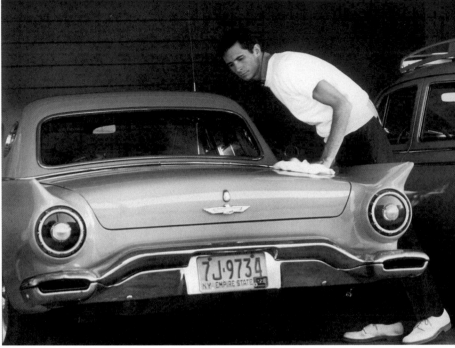

Above left: Rock Hudson hoses down his 1952 Oldsmobile convertible outside his home in the Hollywood Hills.

Above right: Anthony Perkins – star of Alfred Hitchcock's *Psycho* (1960) – checks the sheen on his 1957 Ford Thunderbird.

Opposite: Neile Adams watches with amusement as her husband Steve McQueen washes the hood of his Porsche, outside their home in the hills of Brentwood, California.

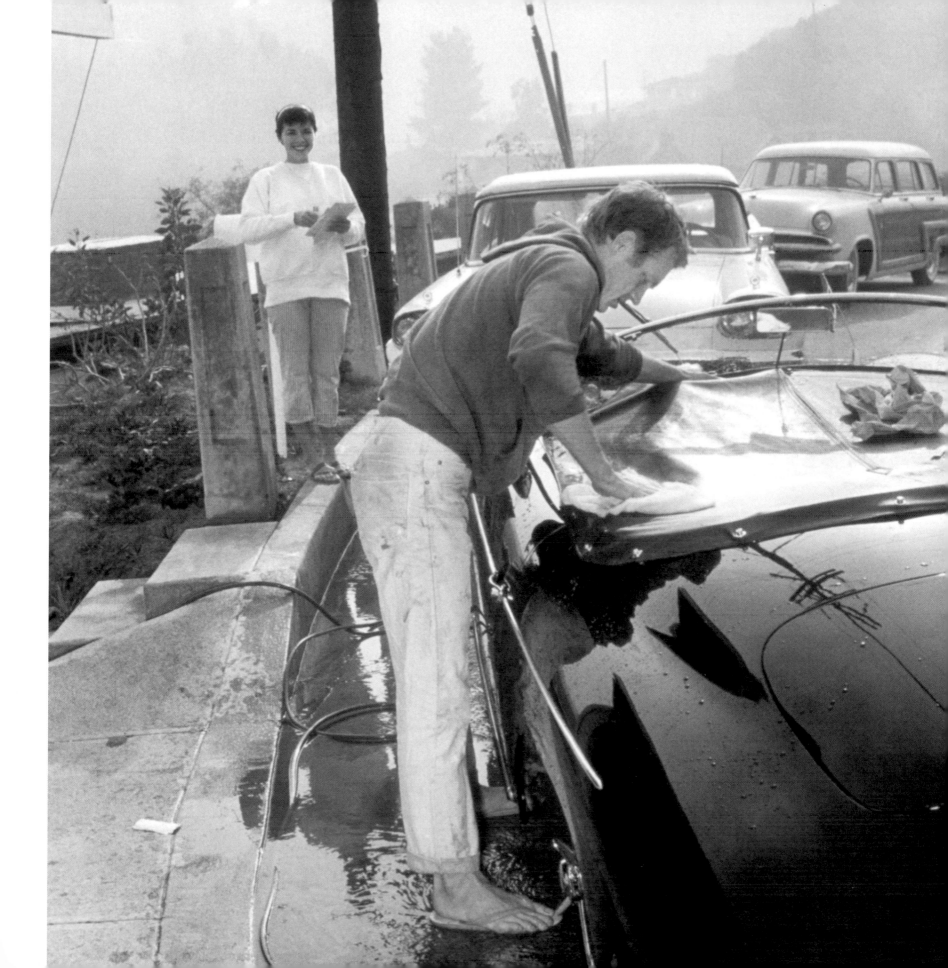

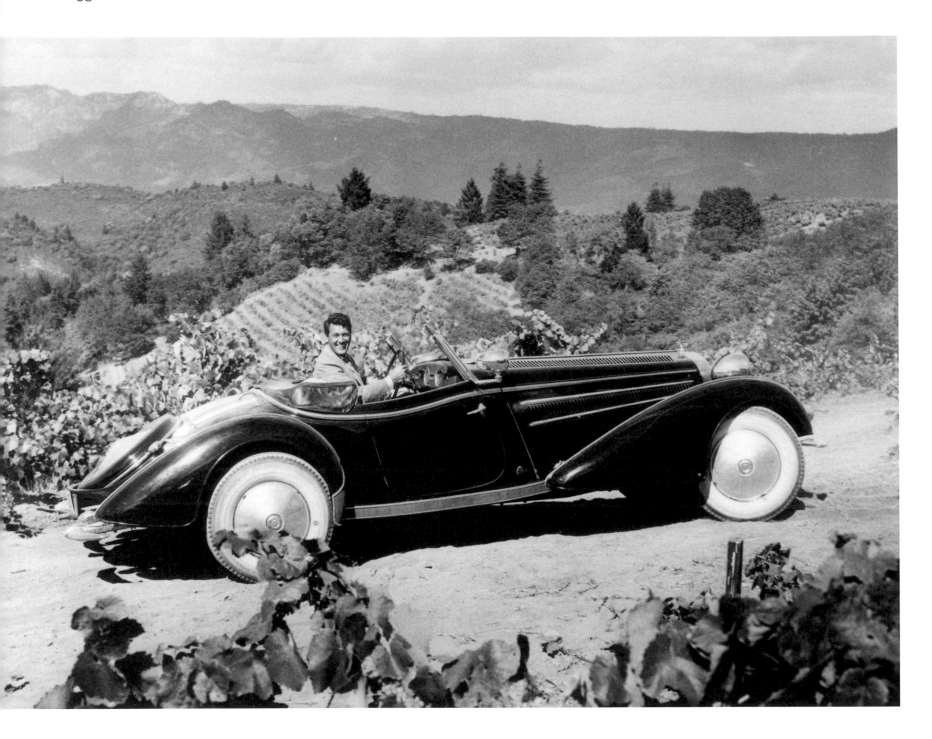

Above: Rock Hudson takes his sleek Mercedes-Benz sports car for a drive in the Napa Valley, California, where he was filming in 1958.
This particular automobile was supposedly custom-made for Adolf Hitler as a gift to his then-girlfriend, Eva Braun.
Opposite: Singer Bobby Darin stands beside a hand-made automobile called the 'Bobby Darin Dream Car', which was unveiled in Hollywood, California on 31 March 1961.
The body of the car, decorative grilles and side strips are all made of aluminium, while crushed diamond dust is said to have been used in the paint job.

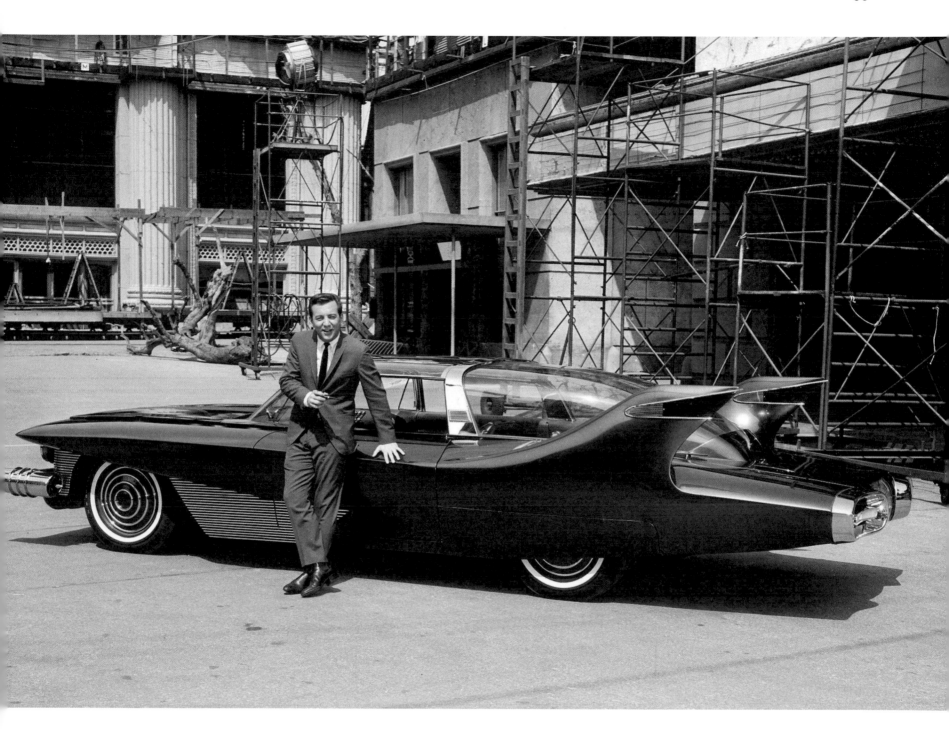

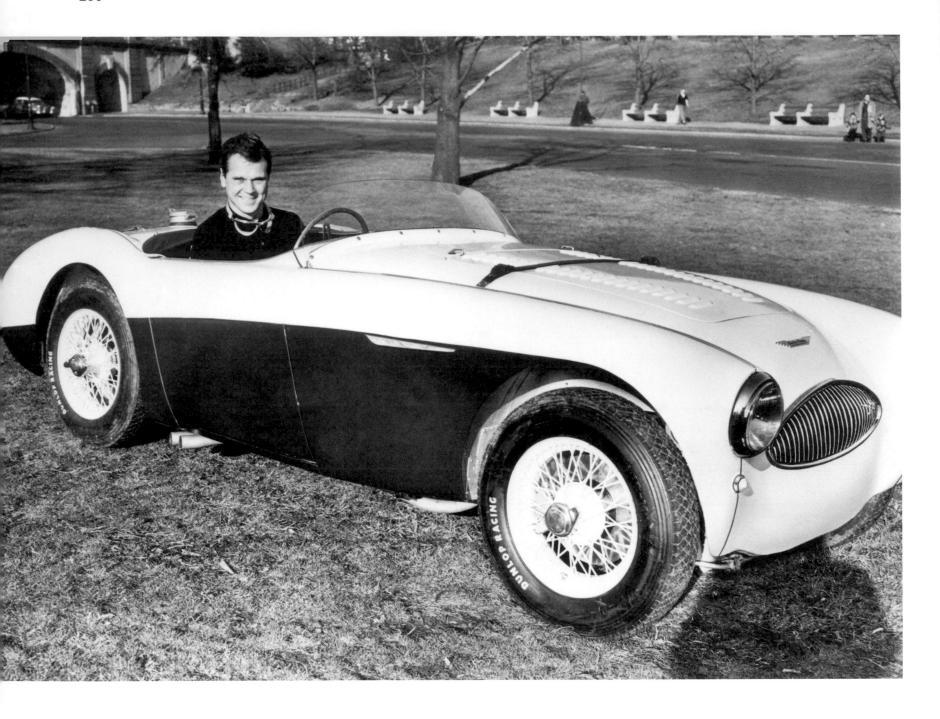

Above: Actor and car enthusiast Jackie Cooper in his Austin-Healey 100S, which he raced extensively on the east coast of America.

The Jackie Cooper 100S was painted Spruce Green especially for him by Donald Healey himself.

Opposite: Joanne Woodward – Paul Newman's wife and an Academy Award-winning Actress in her own right – leaning against her Austin-Healey in Hollywood, 1957.

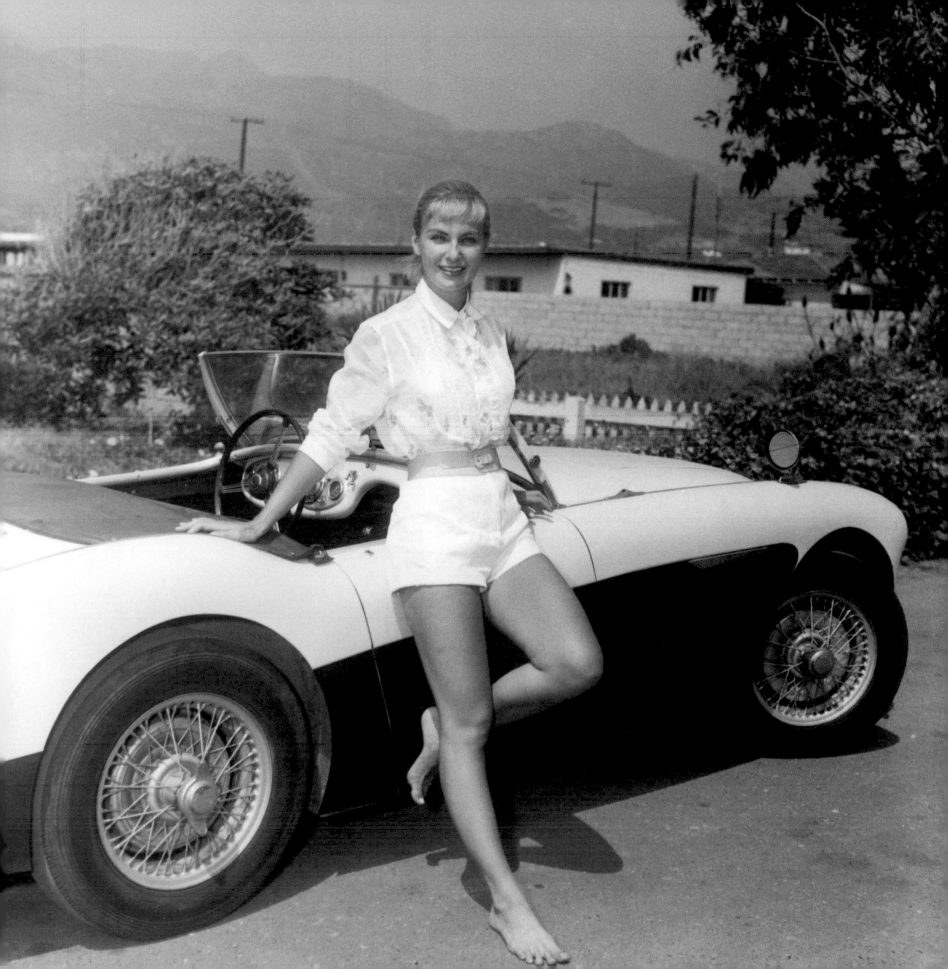

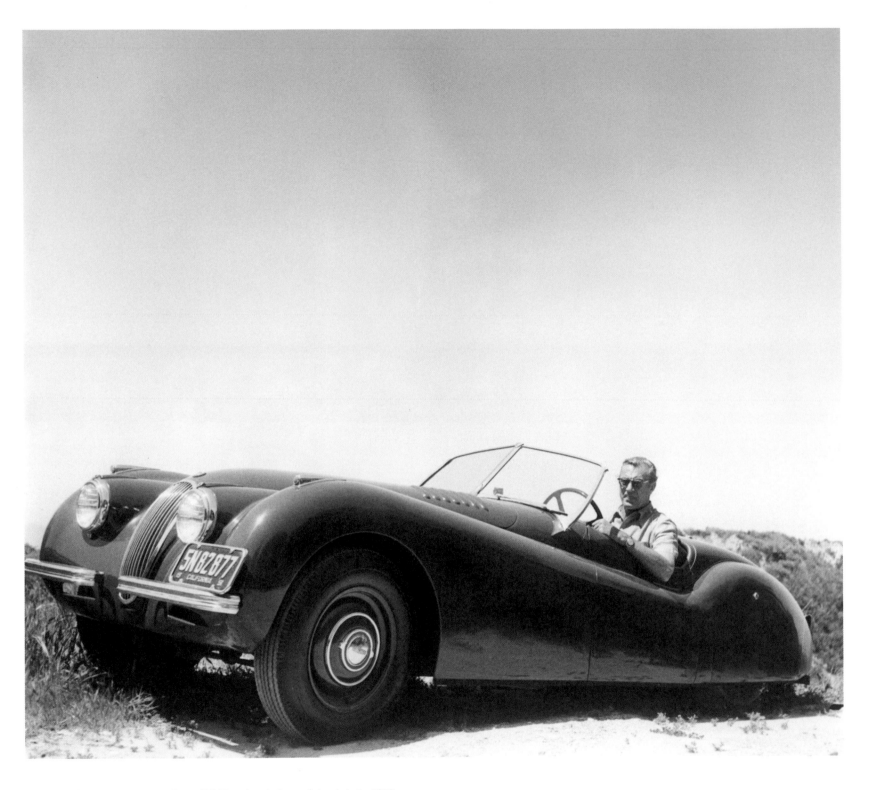

Above: Gary Cooper with his classic Jaguar XK120 roadster in Aspen, Colorado in the 1950s.

Opposite: Robert Stack smiles from the driver's seat of his red Jaguar XK120 coupé. Stack played Eliot Ness in *The Untouchables* on TV from 1959–1962.

He was also an avid car enthusiast who owned a 1965 Aston Martin DB5 and a Mercedes-Benz 190SL.

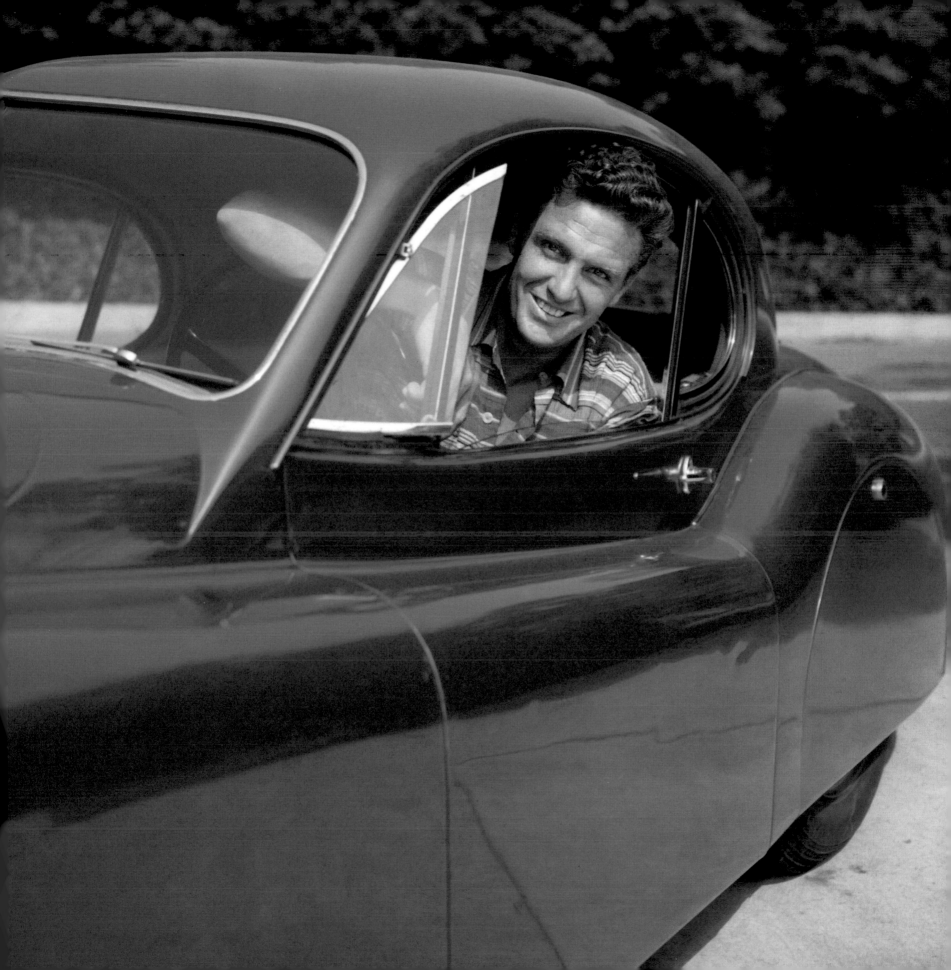

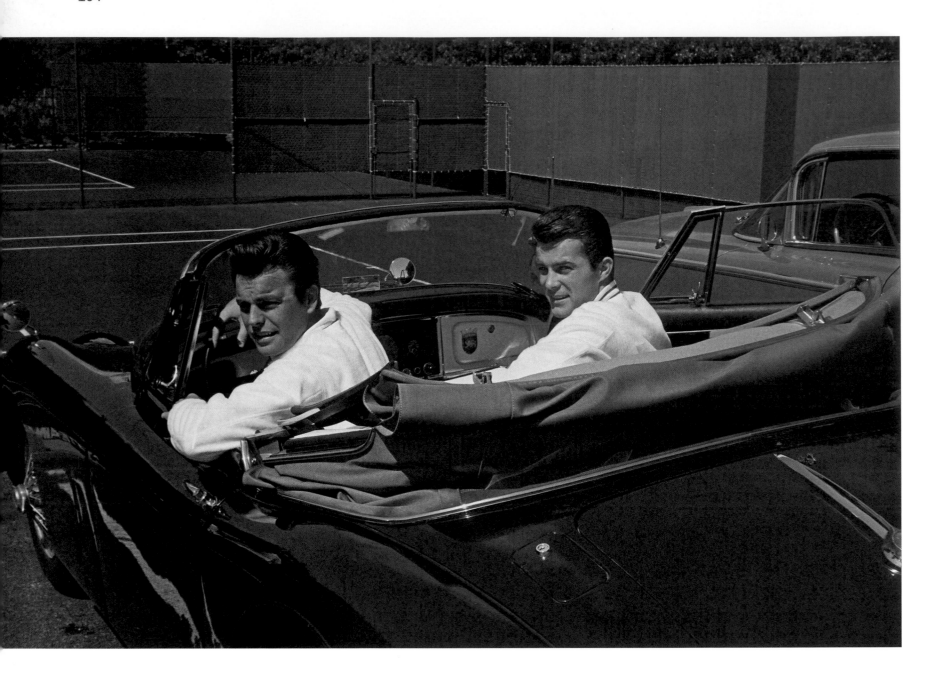

Above: Robert Wagner gives fellow actor Robert Conrad a ride in his 1959 Jaguar XK150 after a game of tennis in Hollywood, California.
Opposite: Roger Moore, script in hand, poses with this 1956 Jaguar XK150.

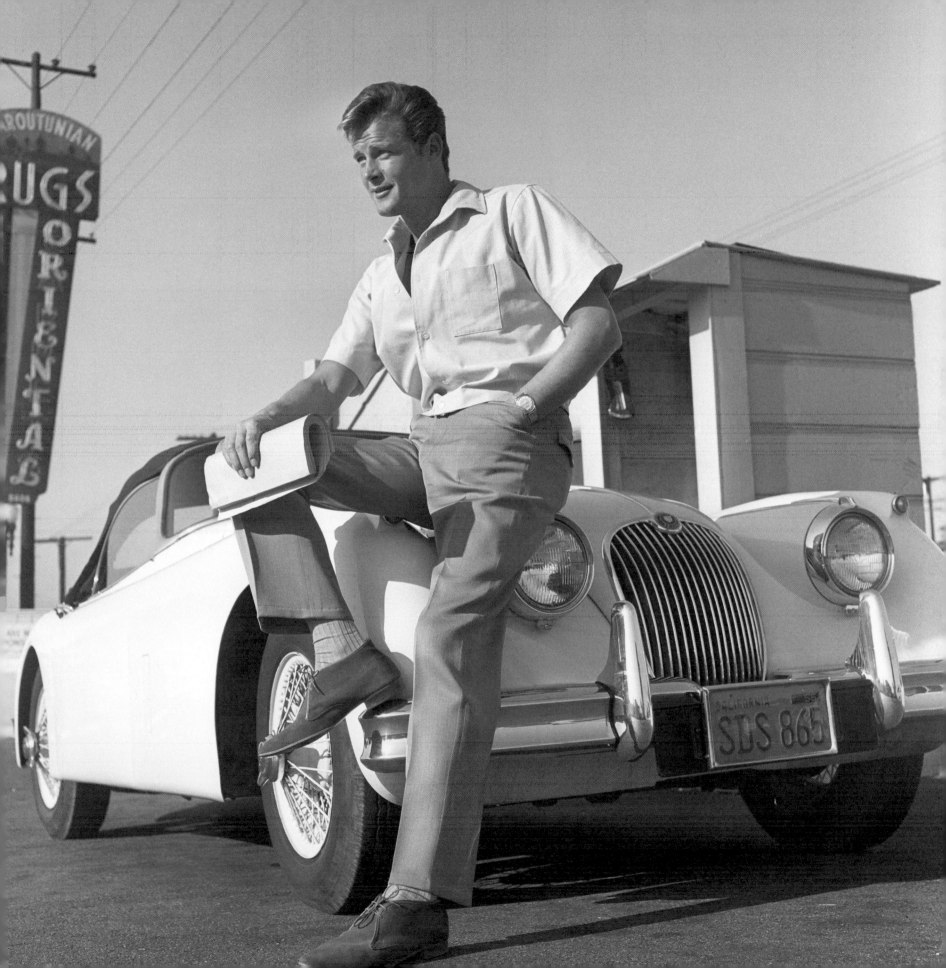

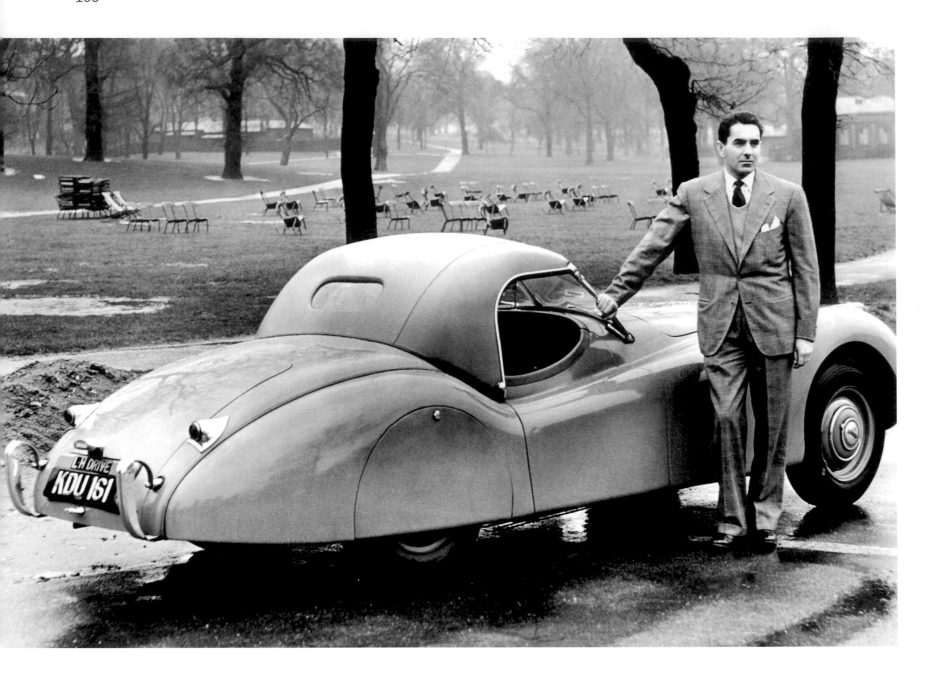

Above: Tyrone Power, swashbuckling star of *The Mark of Zorro* (1940) and *The Black Swan* (1942), with his left-hand-drive Jaguar XK120 – which features a rare, detachable hardtop.

Opposite: Power with his wife Linda Christian in their rare Alfa Romeo 6c 2500, with bodywork by the famous Italian coachbuilder Farina. Prince Aly Khan gave his wife, screen star Rita Hayworth, a very similar car as her wedding gift.

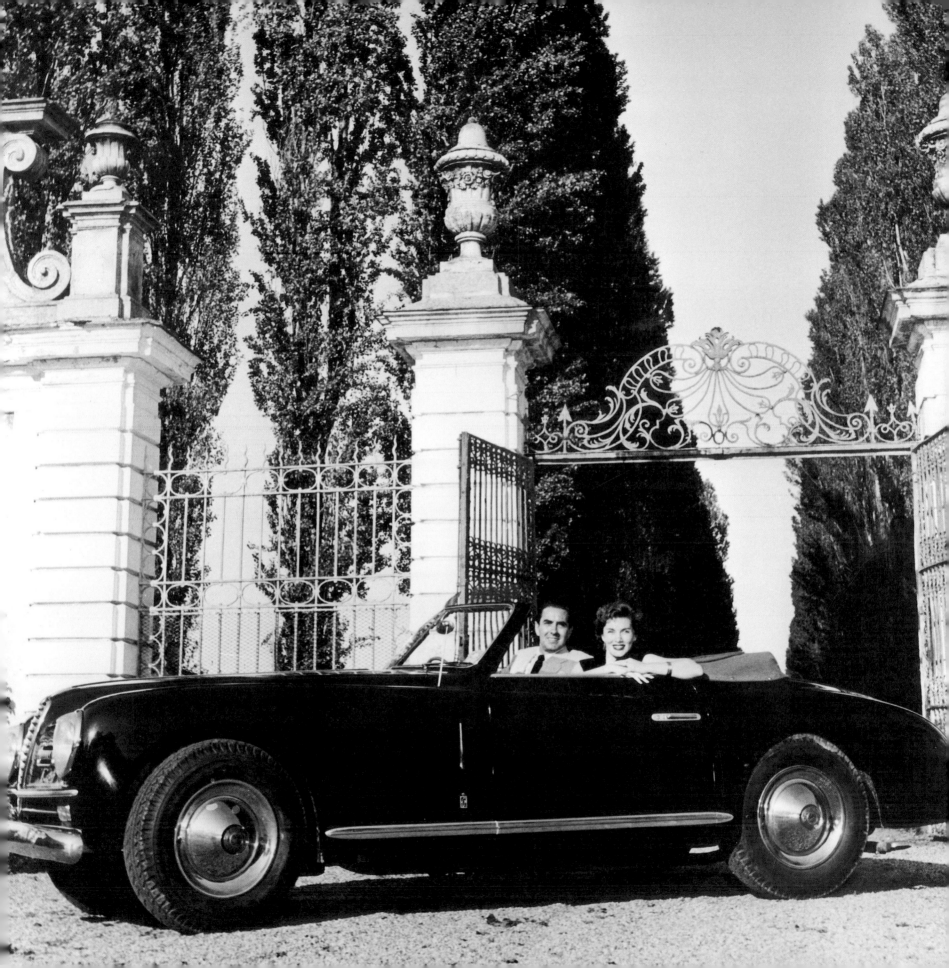

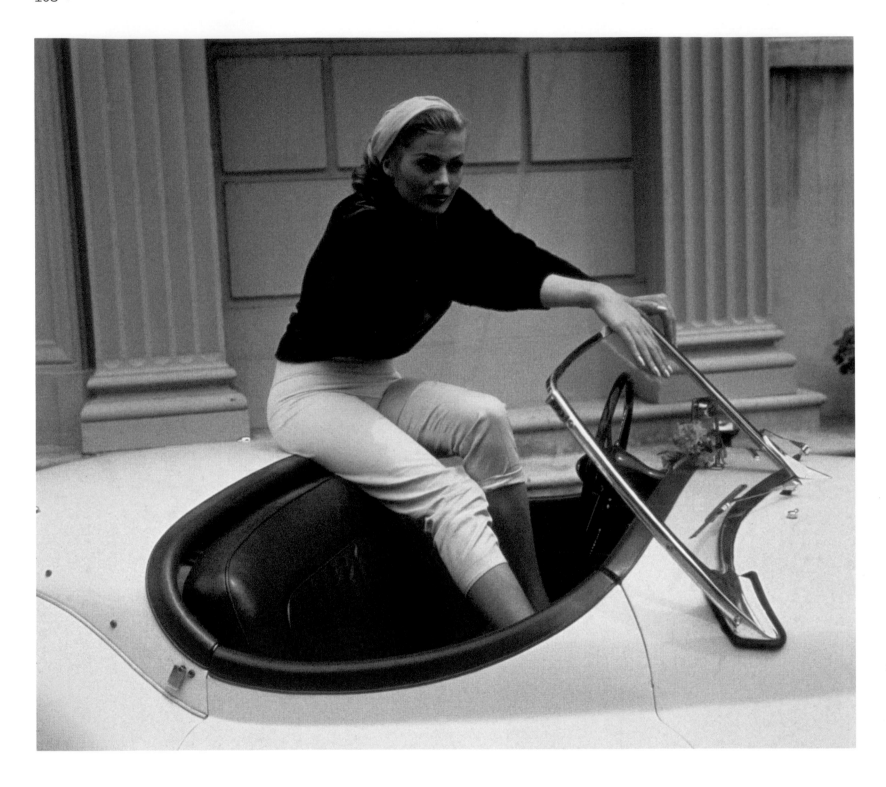

Above: Swedish bombshell Anita Ekberg sits on the trunk of her cream Jaguar XK140 in Hollywood, California in 1955.

Opposite: Ekberg's American counterpart Jayne Mansfield poses on the trunk of her flashy Lincoln Premier convertible in 1956.

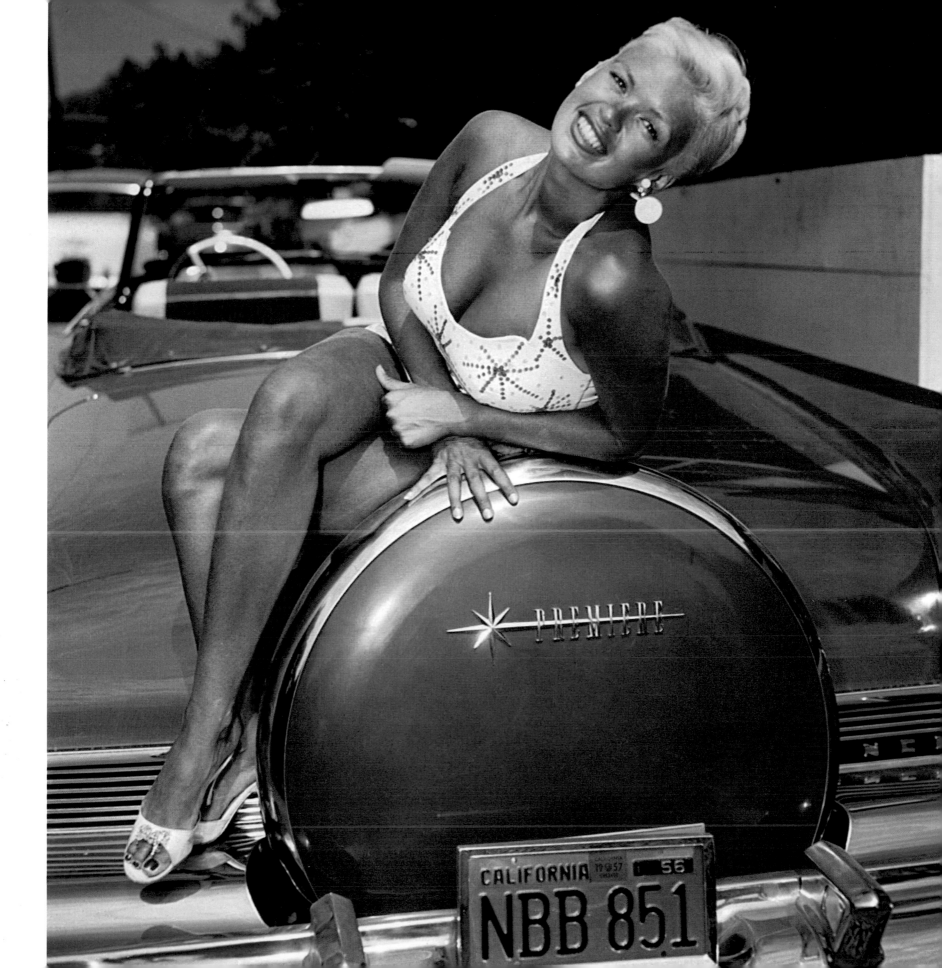

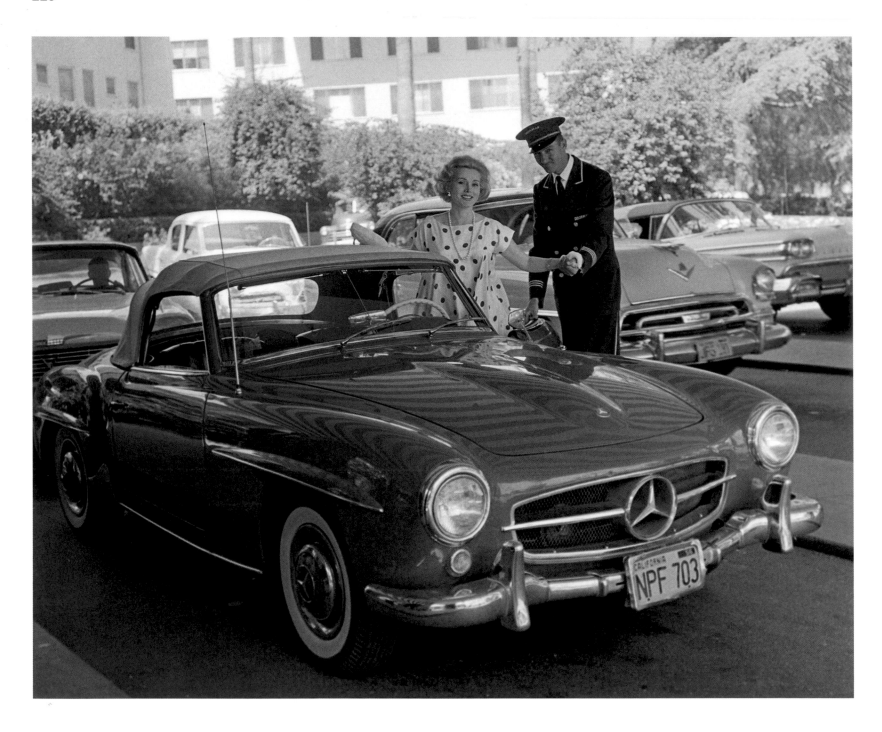

Above: Zsa Zsa Gabor with her brand-new 1958 Mercedes-Benz 190SL at the Beverly Hills Hotel, California.

Opposite: Zsa Zsa poses in front of a 1959 Toyopet Crown Custom sedan.

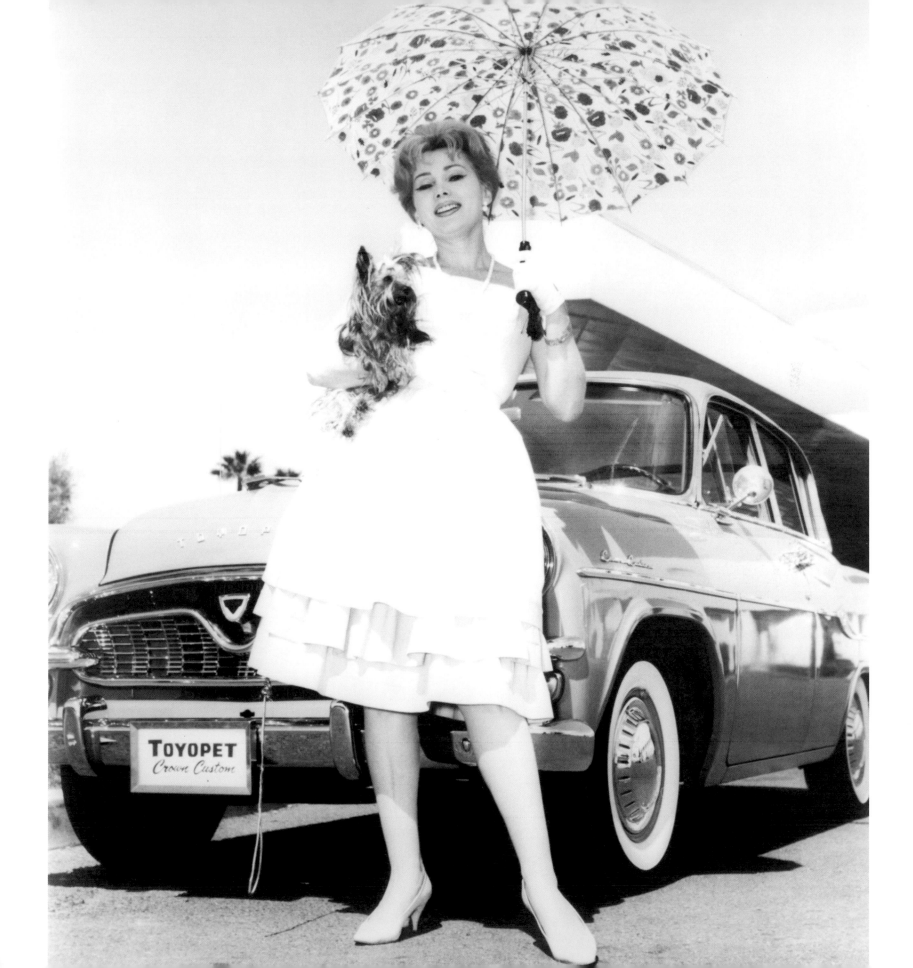

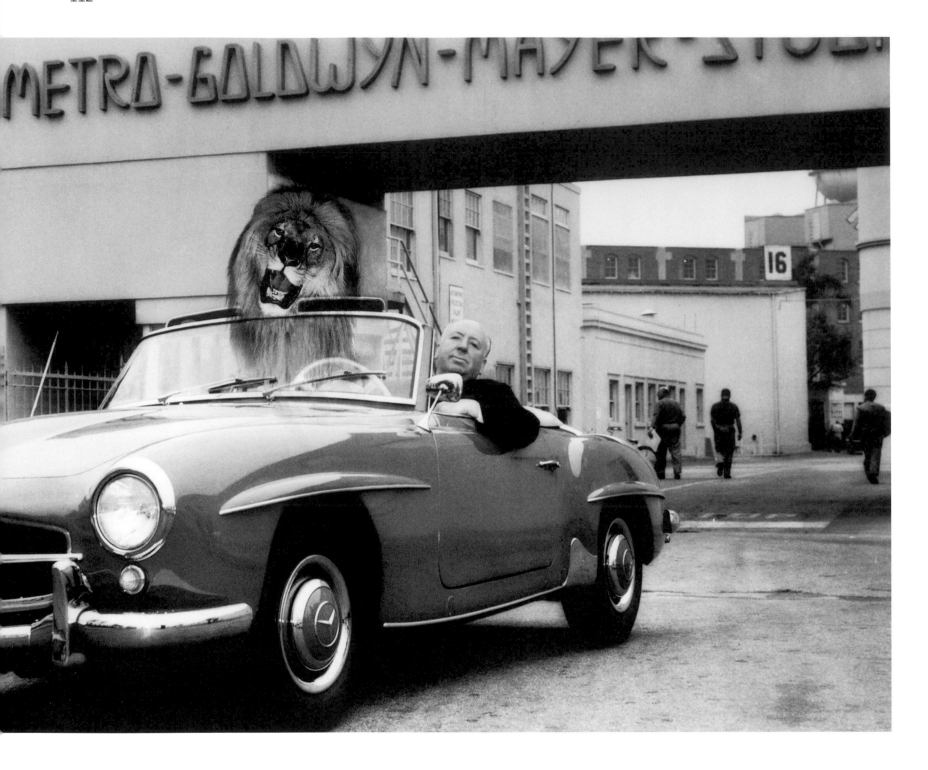

Above: Alfred Hitchcock drives his Mercedes-Benz 190SL roadster, with an illusion of the MGM lion in the passenger seat. 'Hitch' was on the studio lot to direct his only MGM film, the classic 1959 thriller *North by Northwest*.

Opposite: Glenn Ford poses proudly with the latest addition to his collection of cars, a brand-new 1962 Mercedes-Benz 300SL roadster.

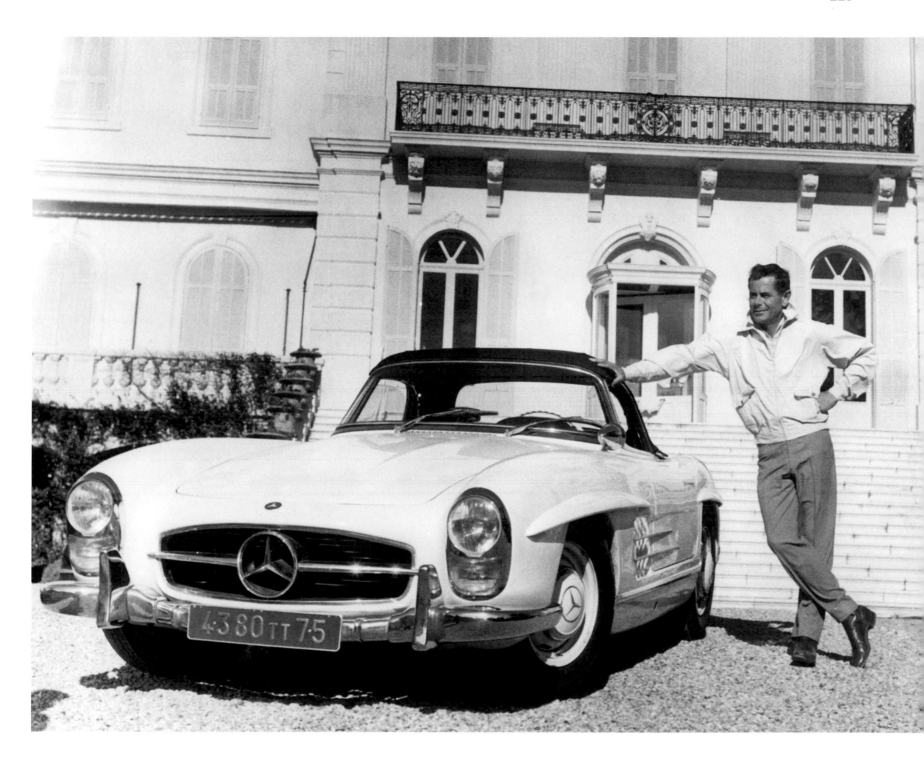

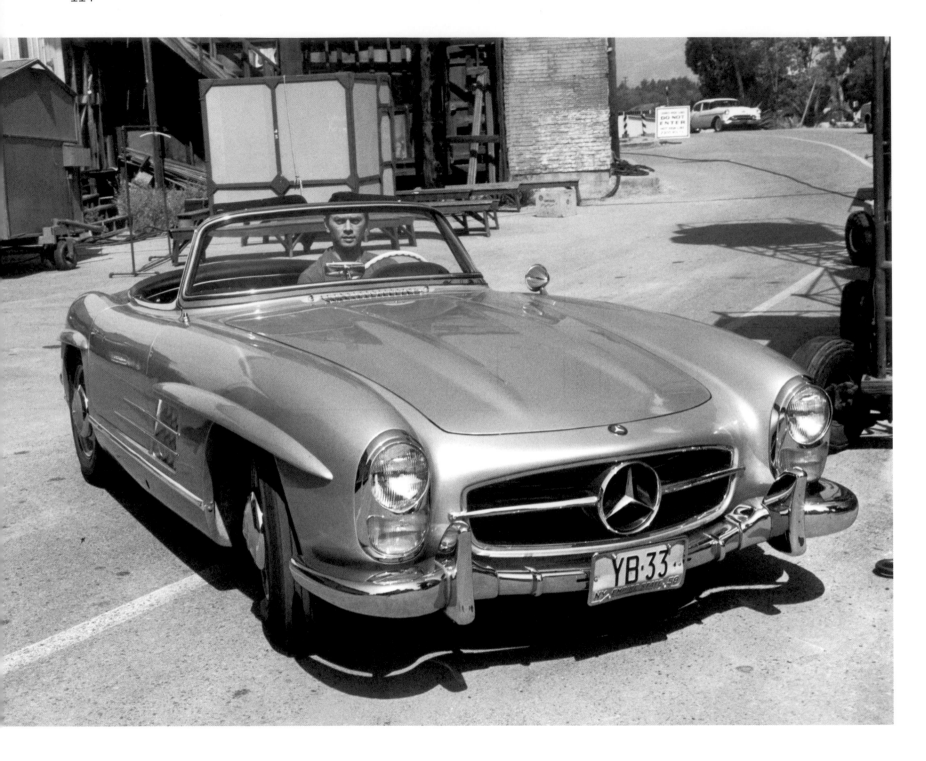

Above: Yul Brynner drives a 1958 Mercedes-Benz 300SL in the 20th Century Fox back lot.

Opposite: Standing in his 1959 Mercedes-Benz 190SL roadster, Brynner obliges a photographer whilst on location filming *Solomon and Sheba* in 1959.

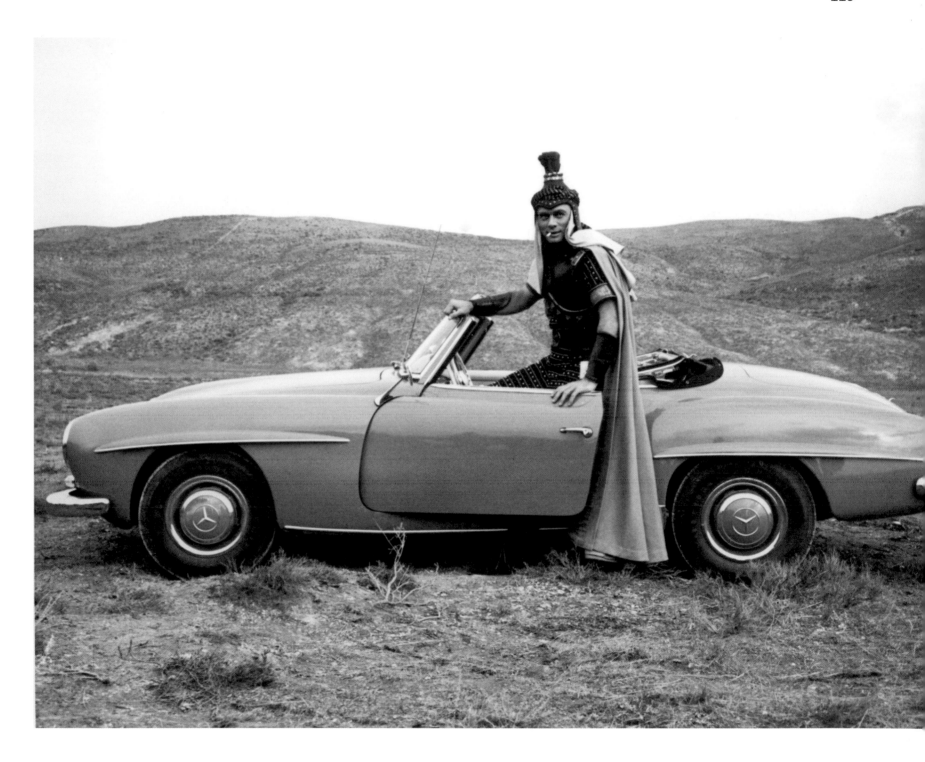

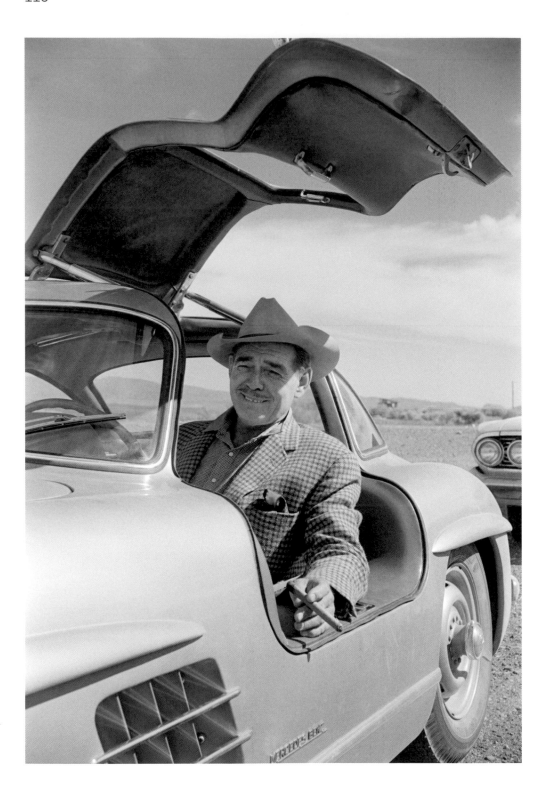

Above: Clark Gable relaxes with a cigar in his Mercedes-Benz 300SL during a break from filming *The Misfits* (1960).

Opposite: Sophia Loren poses with a Mercedes-Benz 300SL gullwing on the outskirts of Rome in 1956.

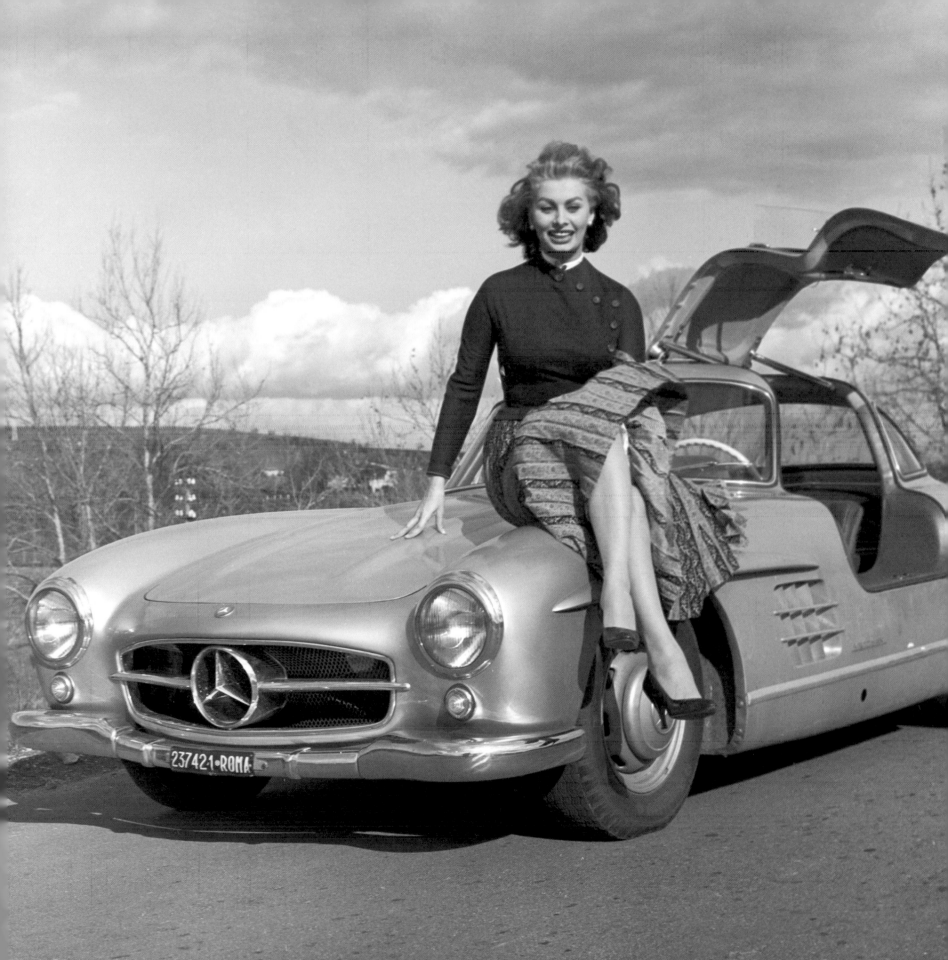

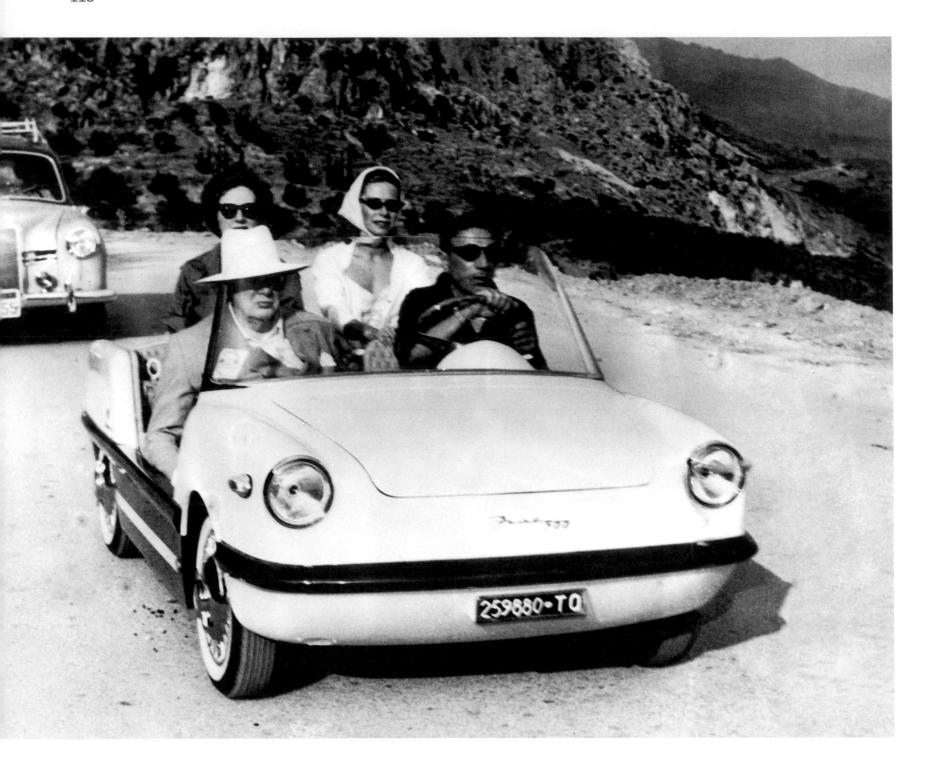

Above: Driving his 1950s microcar, Aristotle Onassis takes guest Sir Winston Churchill to see the famous Delphi antiquities in July, 1959.

Opposite: Pablo Picasso and friends, in his Mercedes-Benz 300SL.

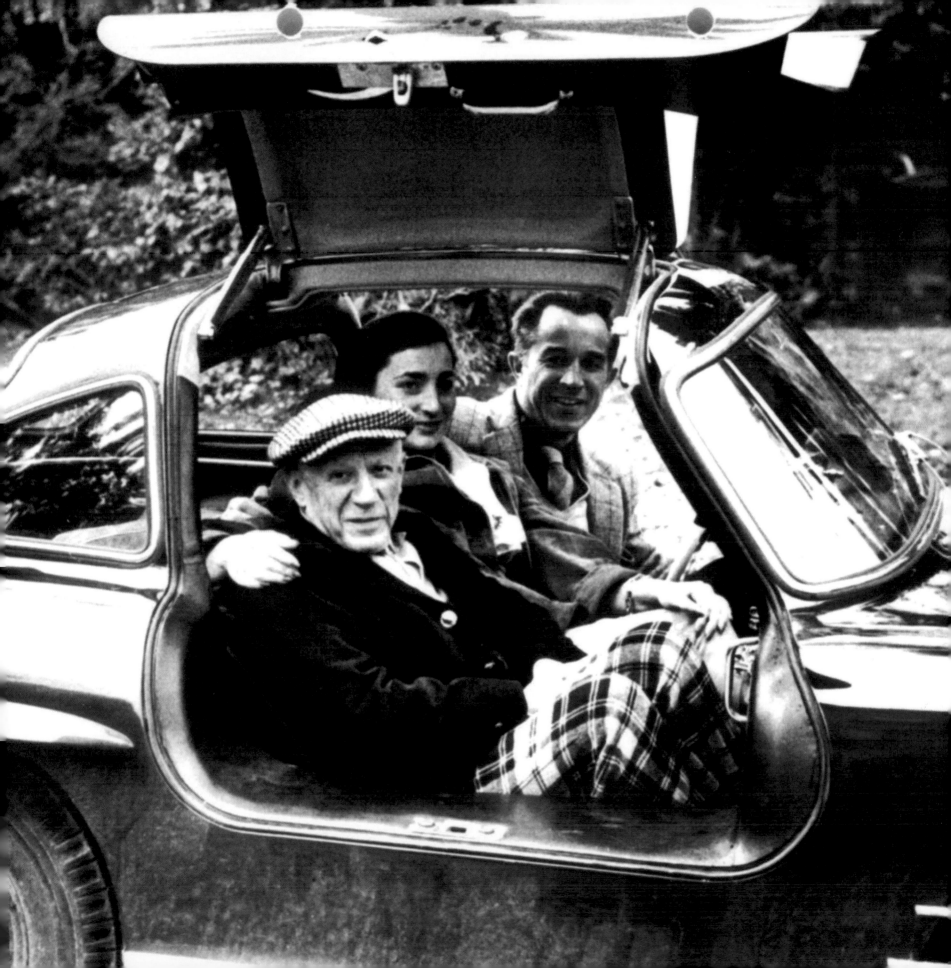

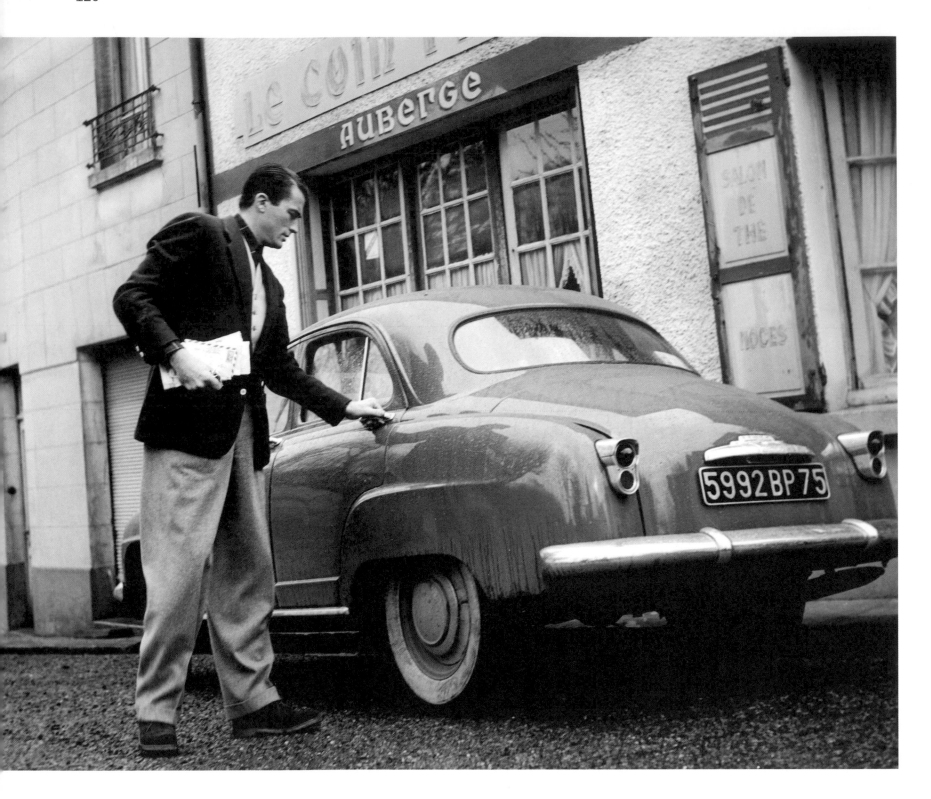

Above: Gregory Peck with his Simca Aronde in a quiet French street, 1950.

Opposite: Farley Granger, star of the Hitchcock classic *Rope* (1948), lights up in front of his convertible outside the Plaza Hotel, New York, 1955.

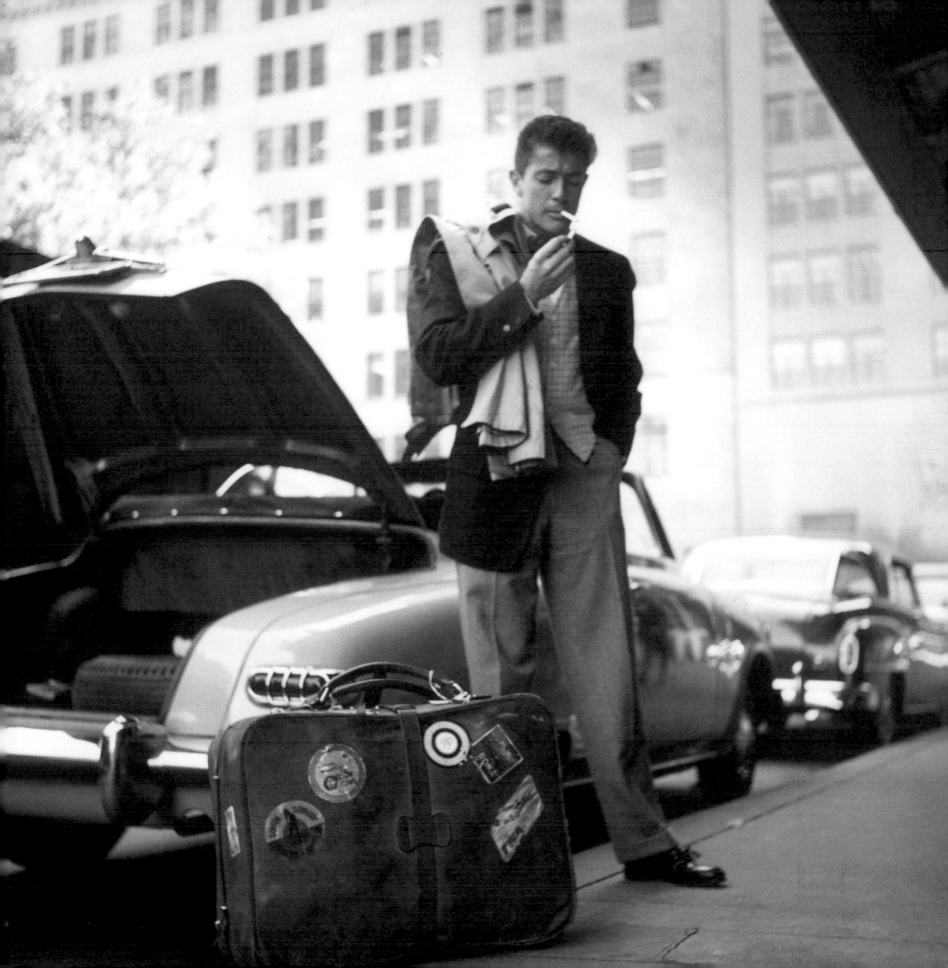

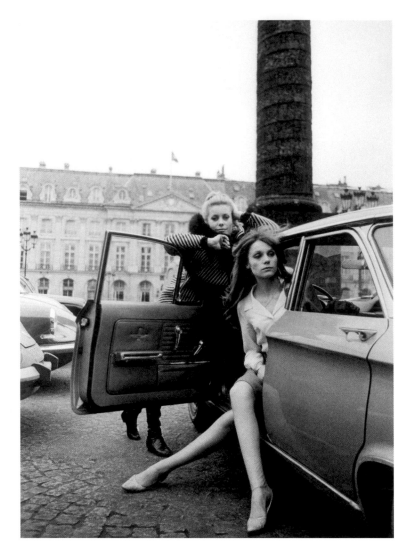

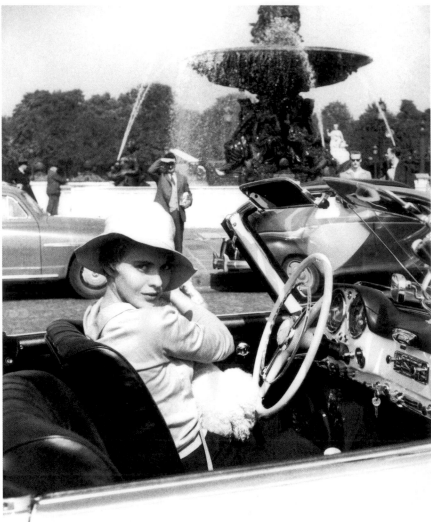

Above left: French sisters leggy Françoise Dorleac and Catherine Deneuve pose in Paris, 1956.

Above right: American actress Jean Seberg, who went on to become a big star in France, sits with a pet poodle in her Mercedes-Benz convertible in the Place de la Concorde, Paris, 1957.

Opposite: Dwarfed by a huge English-registered 1958 Buick, Serge Gainsbourg prepares to pull out in his tiny Auto Red Bug in Le Touquet-Paris-Plage, France.

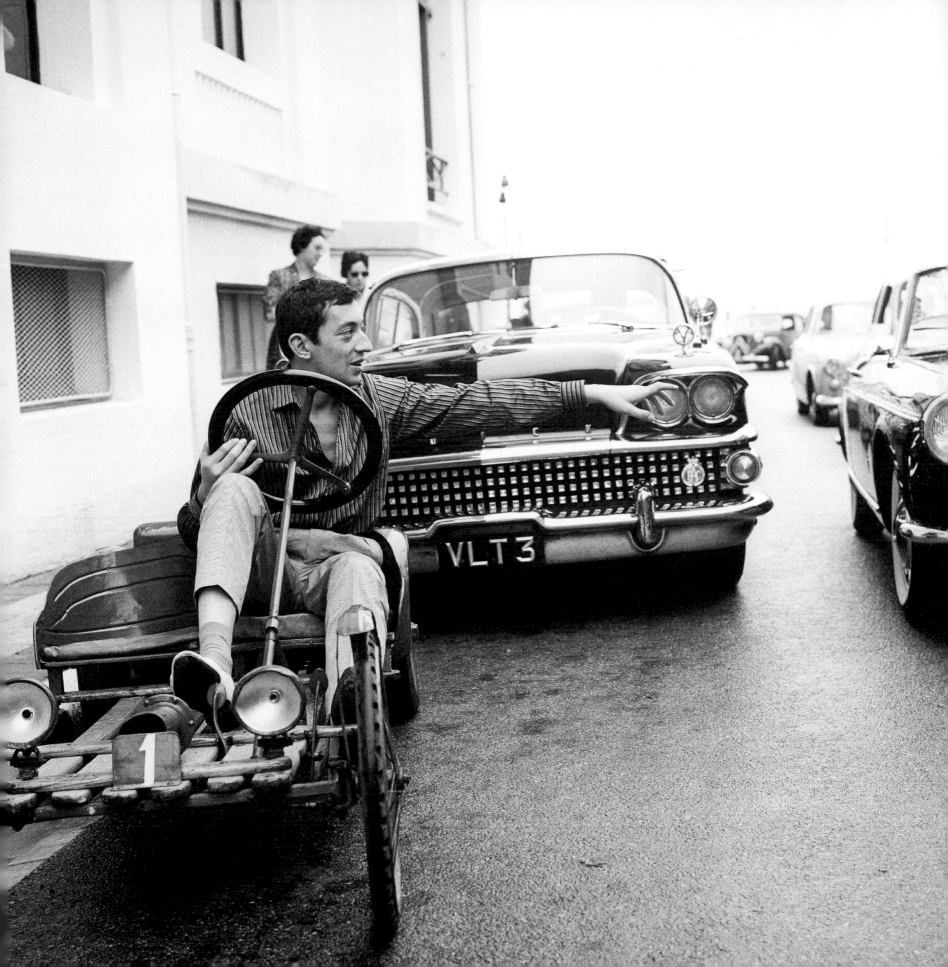

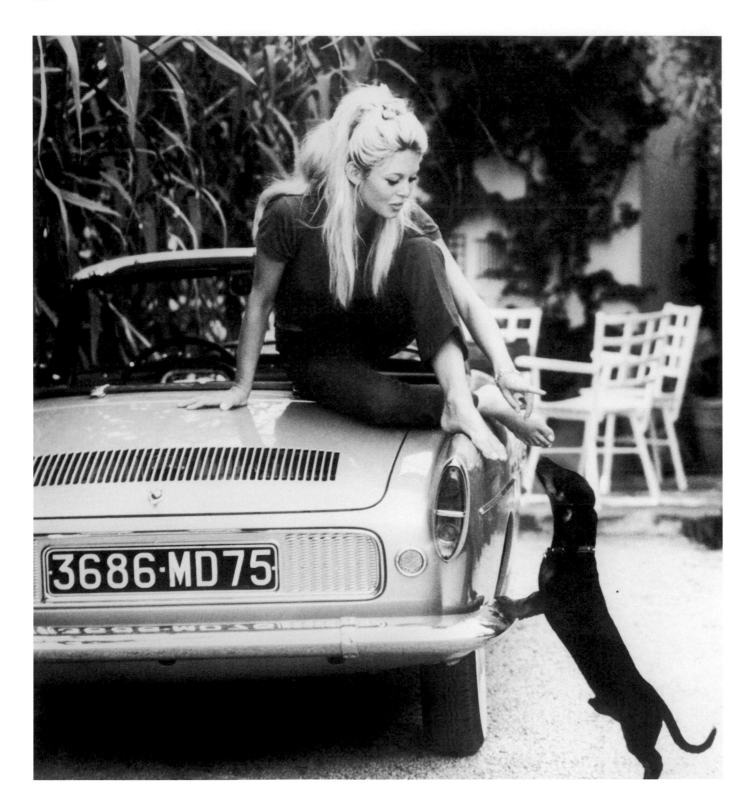

Above: Brigitte Bardot plays with her dog whilst sitting on the trunk of her 1960 Renault Floride.

Opposite: A very young Bardot curls up on the bonnet of a 1950 Simca.

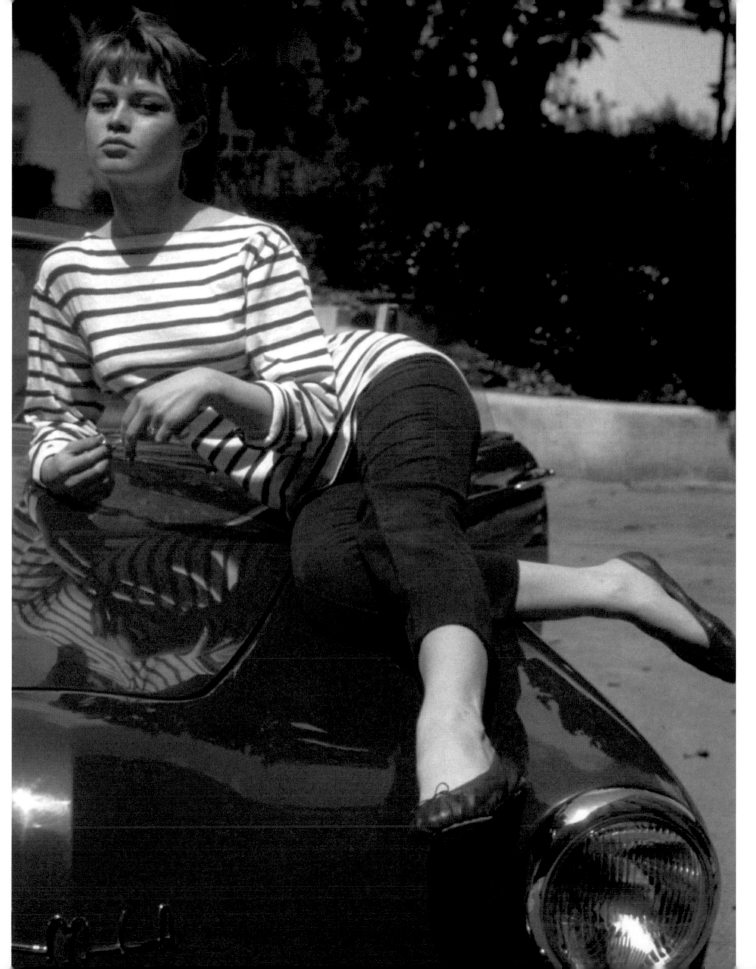

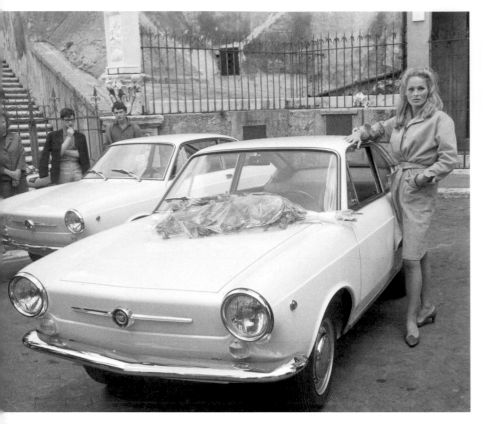

Above left: Ursula Andress alongside a Fiat 850 in Rome, 1965.

Above right: Italian actress Claudia Cardinale with a Panhard in Rome, 1960.

Opposite: Brigitte Bardot promotes a Vespa 400.

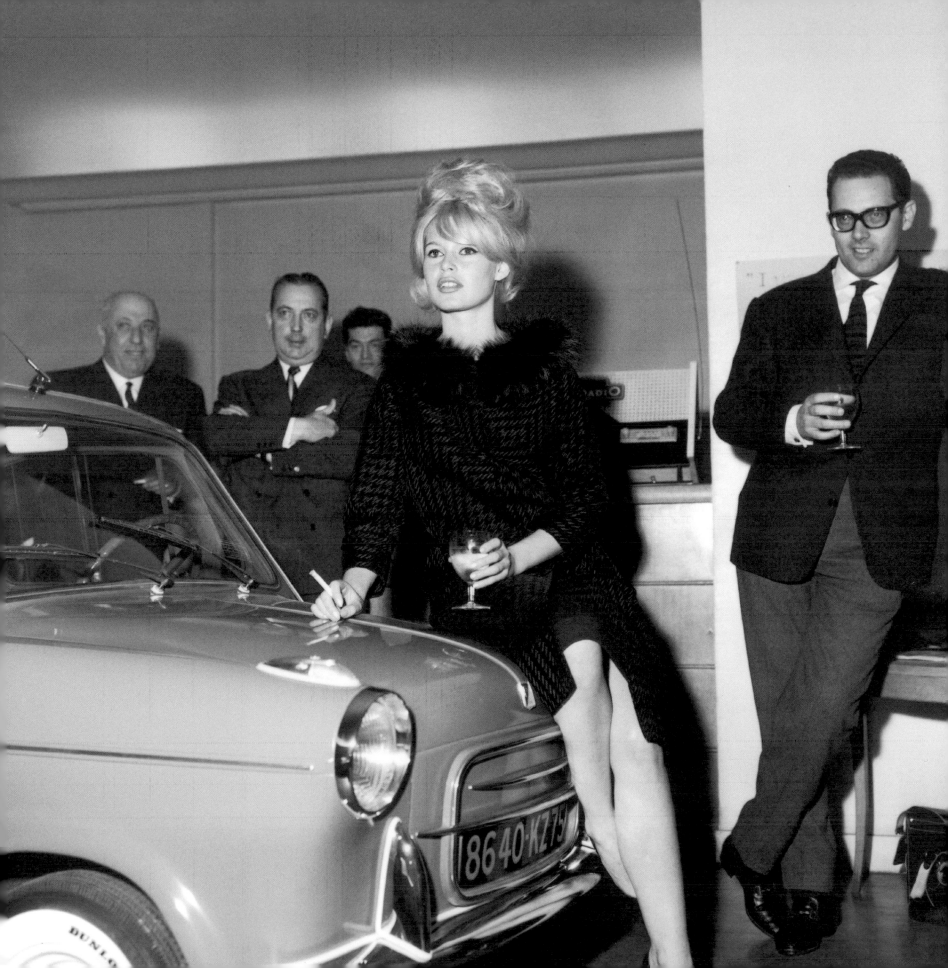

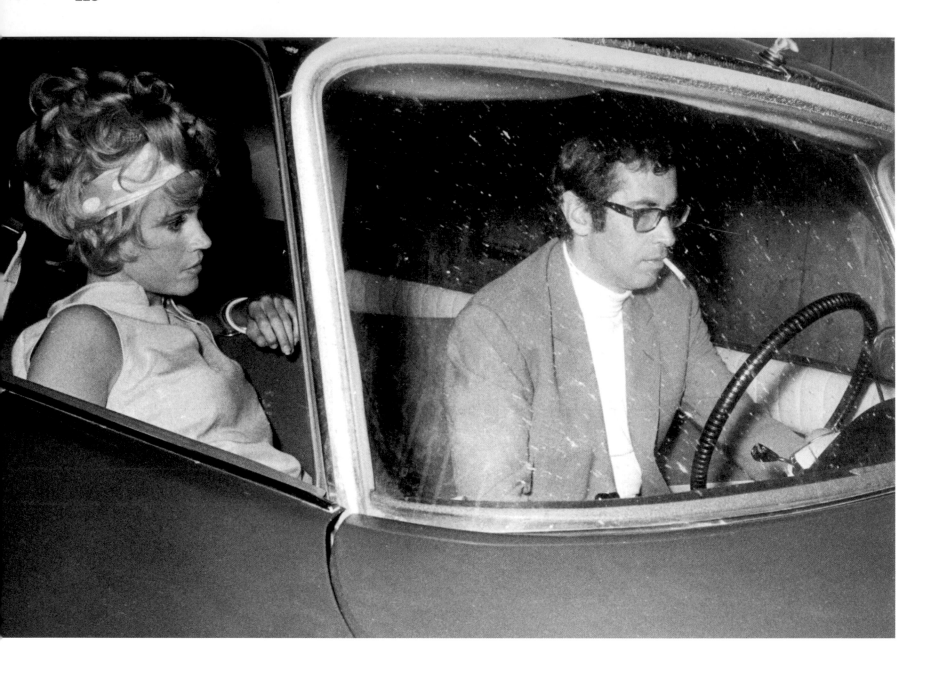

Above: Playboy director Roger Vadim drives his third wife, Jane Fonda, in a Citroën DS, 1968. Vadim and Fonda made *Barbarella* together in 1969.

Opposite: Vadim with his second wife, Annette Stoyberg, getting into a Ferrari convertible in Via Veneto, Rome, 1959. Vadim's first wife was, of course, none other than Brigitte Bardot.

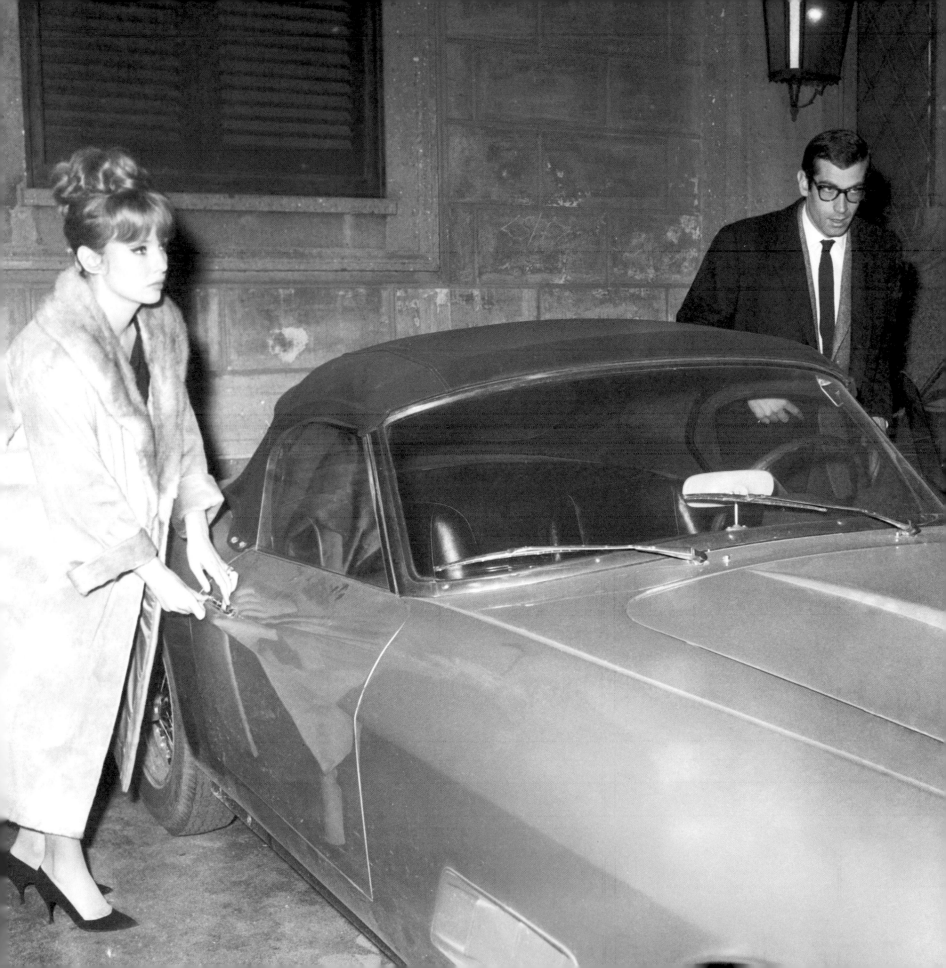

Above: Bing Crosby – on vacation with his family in 1963 – is cosily squashed into an open Renault 4CV.

Opposite: French actor Jean Marais climbs out of a tiny Renault 4CV, Paris, 1950.

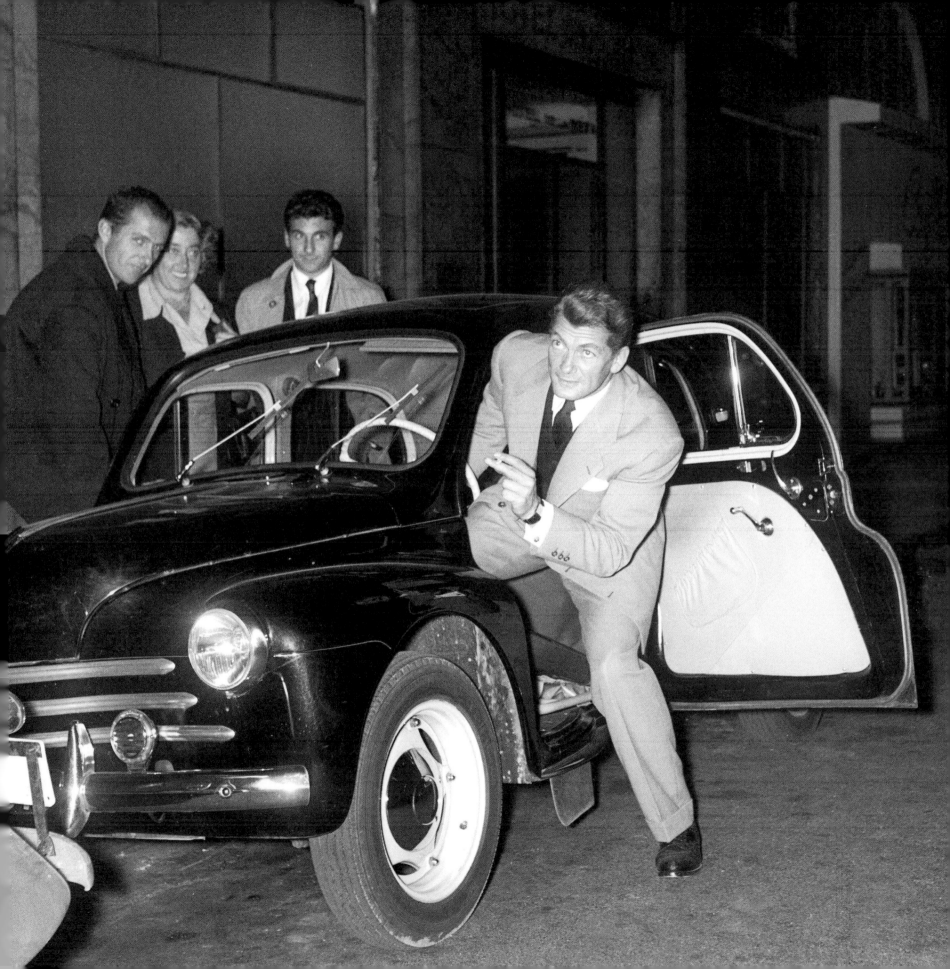

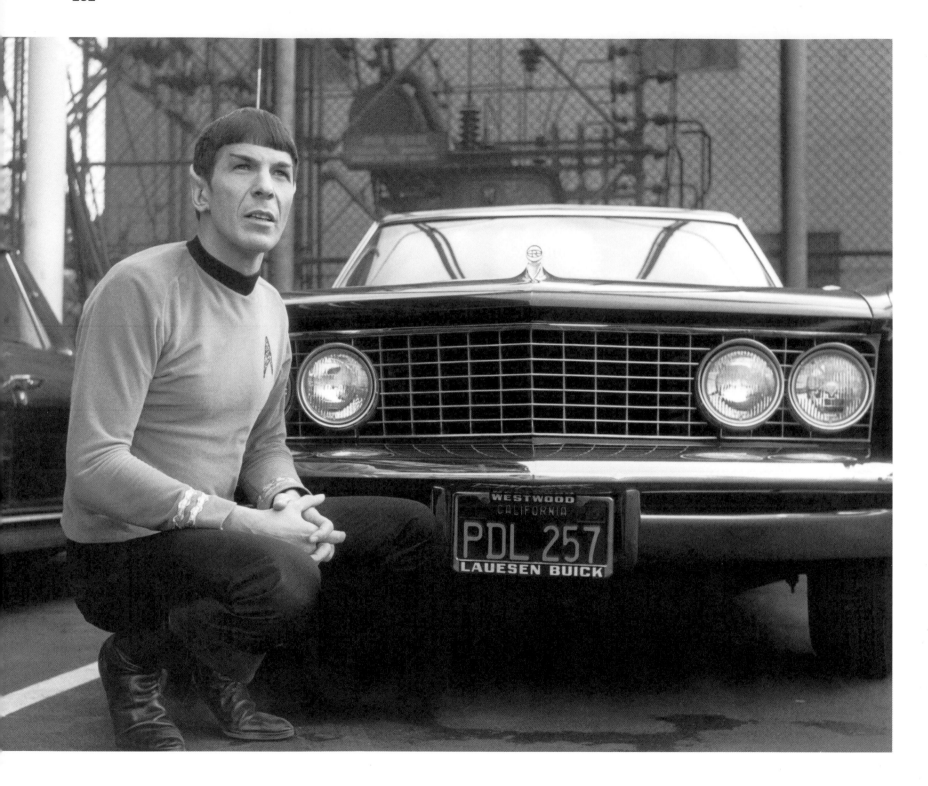

Above: Leonard Nimoy kneels next to his brand-new c.1967 Buick Riviera on the Paramount back lot, during a break from shooting an episode of *Star Trek*.

Opposite: Fellow *Star Trek* actor William Shatner in his 1963 split-window Chevrolet Corvette.

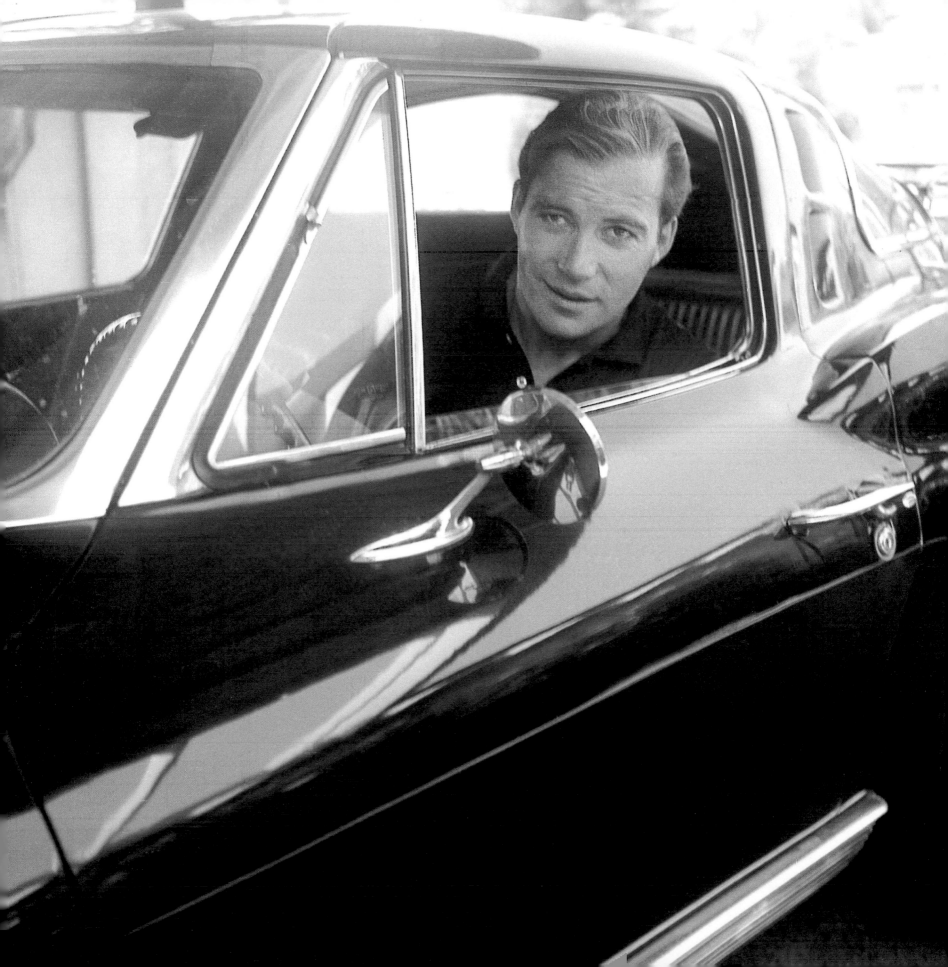

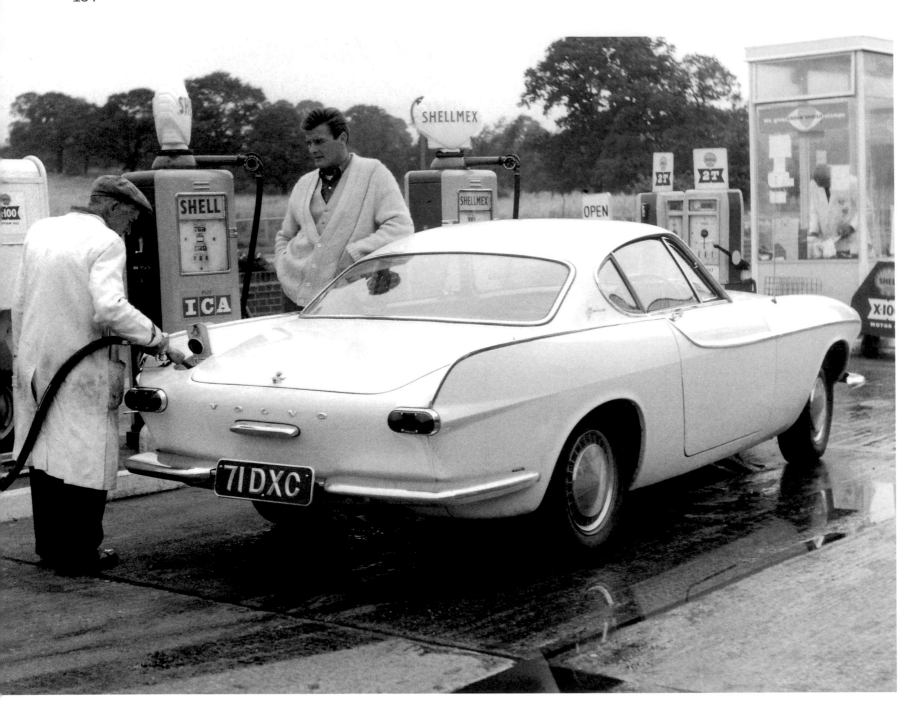

Above: Roger Moore fills up his fashionable early-Sixties Volvo P1800 coupé.

Opposite: Fresh from the success of the first Bond movie *Dr No* in 1962, Sean Connery with his Porsche 356 in his hometown of Edinburgh.

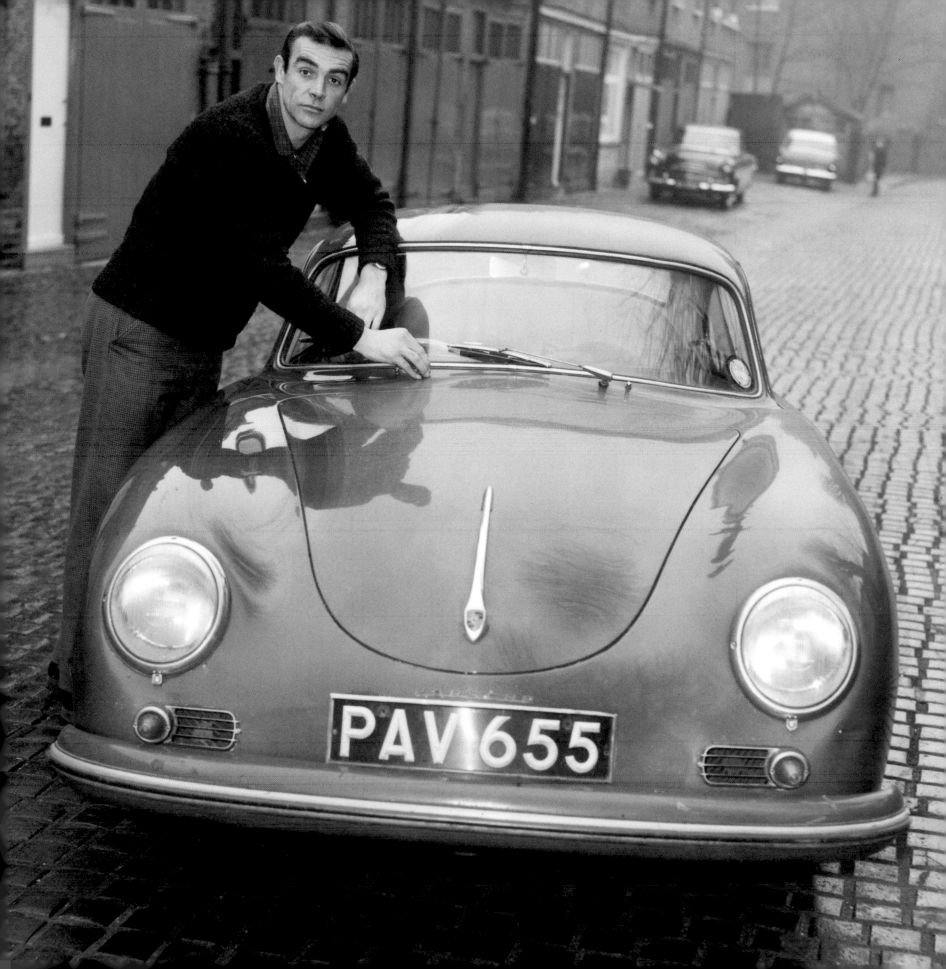

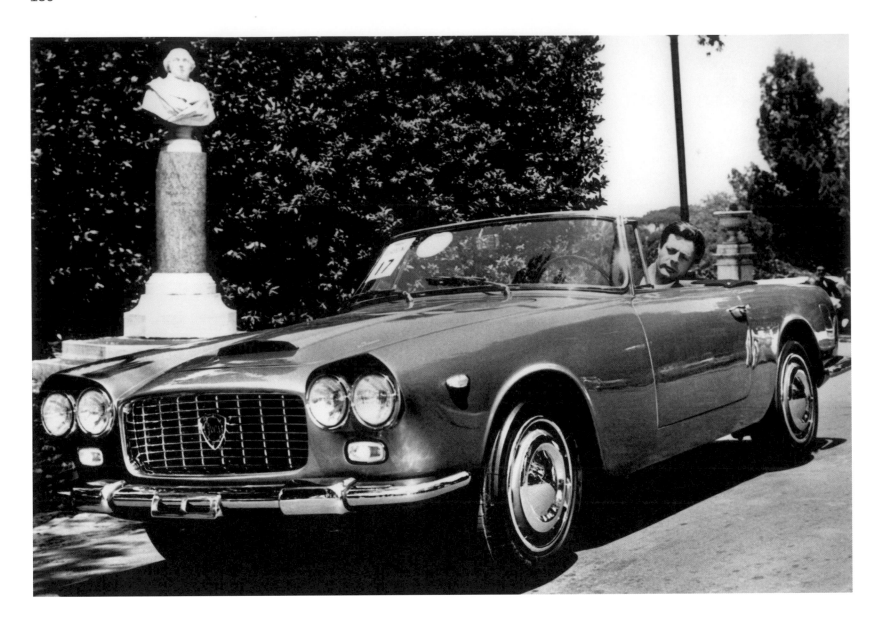

Above: Italian actor Marcello Mastroianni sitting in his Lancia Flaminia convertible. The Flaminia was a luxurious coachbuilt car whose body was made by the most prestigious coachbuilders in Italy, in this case Touring.

Opposite: One year after the release of *La Dolce Vita* Mastroianni poses next to his Porsche 356 at his villa in Appia Antica, Rome, 1961.

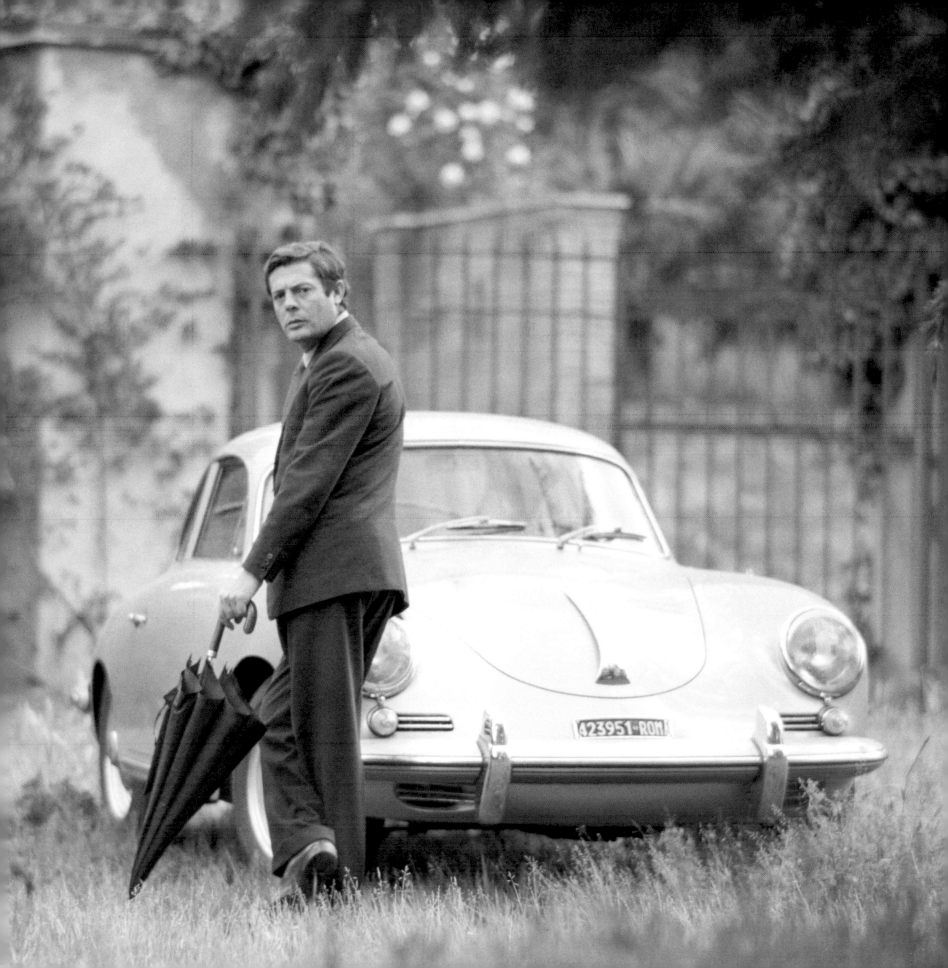

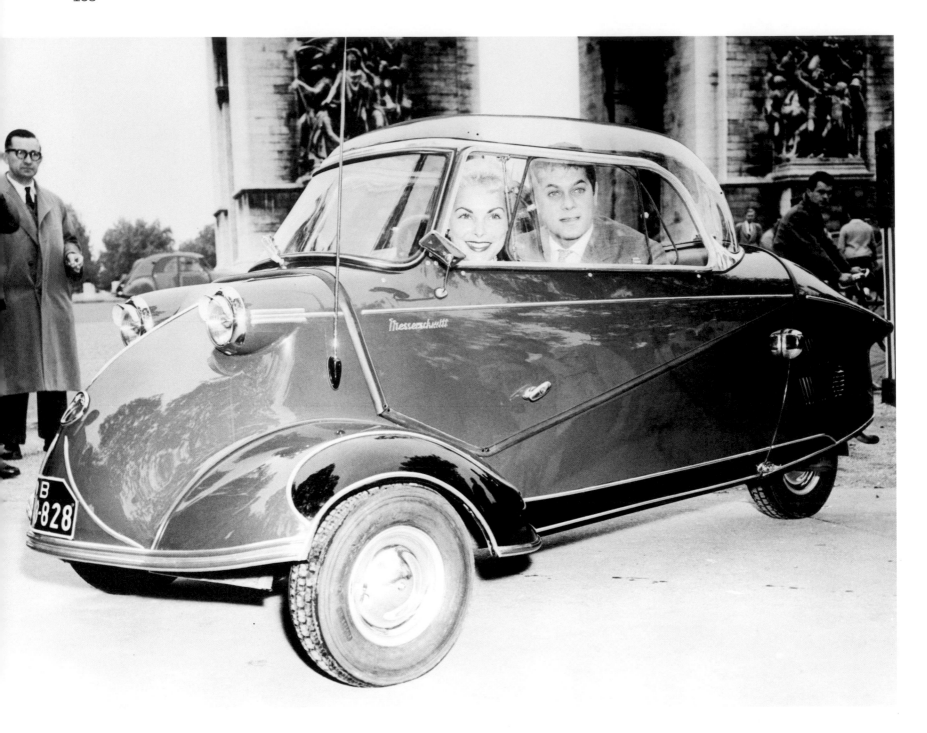

Above: Actress Janet Leigh and her second husband, Tony Curtis, have fun in a 1955 Messerschmitt three-wheeler microcar.
The Messerschmitt was a surprise homecoming present to Leigh from Curtis after he returned from an African tour.
Opposite: Tony Curtis messing about on a studio lot with his 1957 Simca Aronde, imported from Europe.

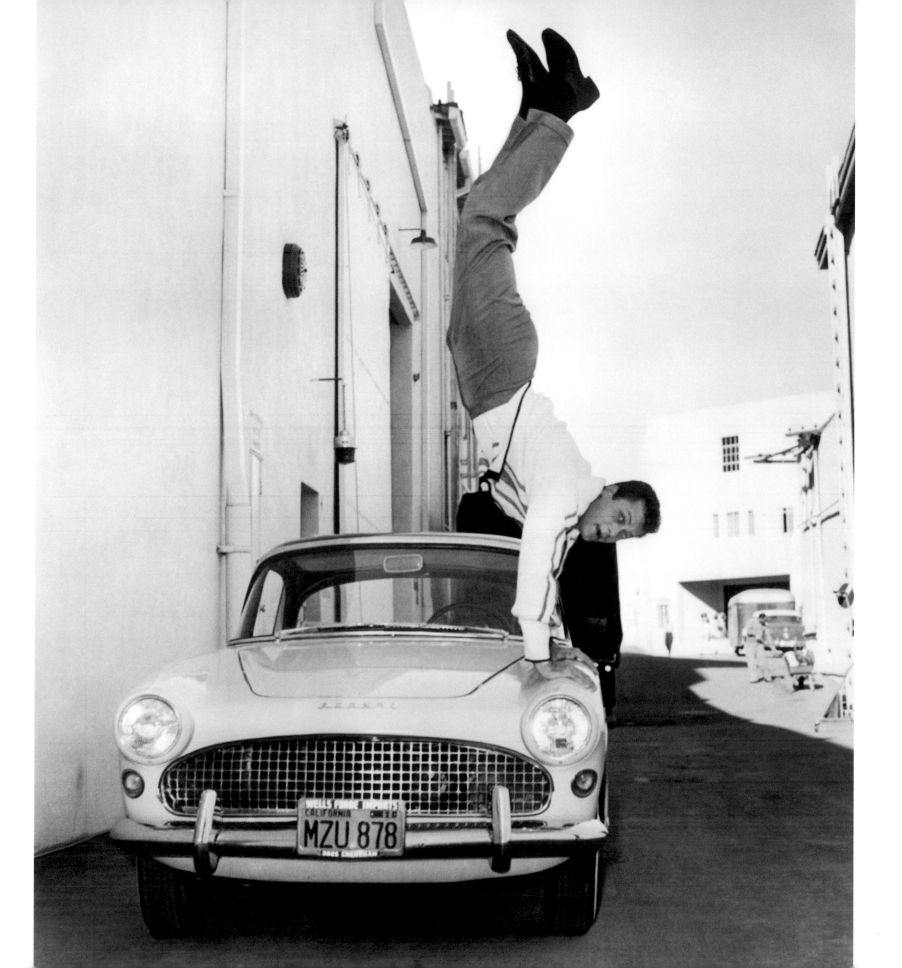

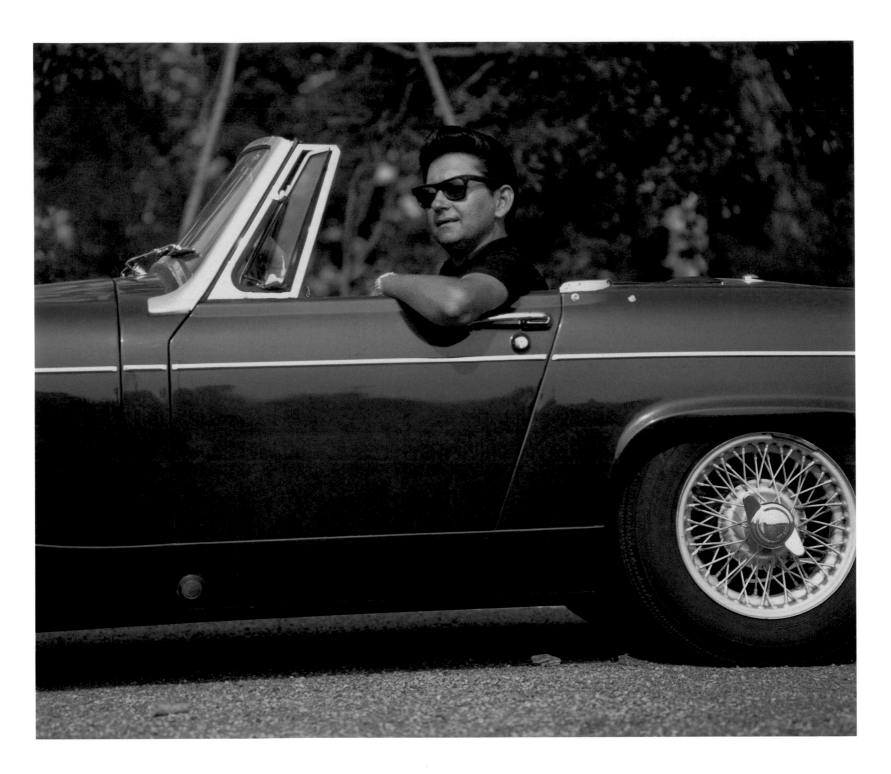

Above: Roy Orbison sitting in his c.1962 MG Midget roadster.

Opposite: Frankie Avalon leaning against his 1959 Ford Thunderbird.

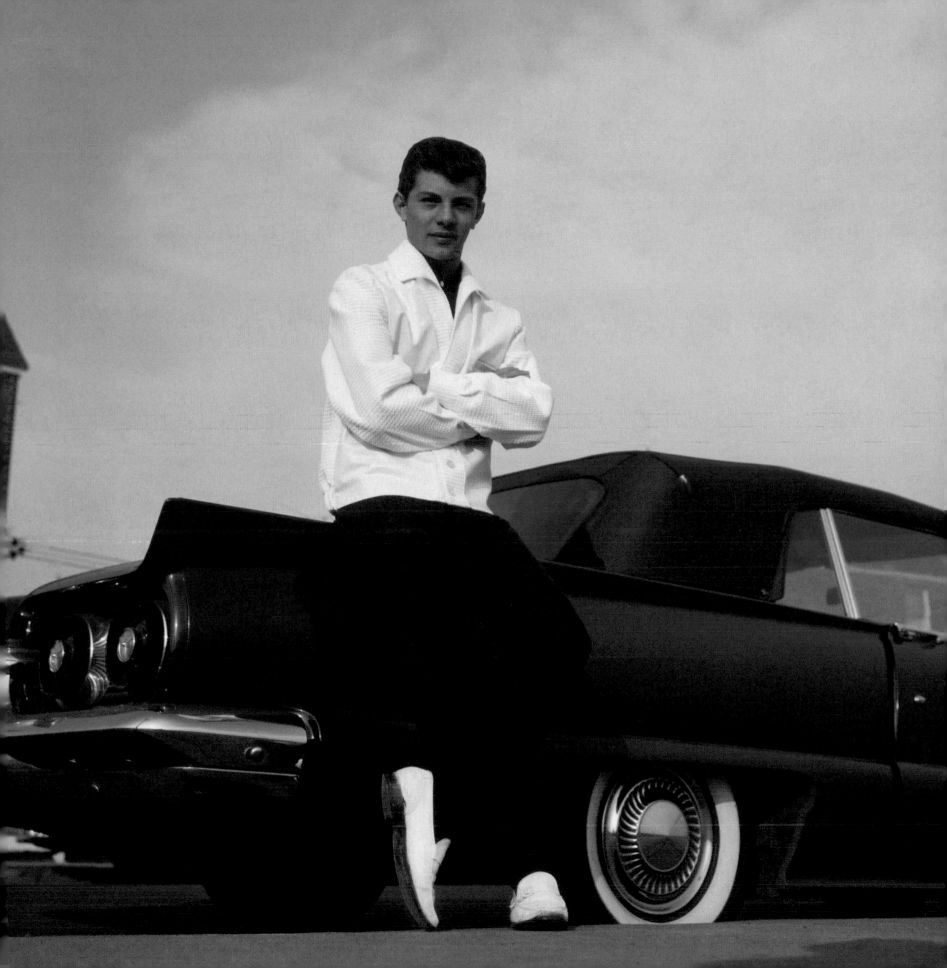

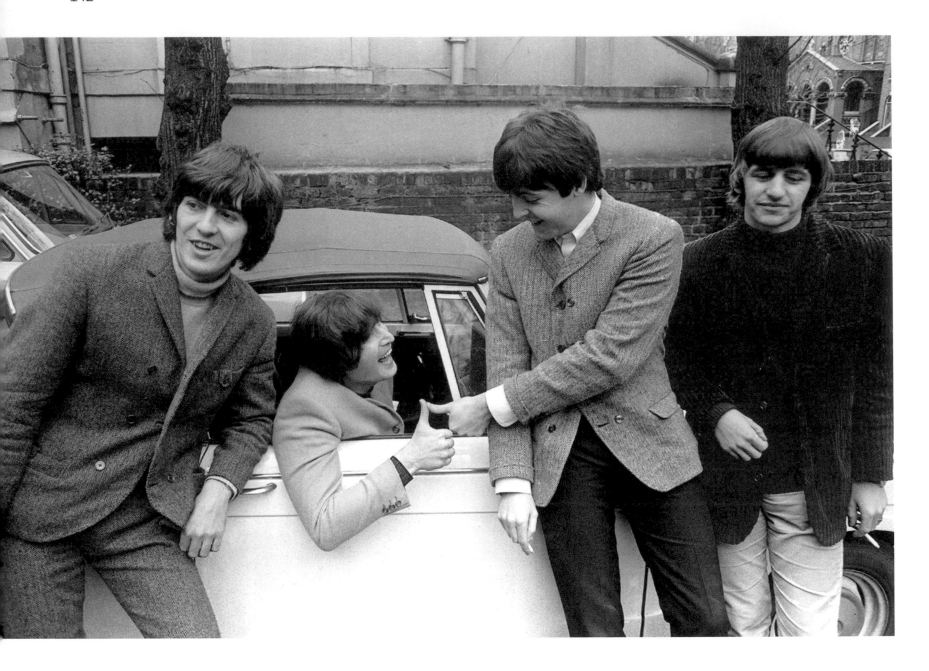

Above: John Lennon, in his brand-new 1965 Triumph Herald convertible, gives a 'thumbs up' after passing his driving test on 16 February 1965.
The rest of the Beatles were also there to show their support.

Opposite: Lennon looks forward to hitting the open road. He was to become an avid car enthusiast.

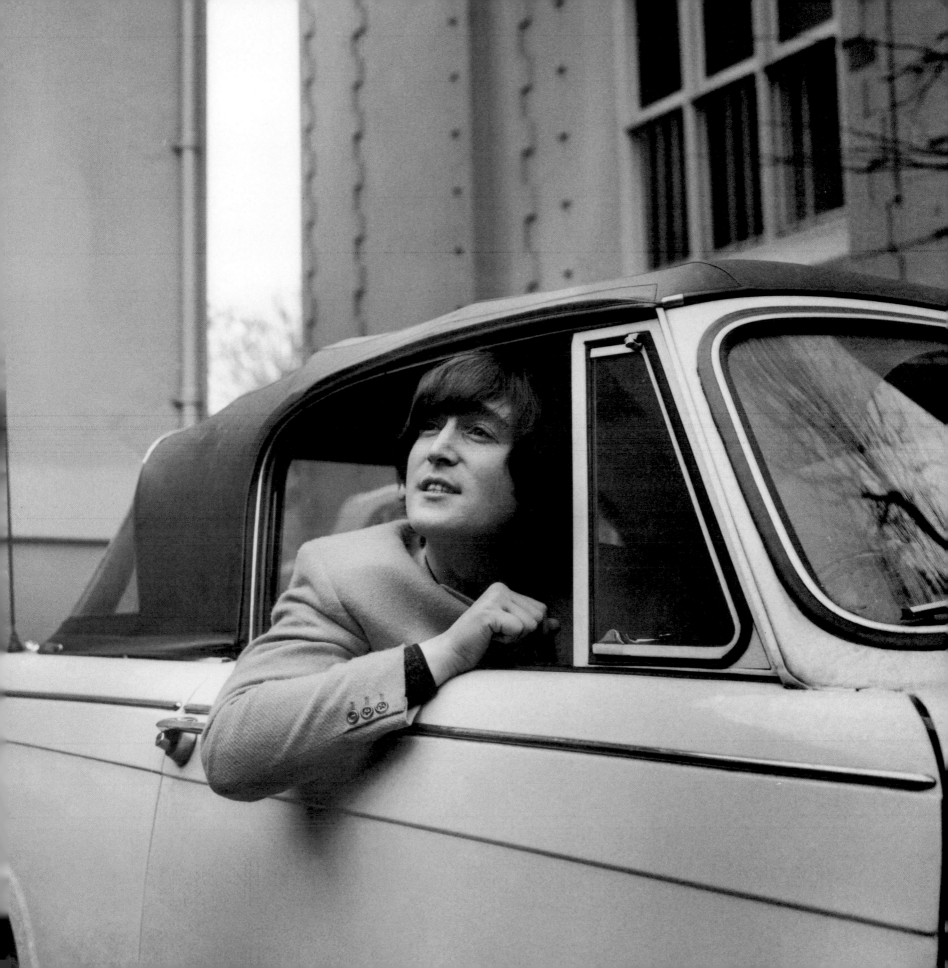

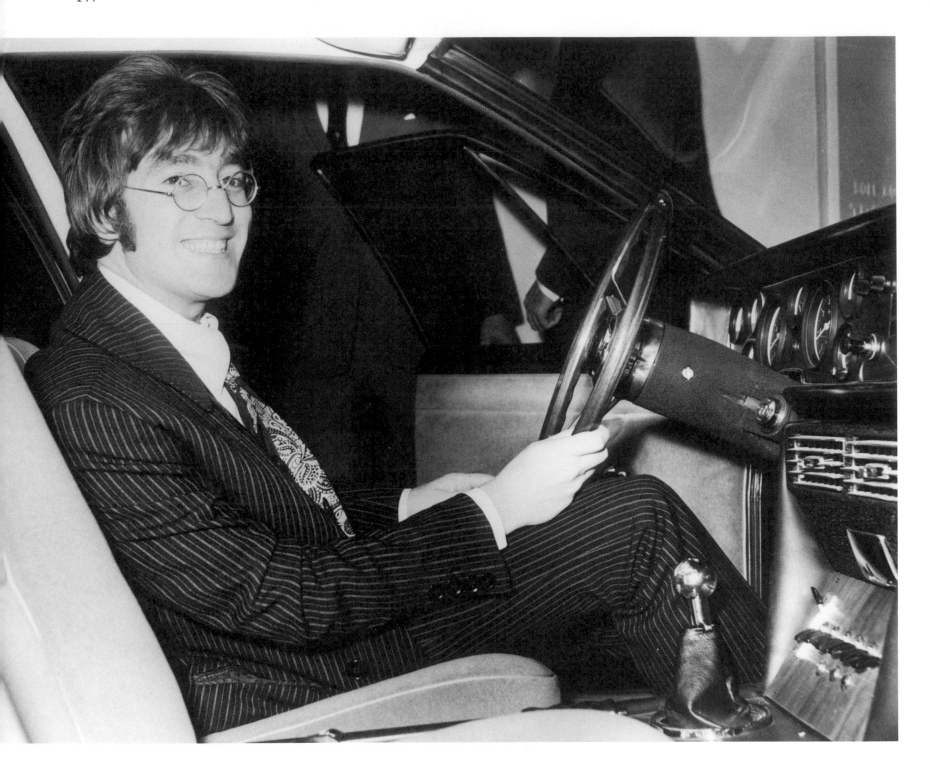

Above: A happy John Lennon at the wheel of his 1967 ISO Rivolta S4.

Opposite: George Harrison drives his Ferrari at London airport, 1966.

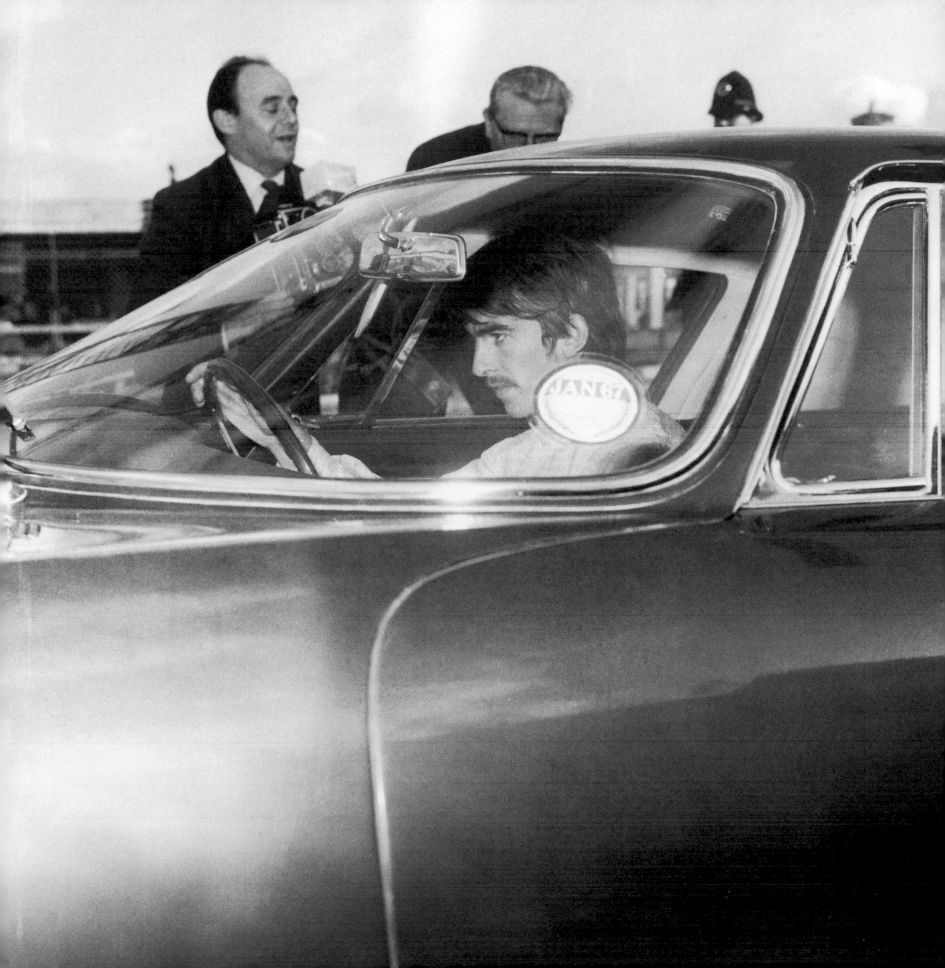

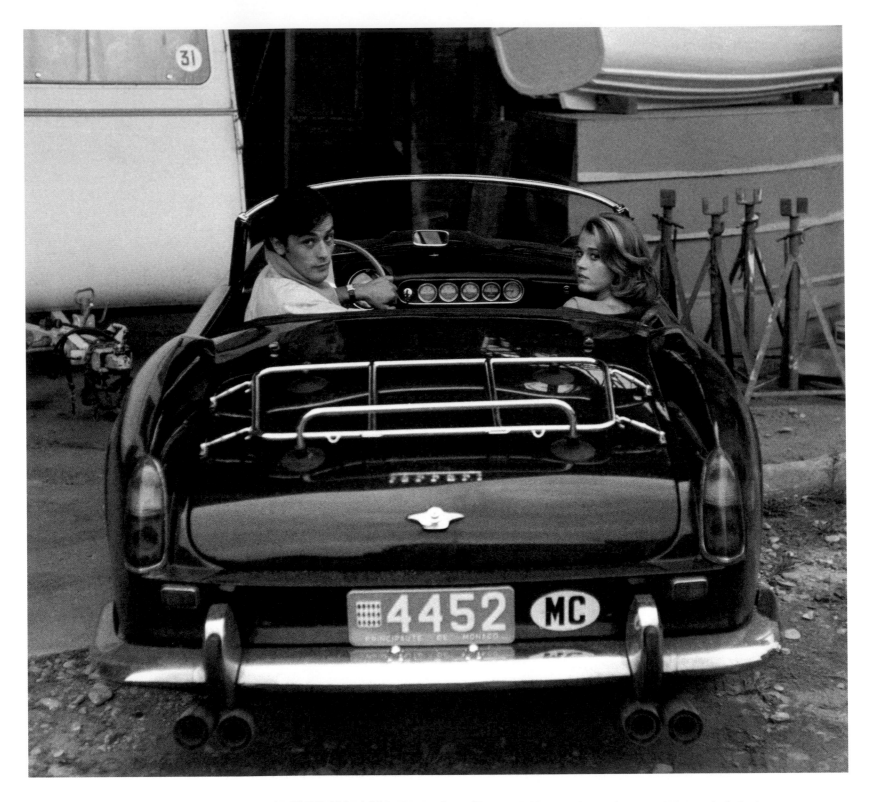

Above: Jane Fonda and her co-star, Alain Delon, arriving at the film set of *Les Felins* in a Ferrari in Antibes, 1964.

Opposite: Italian actress Monica Vitti in her Ferrari convertible at the Cannes Film Festival, 1966.

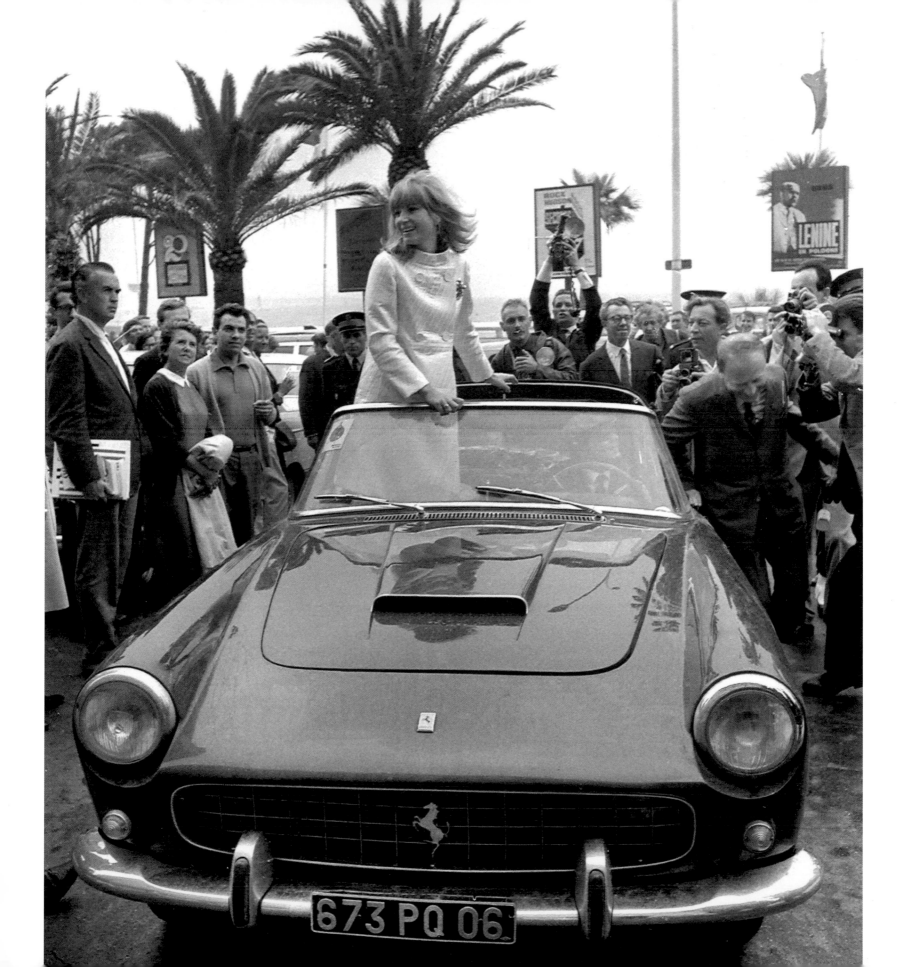

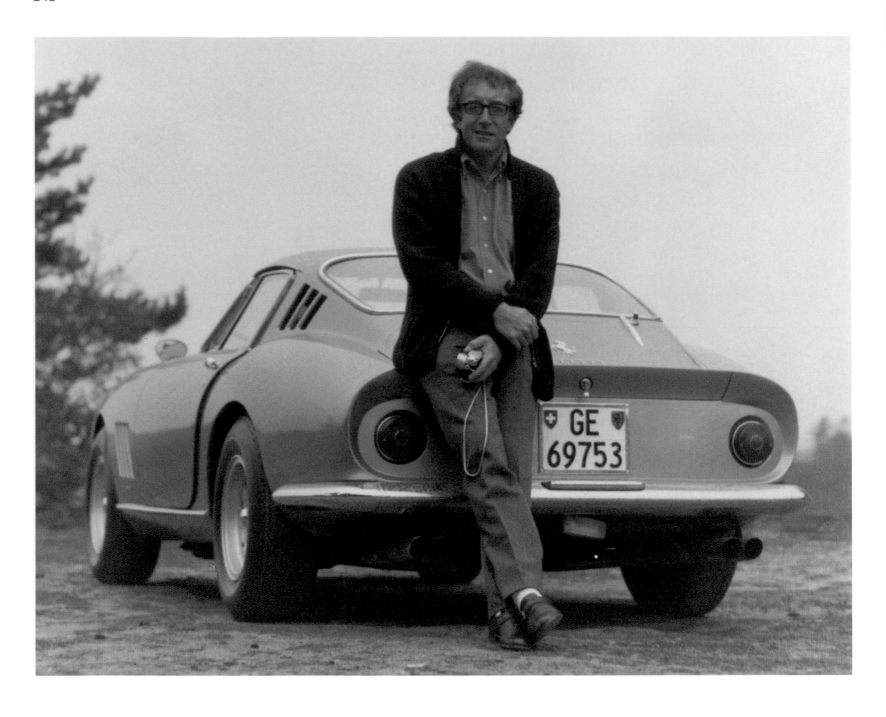

Above and opposite: British actor Peter Sellers with his Geneva-registered Ferrari 275 GTB.

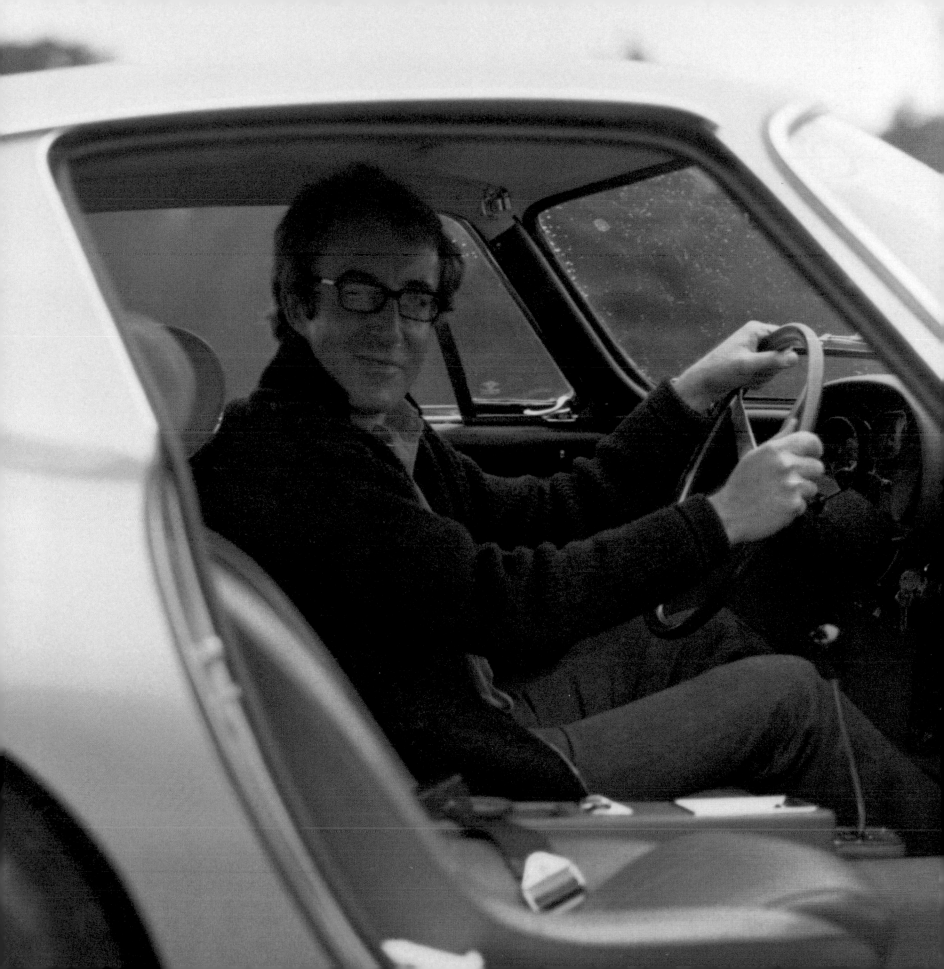

150

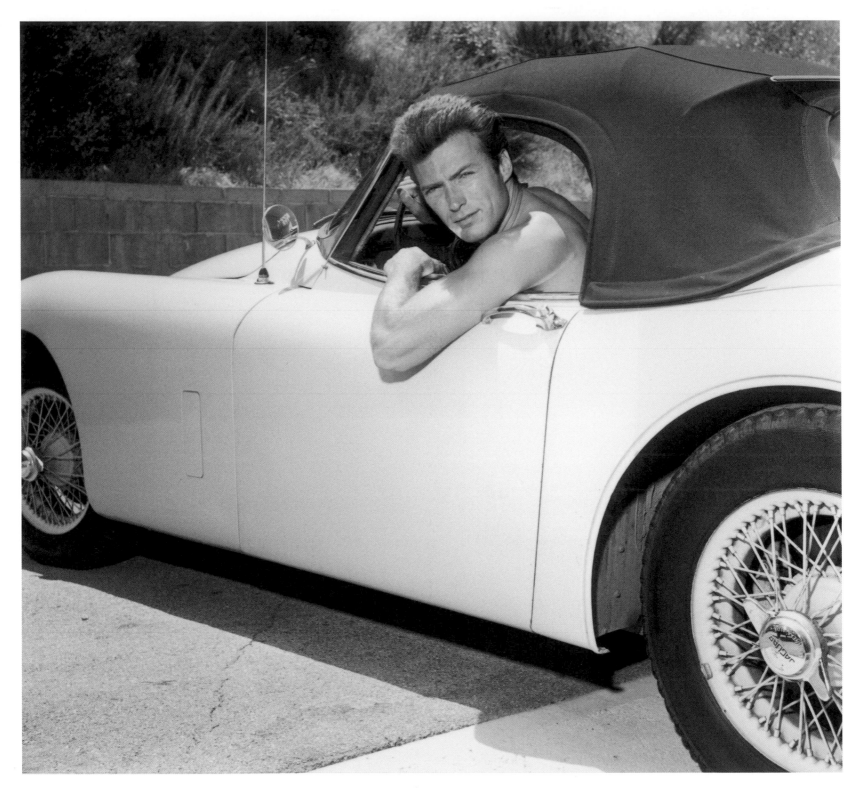

Above: Clint Eastwood at the wheel of his Jaguar XK150 and *opposite* with his Ferrari 275 GTB in 1965.

Overleaf: James Coburn in the driveway of his home in LA, 1966, with his Ferrari 250 GT and Ferrari Lusso.

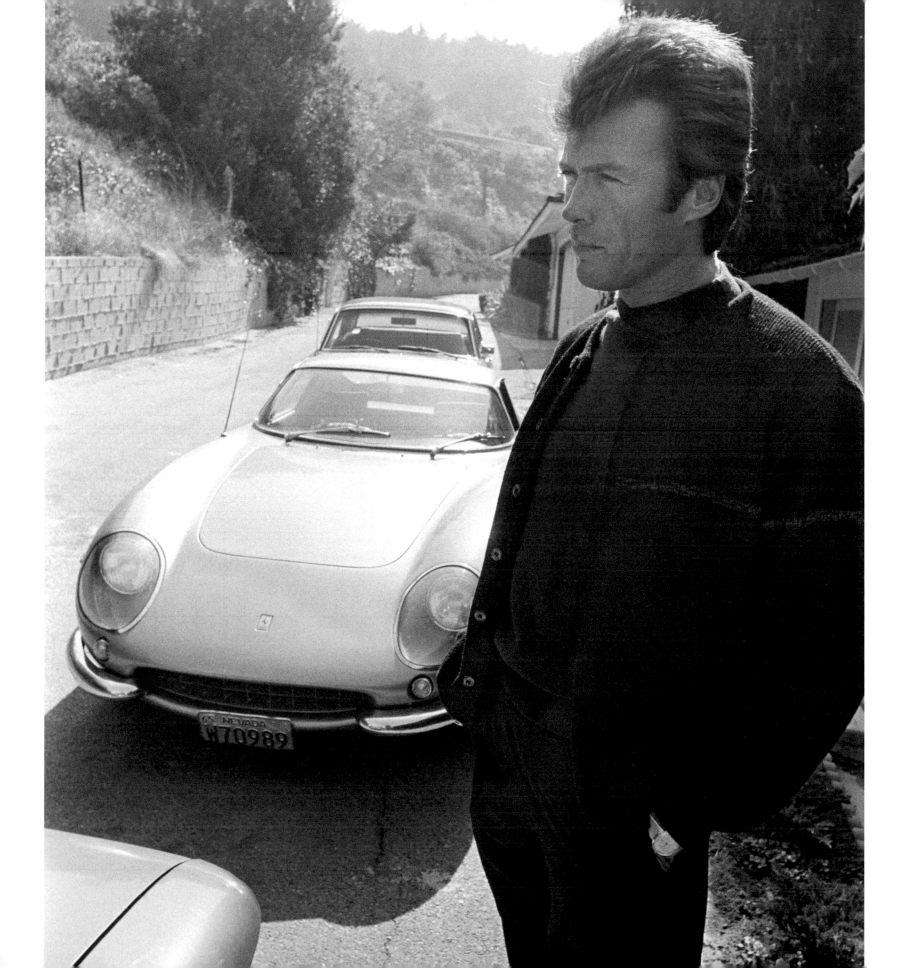

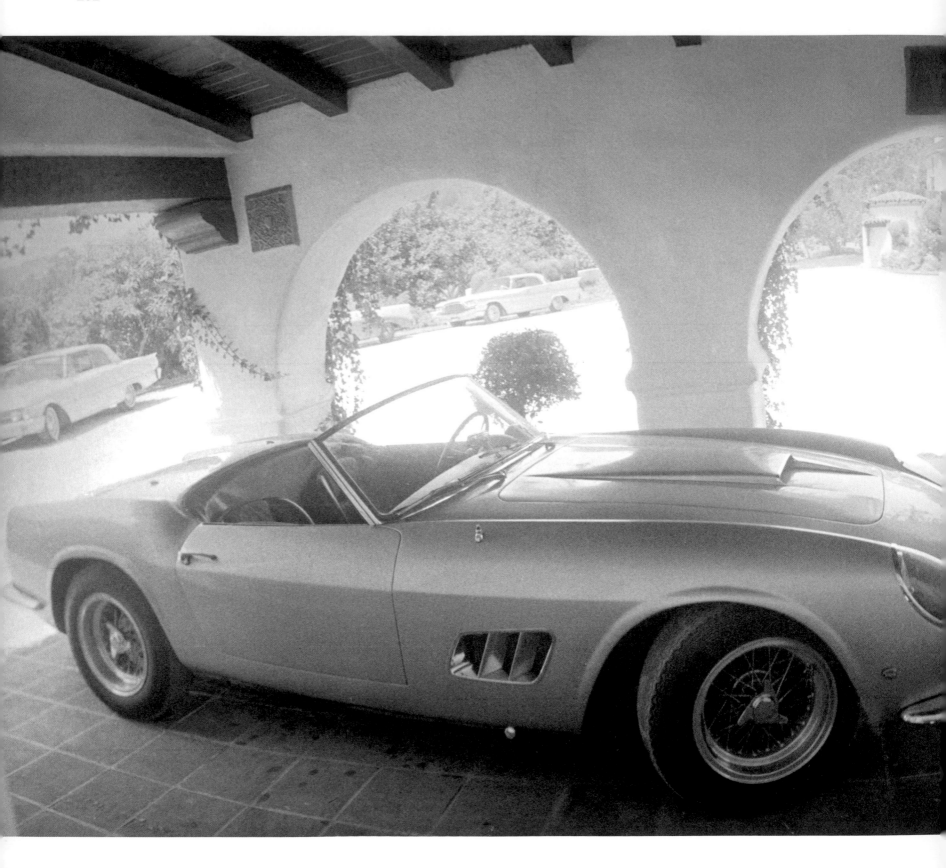

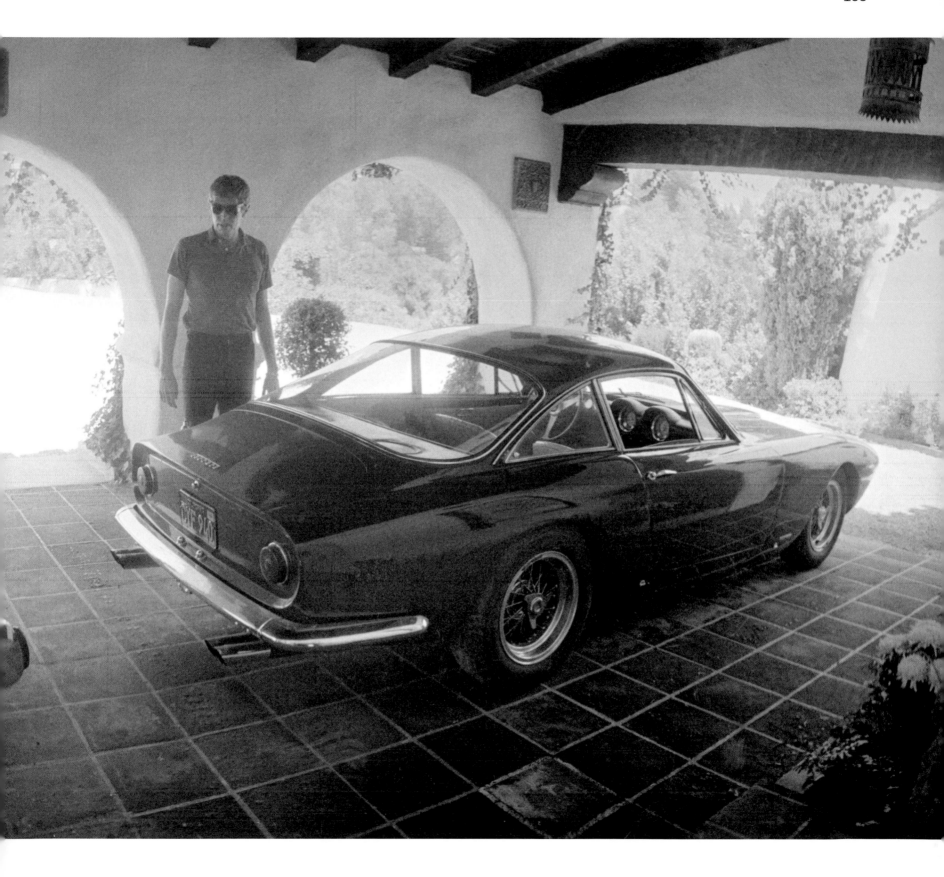

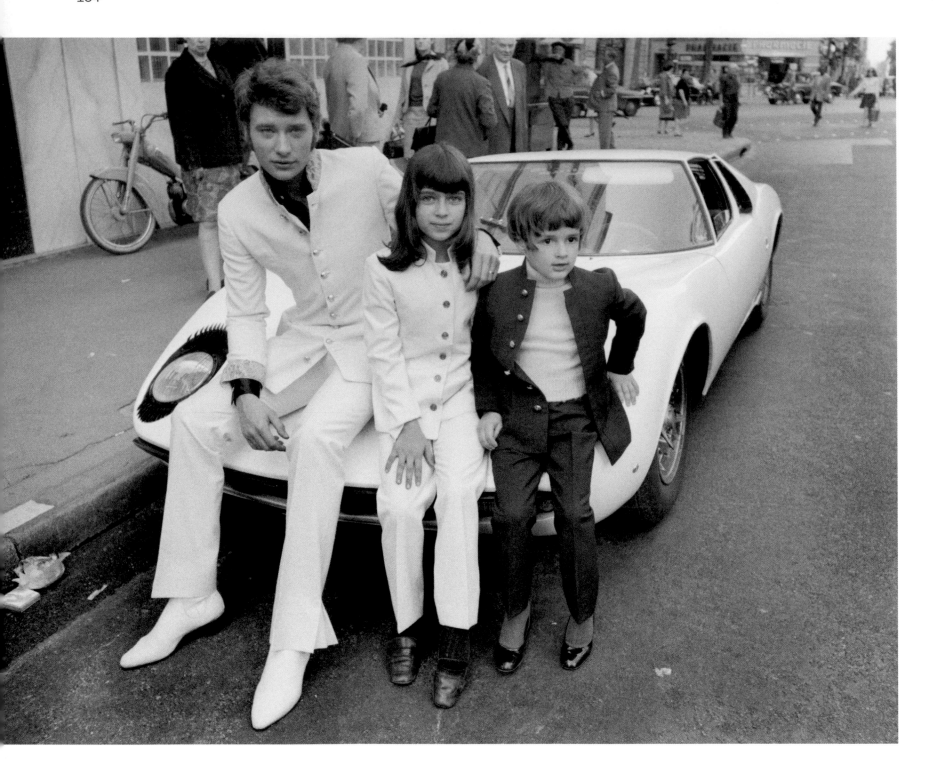

Above: Johnny Halliday, France's most famous rocker, perches with his children on the ultimate status symbol, his c. 1967 Lamborghini Miura.

Introduced at the Geneva show in 1966, the Miura was Ferruccio Lamborghini's impressive challenge to his Italian rivals in the grand-touring, two-seater field.

And what a challenge; at the time it was the fastest road-going car ever, tested with a mean maximum speed of 172 m.p.h.

Opposite: Hipster saint Miles Davis sitting on his trophy car, a c.1970 Lamborghini Miura.

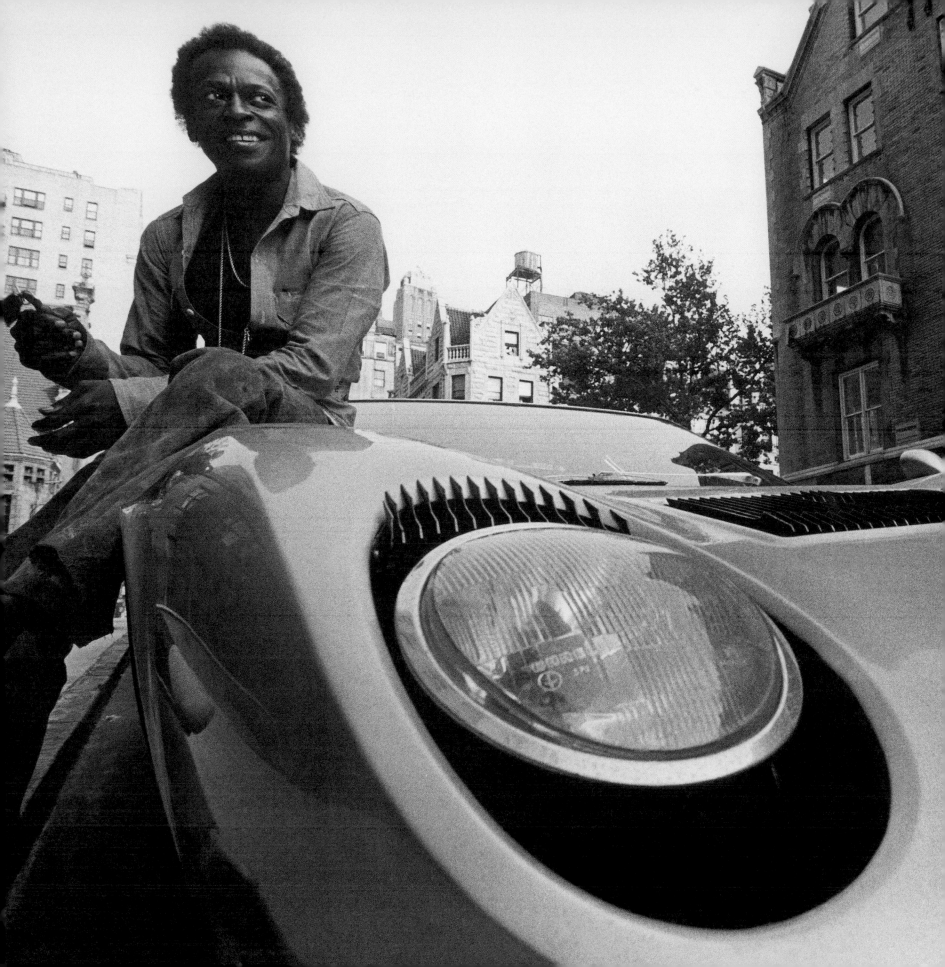

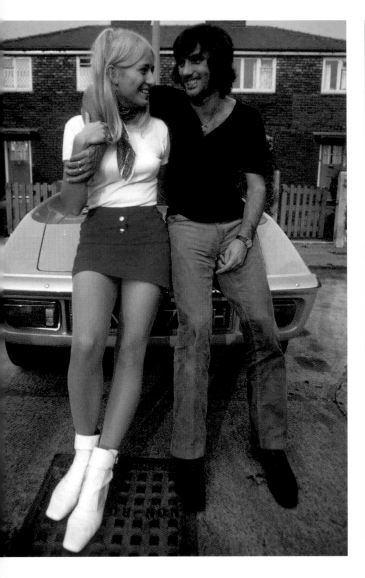

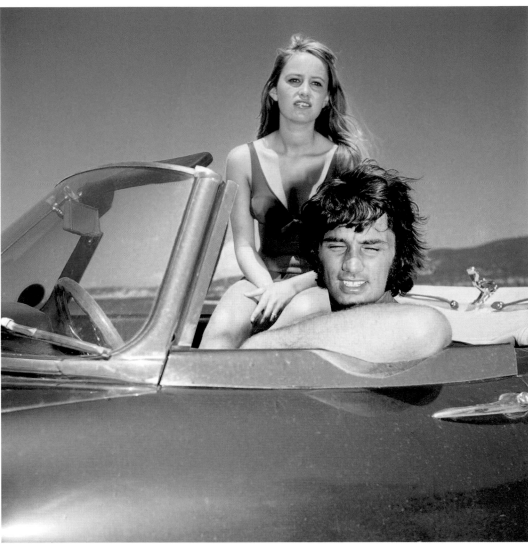

Above left: George Best and mini-skirted former fiancé Eva with his c.1970 Lotus Elan – a make mischievously nicknamed by some 'Lots Of Trouble, Usually Serious'.

Above right: Best with his then-girlfriend, actress Susan George and Jaguar E-type on holiday in sunny Majorca, 1969.

Opposite: Suited and booted, Pele proudly stands with his brand-new Mercedes-Benz saloon in Brazil, 1966.

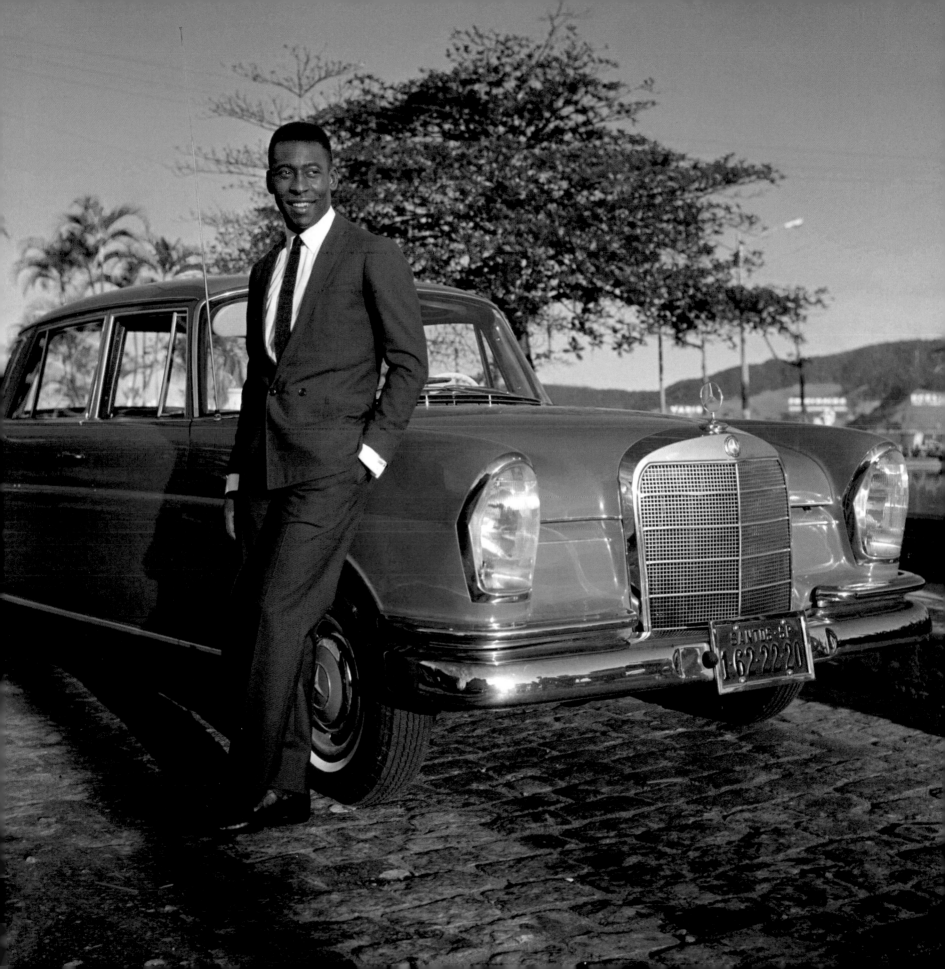

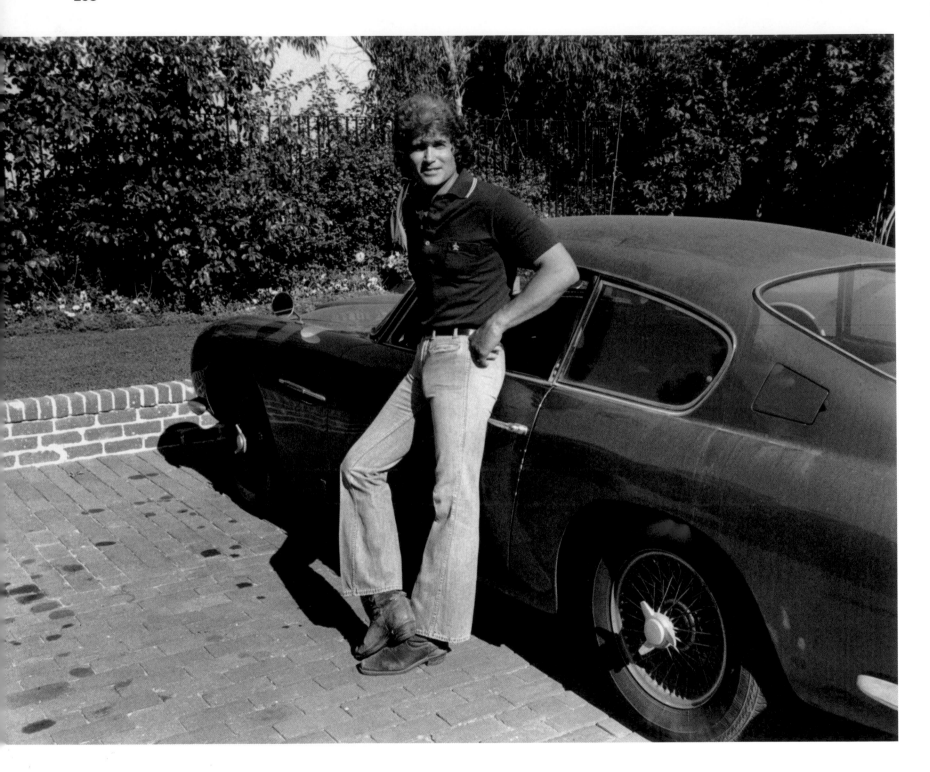

Above: Michael Landon with his 1967 Aston Martin DB6 at home in Beverly Hills in 1972. The star of B-movie classics such as *I Was A Teenage Werewolf* (1957) and *High School Confidential* (1958), Landon went on to find lasting fame in numerous TV shows including *Bonanza* and the phenomenally popular 1970s series *Little House on the Prairie.*
Opposite: Landon sitting on the bonnet of his 1955 Alfa Romeo Giulietta Sprint in 1956.

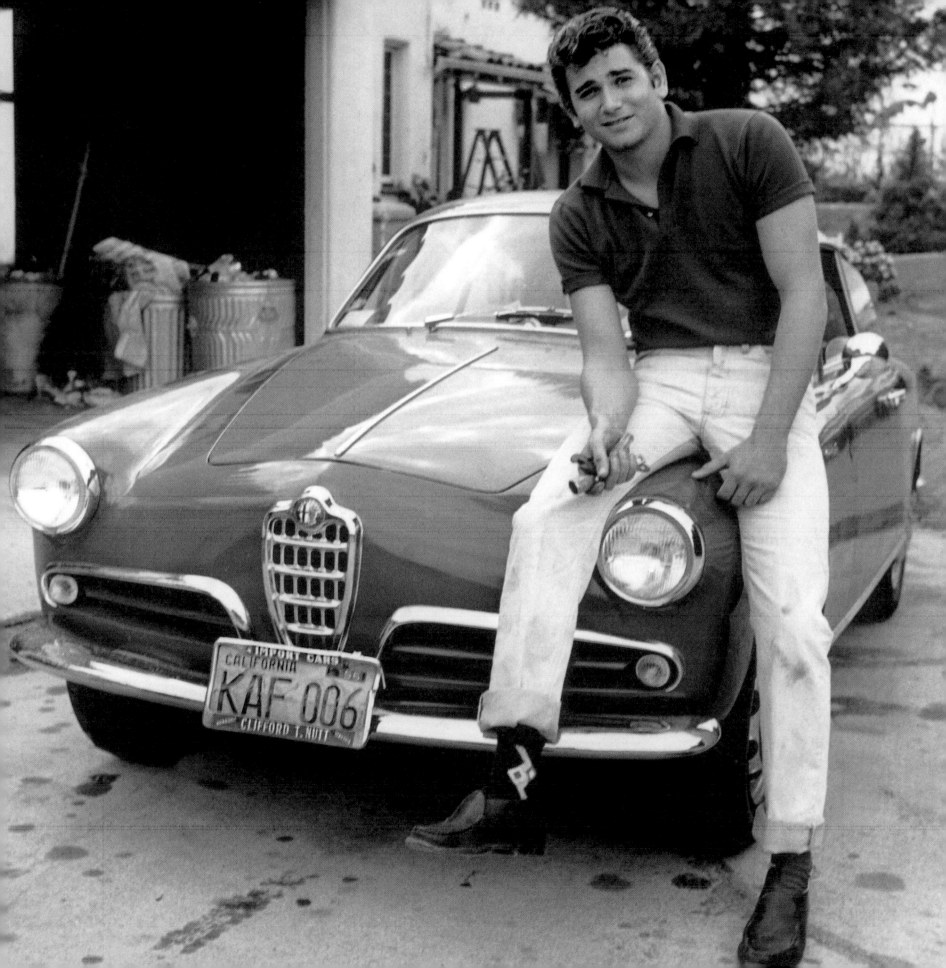

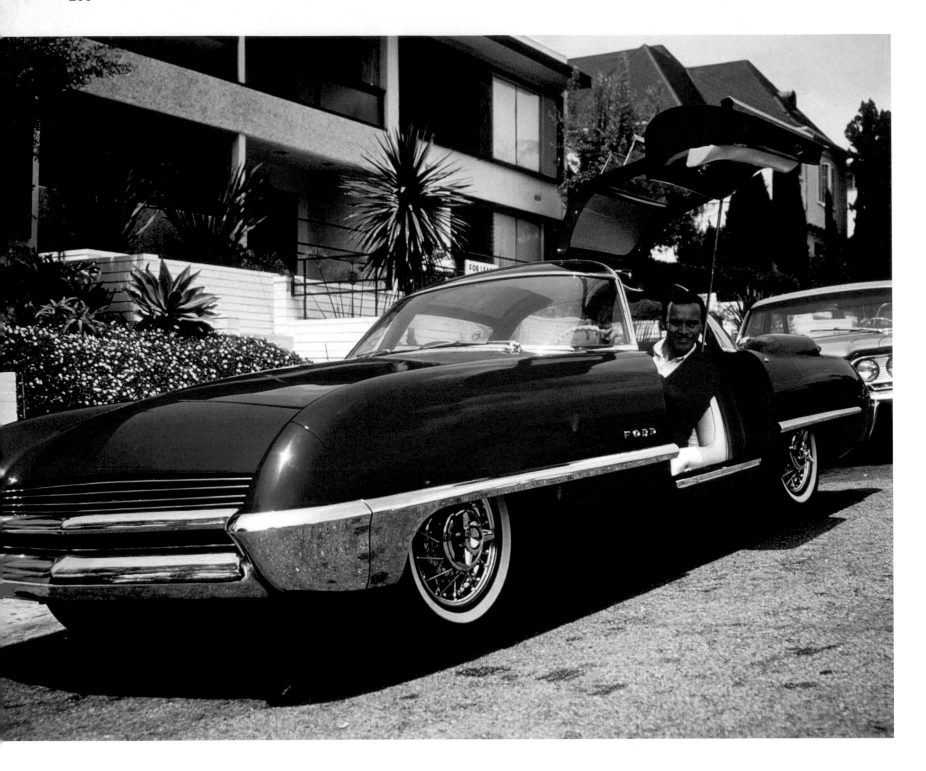

Above: Jack Lemmon with his uniquely futuristic Ford, which featured gull-wing doors.

Opposite: Sammy Davis Jr with his DeLorean DMC 12. The DeLorean Motor Company was a short-lived manufacturer formed by automobile industry executive John DeLorean in 1975.

It is remembered for the one distinctive model it produced: the stainless-steel DeLorean DMC 12 sports car, whose gull-wing doors were made famous by the film *Back To The Future* (1985).

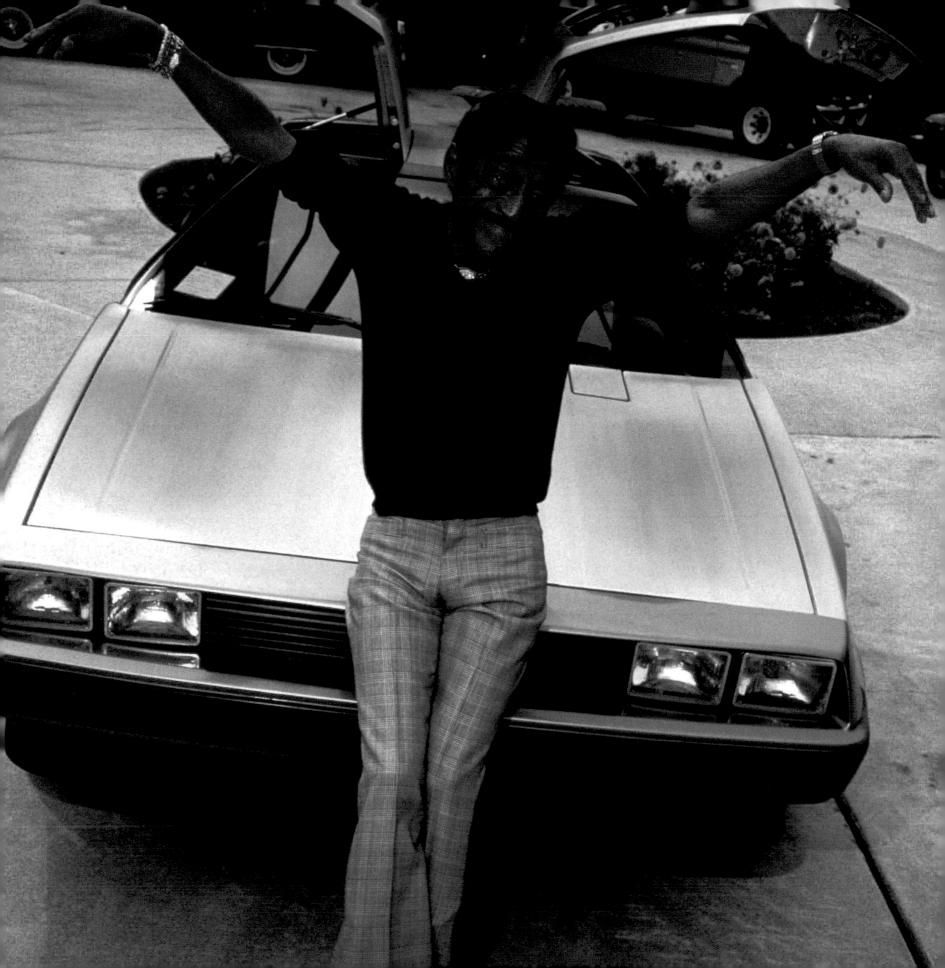

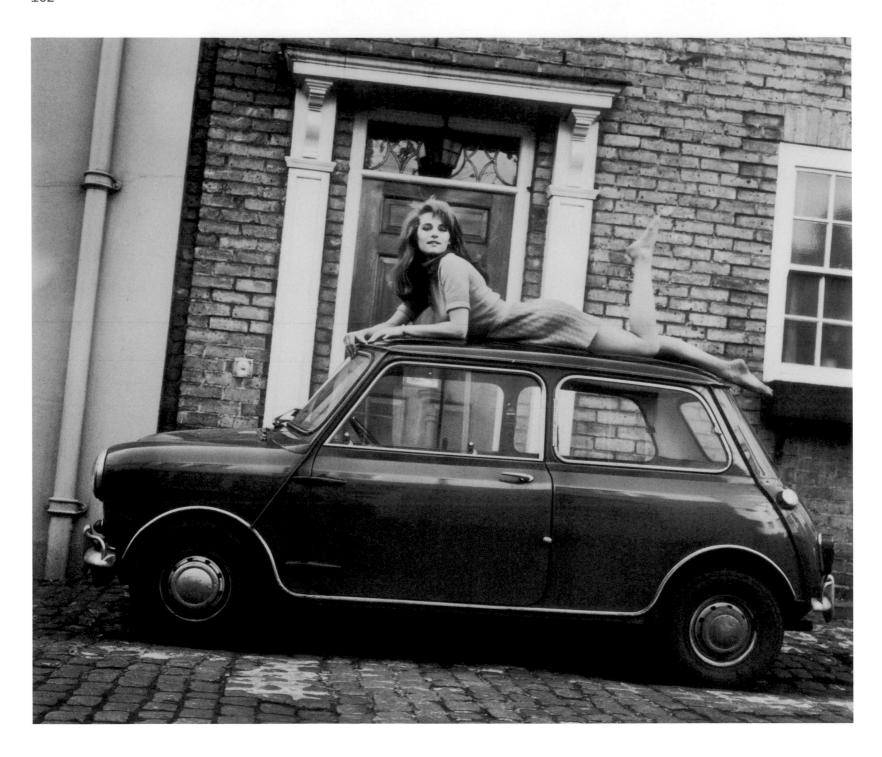

Above: In the 1960s, as skirts rose, cars shrank. Charlotte Rampling poses on the roof of a Mini in 1967.

Opposite: Brigitte Bardot leans against a Mini during a break from filming *Two Weeks in September* in Whitehall, London, 1966.

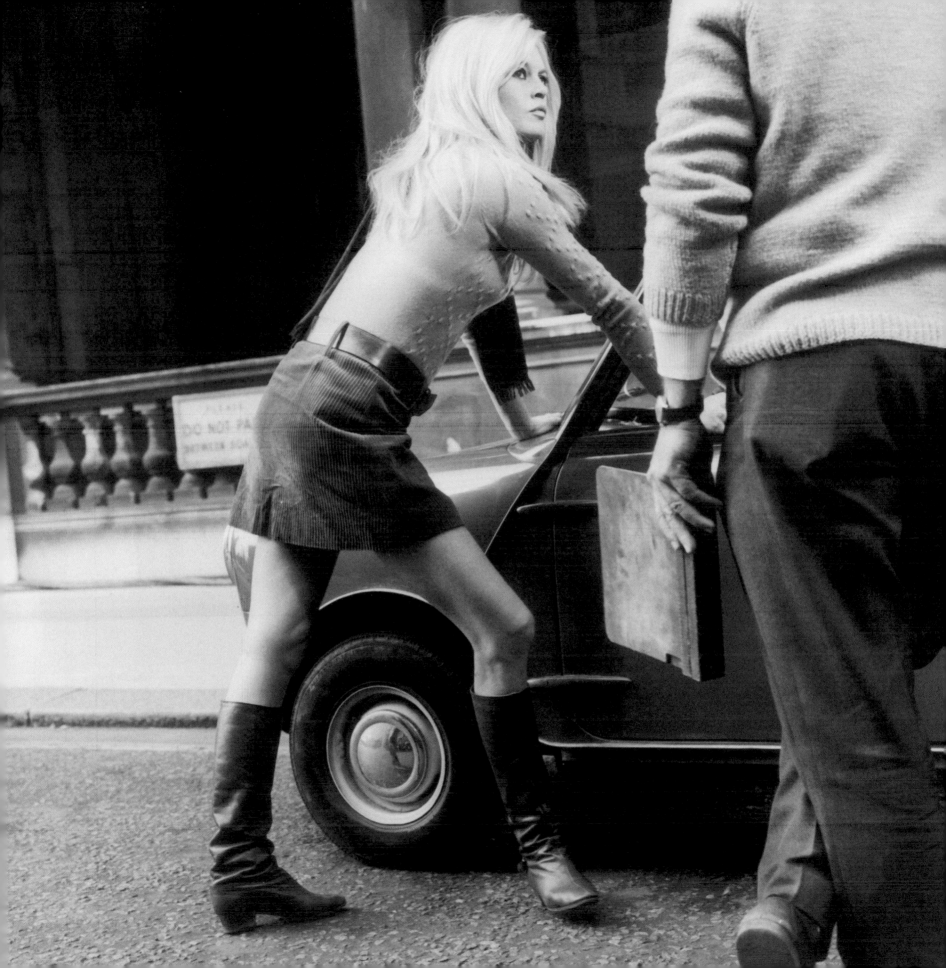

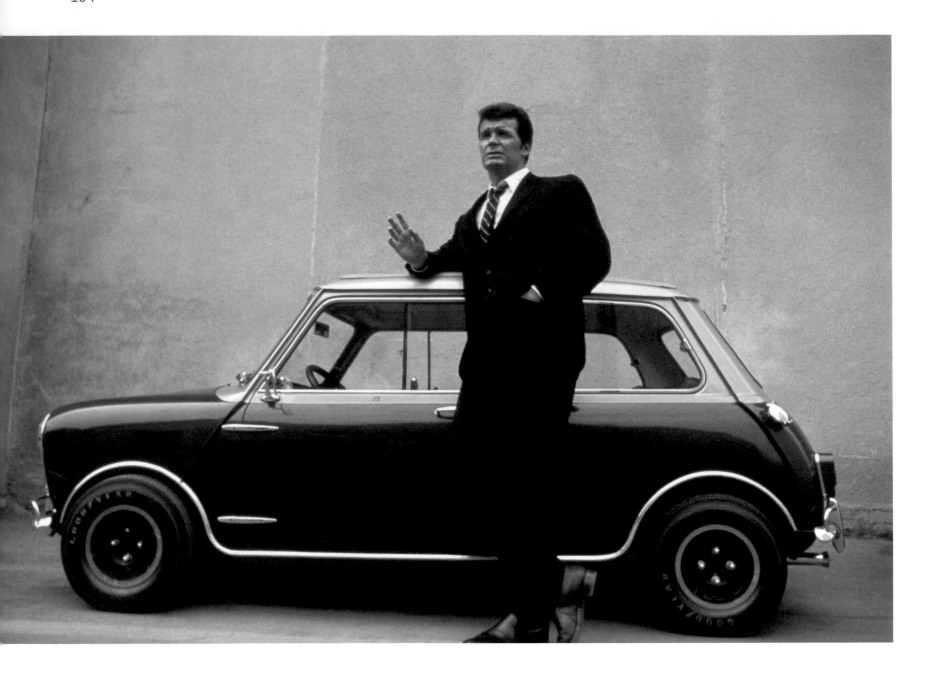

Above: Smooth-talking James Garner poses with his top-of-the-range 1966 Mini Cooper S.

Opposite: Warren Beatty with his c.1965 Mini Minor.

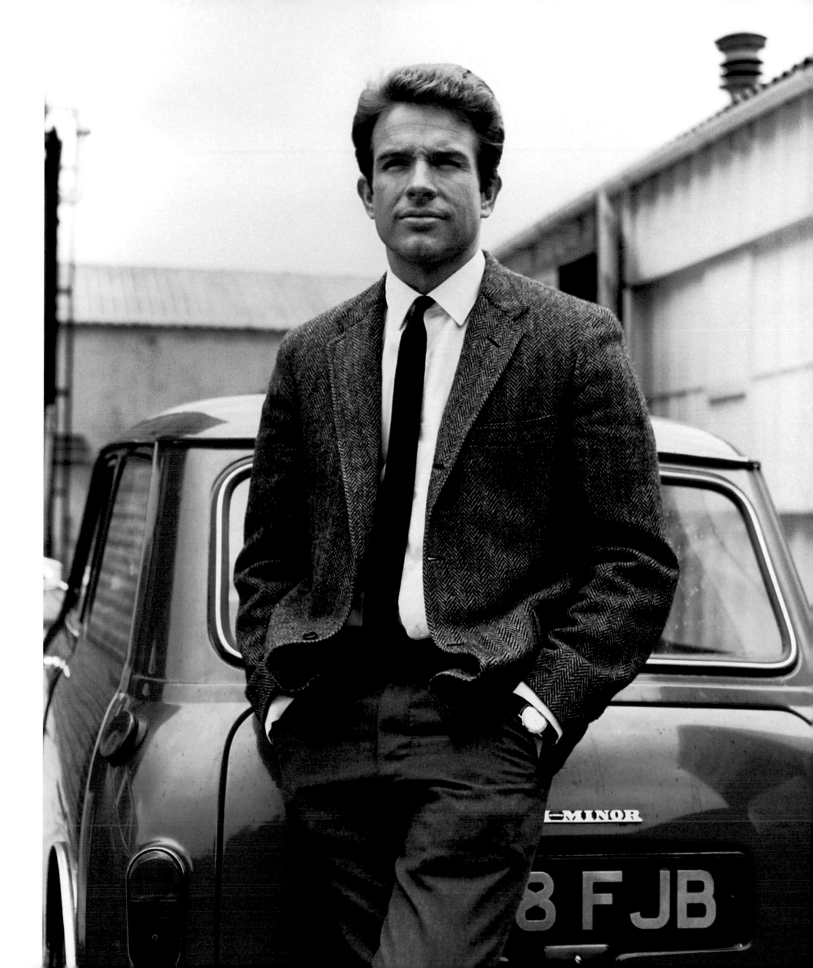

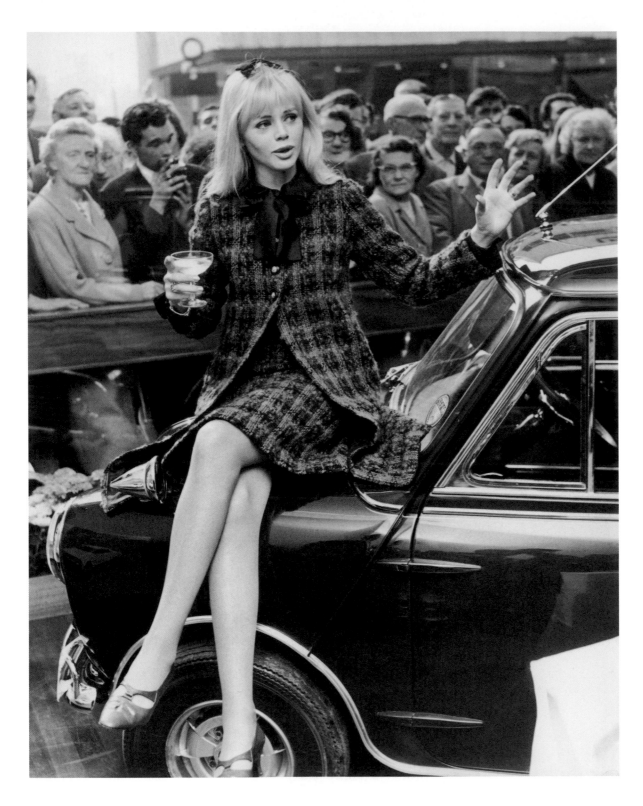

Above: Britt Ekland celebrates her brand-new luxury 1965 Radford Mini De Ville GT.

Opposite: Always the showman, Peter Sellers drives the Mini out of a giant cake, as a gift for his new bride.

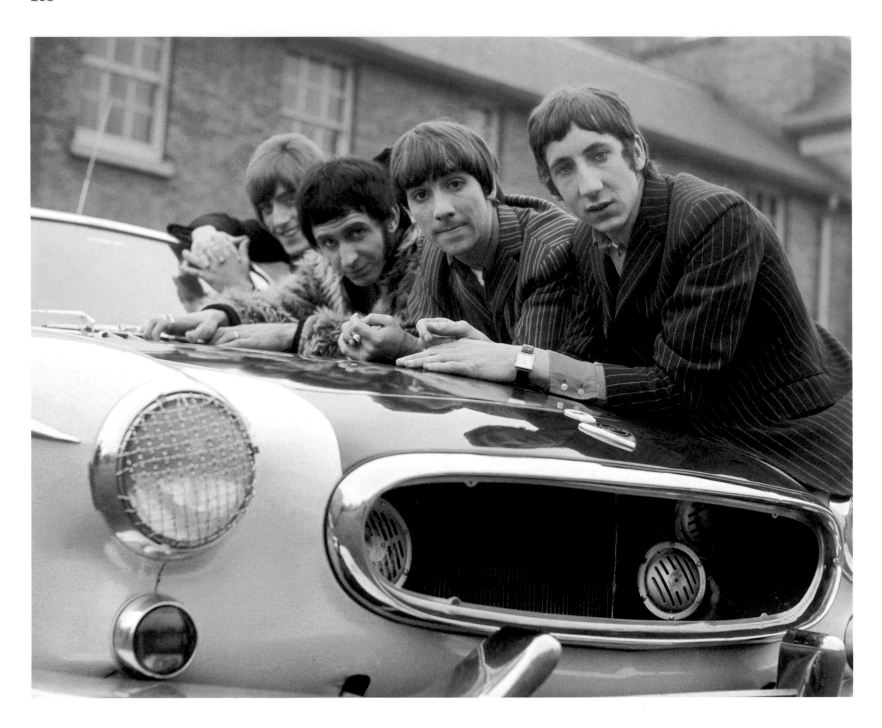

Above: The Who pose moodily with Roger Daltrey's 1966 Volvo P1800 coupé in London.

Opposite: The Dave Clark 5 pose on the South Bank, London with a 1964 Jaguar E-Type convertible.

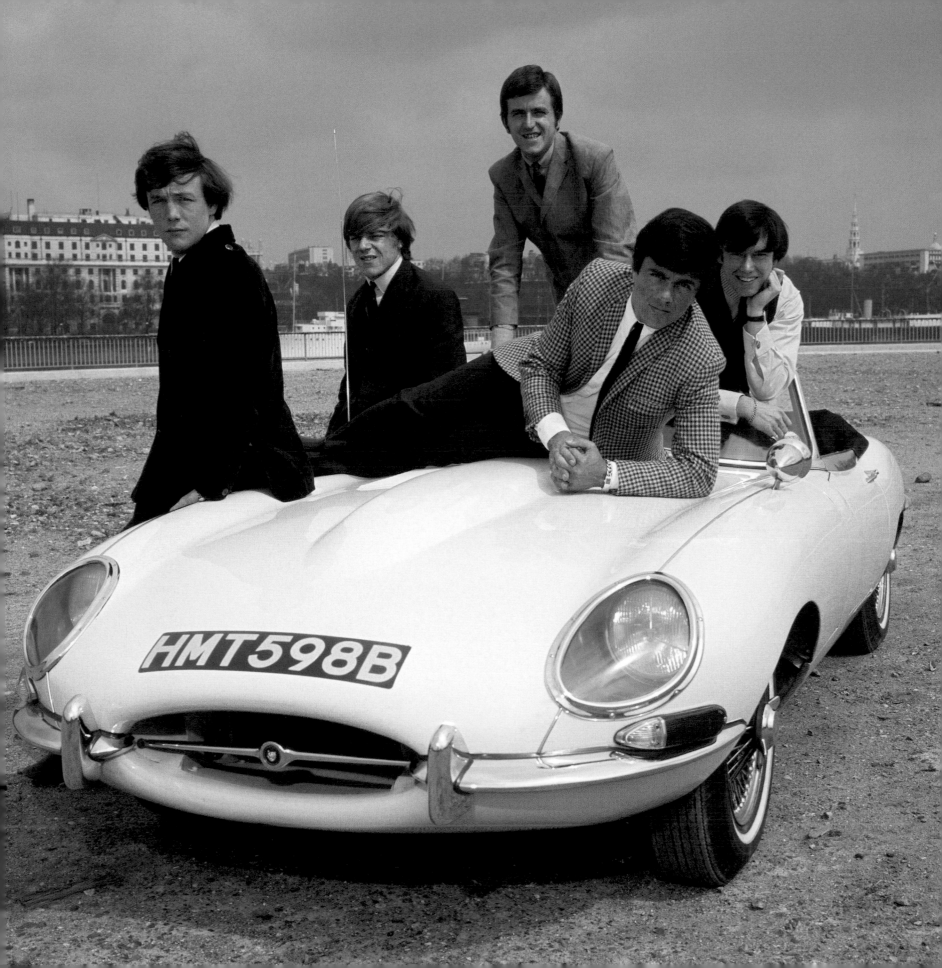

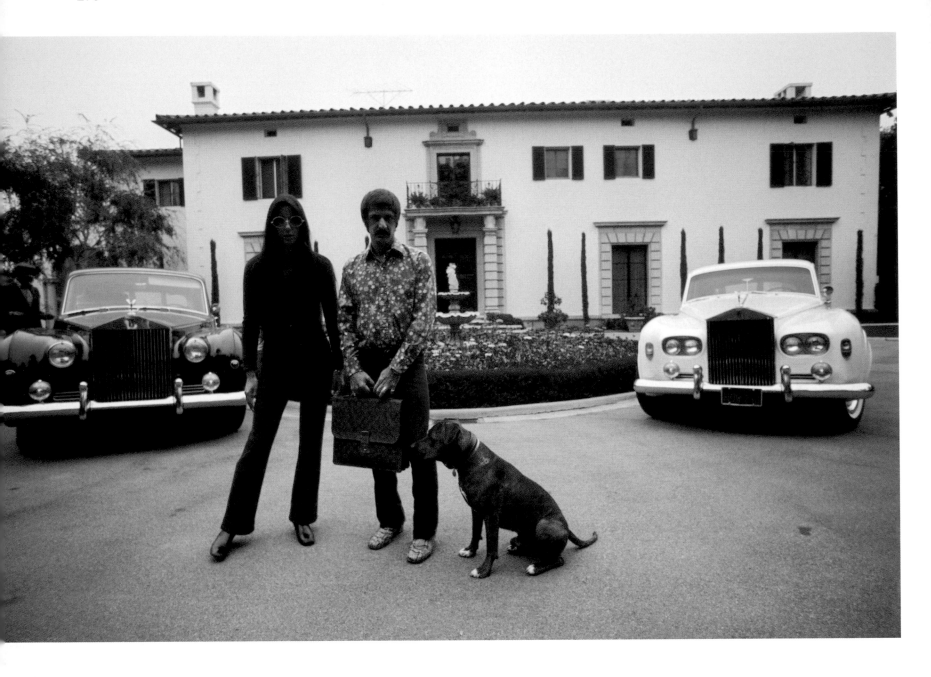

Above: Sonny and Cher with his-and-hers Rolls-Royces, outside their home in 1970.

Opposite: They also had twin-styled Mustangs made for them by famous craftsman George Barris. Affectionately known as the 'King of the Customisers', he supplied and built many famous cars for the stars.

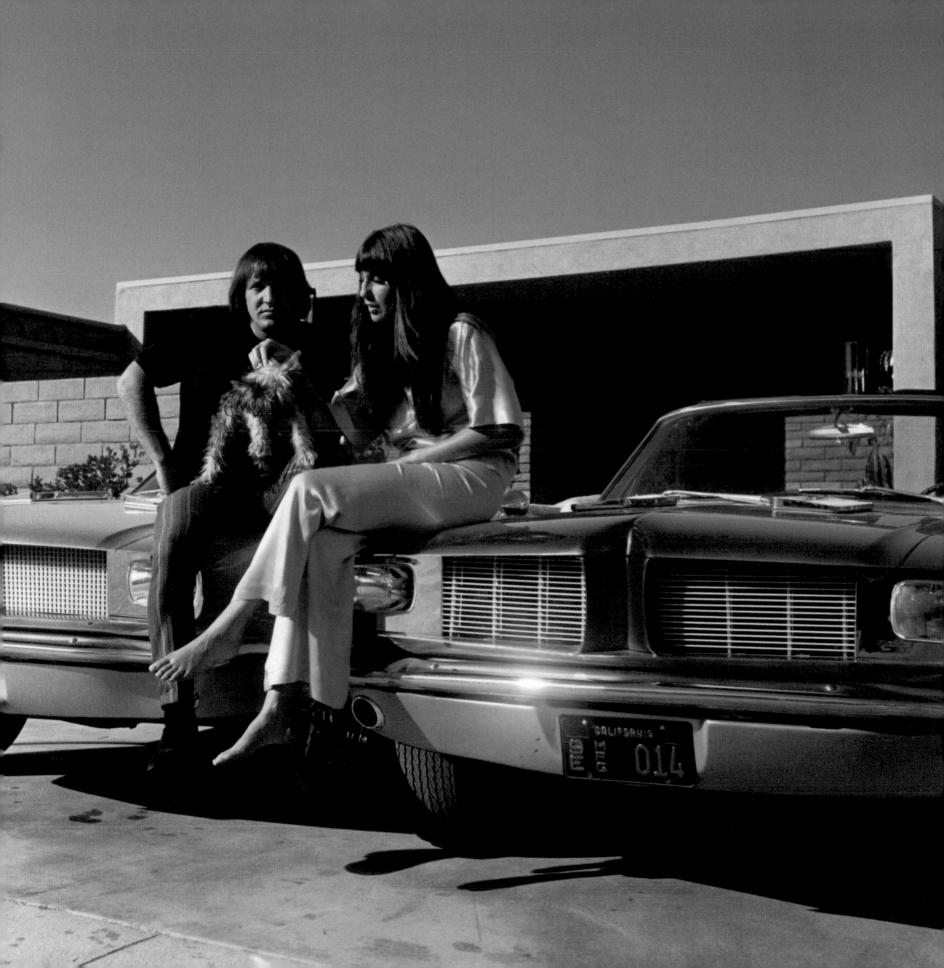

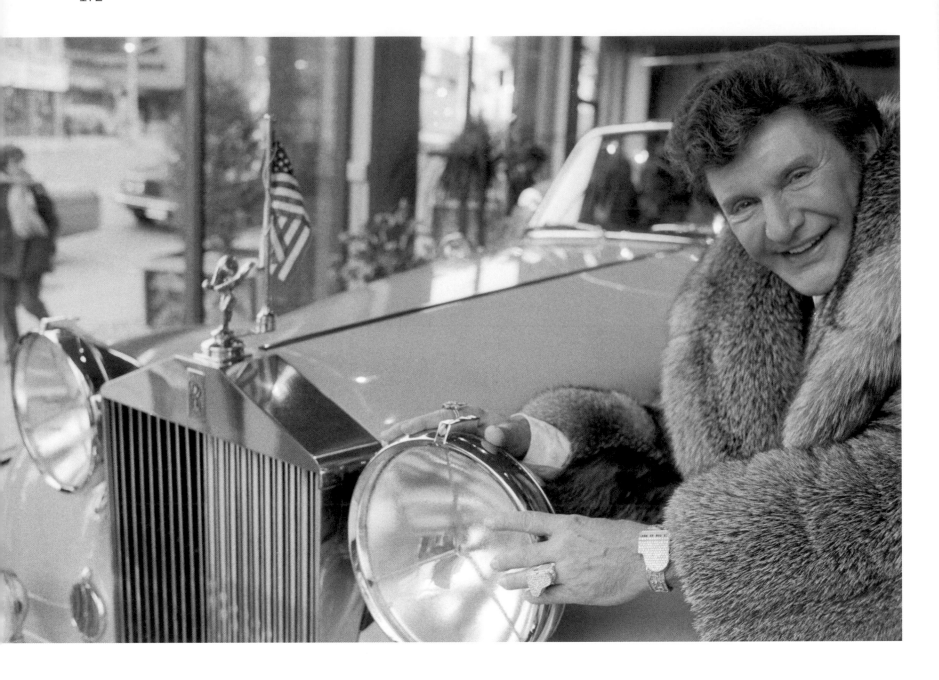

Above: Liberace purrs over his c.1957 Rolls-Royce Silver Cloud, which was formerly owned by Elizabeth Taylor and then-husband Mike Todd (who had helped to design the car).

The flamboyant piano prodigy also owned another Rolls-Royce, a diamond-studded dune buggy and a gold, gull-winged Bradley GT.

Opposite: Dudley Moore – 'Cuddly Dudley' – surrounded by a few of his admirers with his 1979 Rolls-Royce convertible.

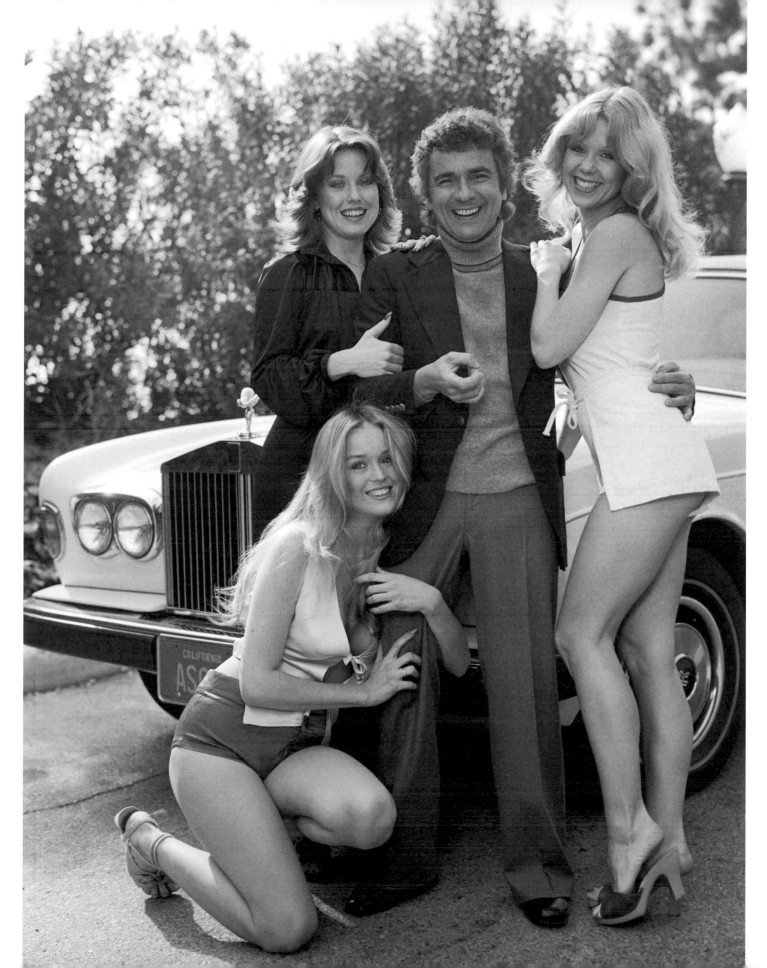

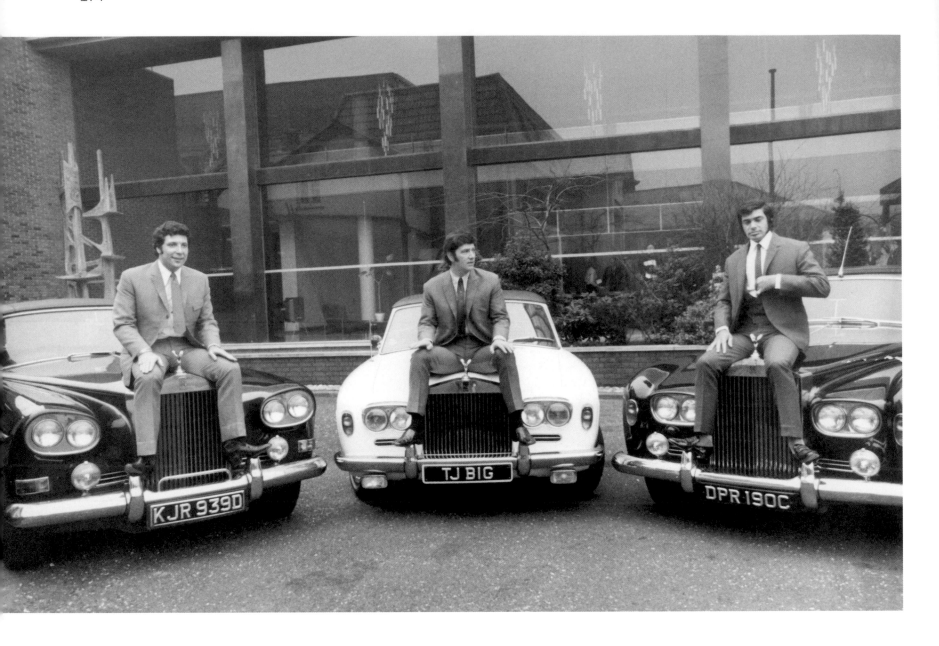

Above: Three men who are proud to show they have finally made it: singers Tom Jones (left) and Engelbert Humperdink (right) flank their manager Gordon Mills on the bonnets of three Rolls-Royce motor cars outside ATV Studios in Elstree. Tom and Engelbert both owned Silver Clouds, while Gordon opted for a Silver Shadow.
Opposite: Engelbert Humperdink poses next to his 1971 Rolls-Royce.

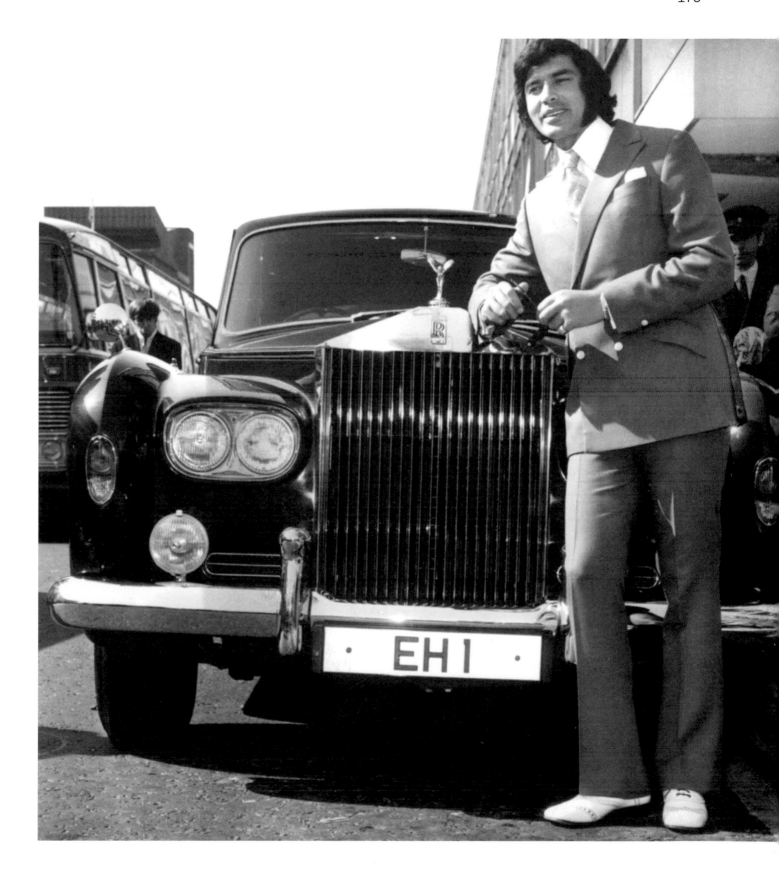

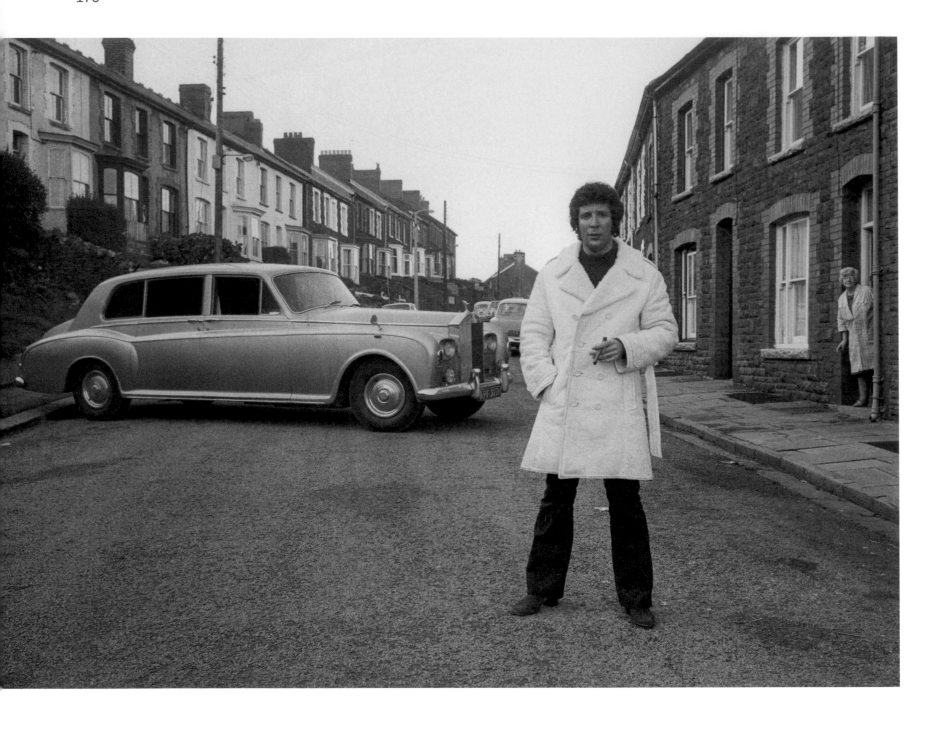

Above: Tom Jones, seen here with his huge, luxurious Rolls-Royce Phantom limousine, revisits his birthplace of Pontypridd, South Wales, 1974.

Opposite: Marvin Gaye walks ahead of his Rolls-Royce in Notting Hill, London, 1976.

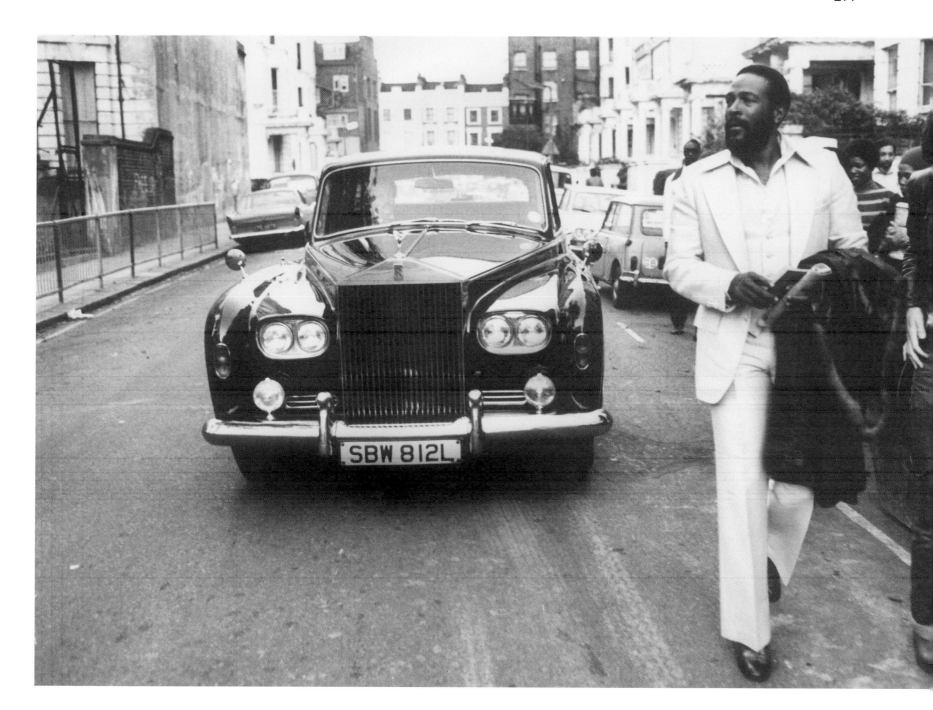

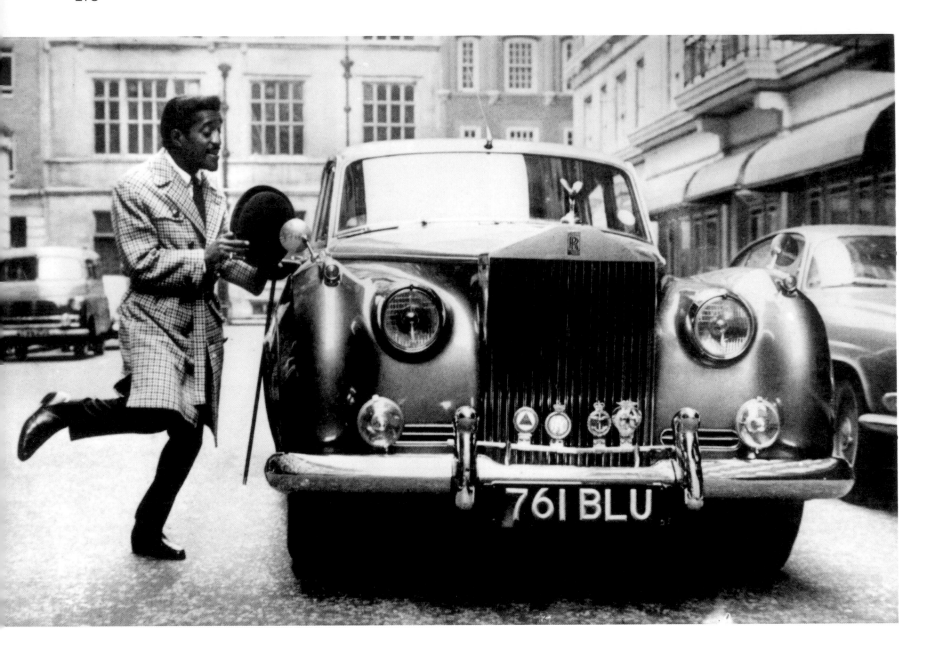

Above: Sammy Davis Jr skips happily to his Rolls-Royce whilst in England for a week of variety performances at the Empire Theatre, Liverpool in 1963.

Opposite: Cat Stevens with his Rolls-Royce in London, 1967.

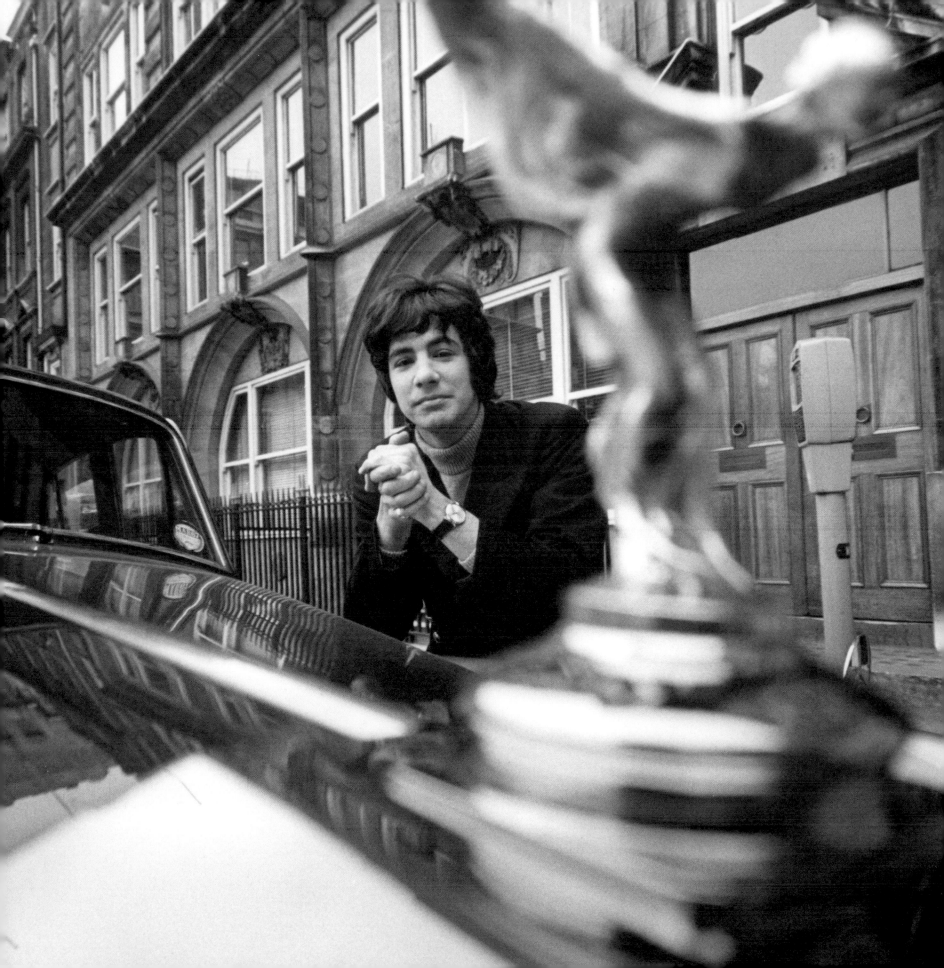

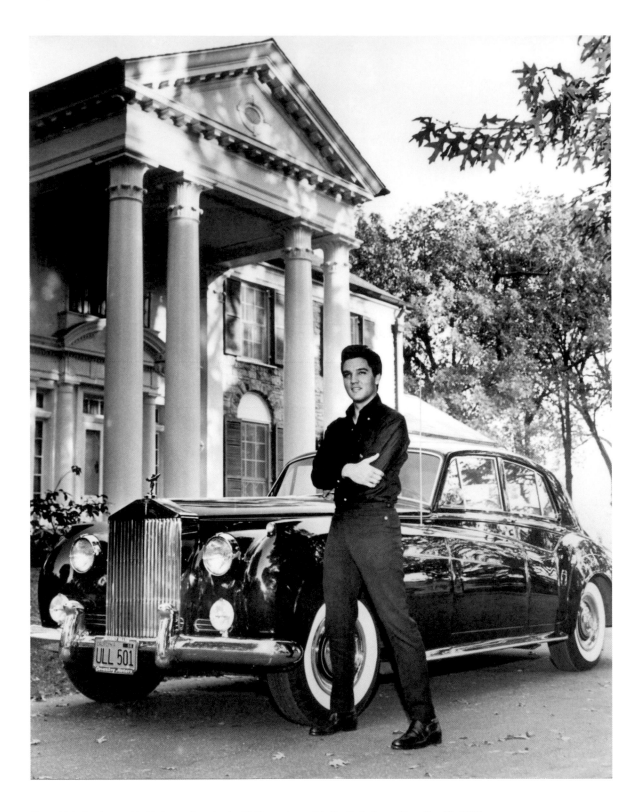

Above: Elvis Presley outside his home, Graceland, with his much-sought-after Rolls-Royce Silver Cloud in 1958.

Opposite: John Lennon in 1967 with his famous psychedelic Rolls-Royce.

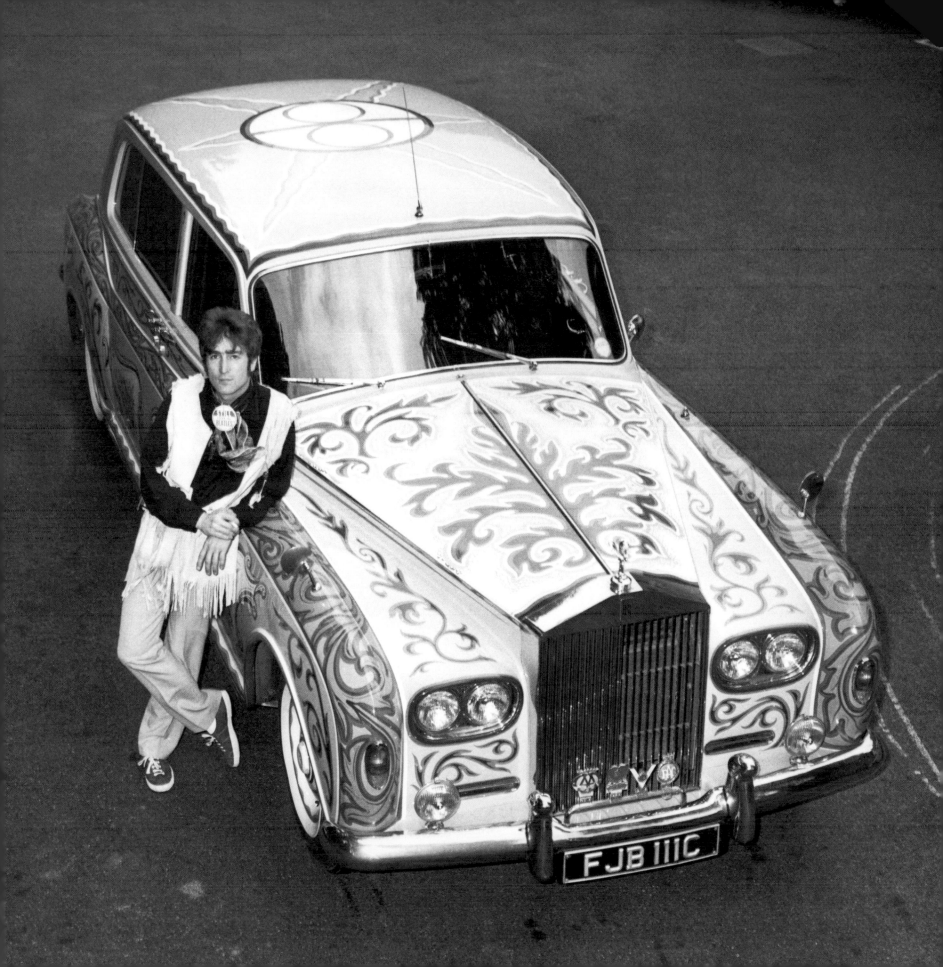

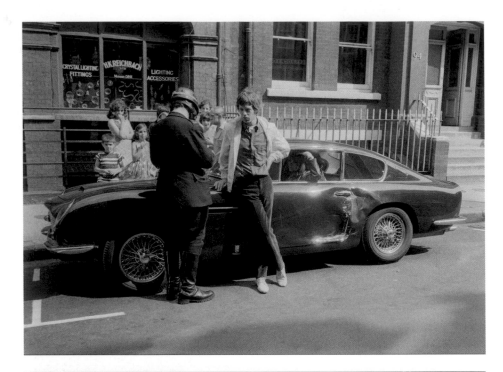

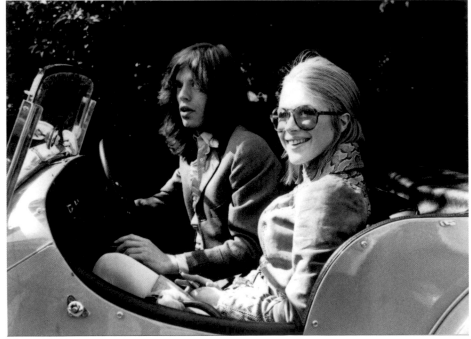

Top left: While his then-girlfriend Chrissie Shrimpton looks on, Mick Jagger has his particulars
taken by a policeman in London after a car crash in his Aston Martin DB6, 1966.
Bottom left: Jagger and his girlfriend Marianne Faithful in his Morgan sports car. The couple are on their
way to their hearing at Marlborough Street Court, London on charges of drug possession in 1969.
Opposite: The Rolling Stones pose with a 1930s Derby Bentley convertible in 1964.

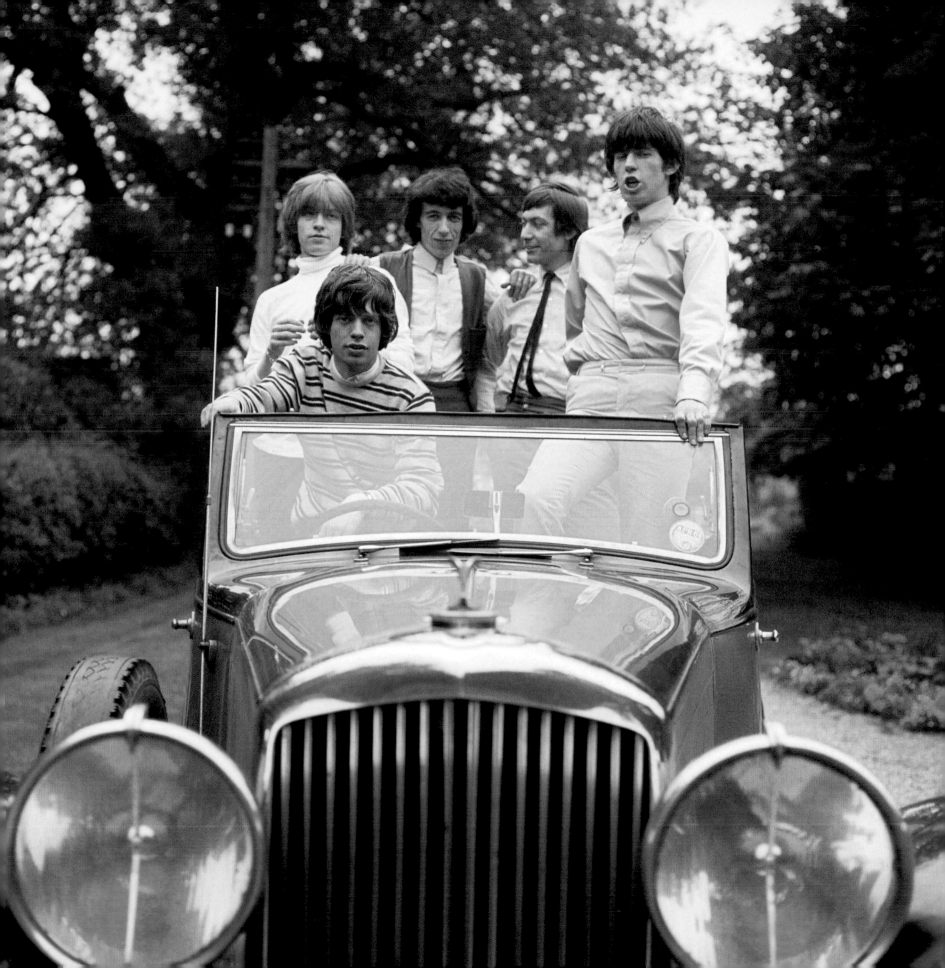

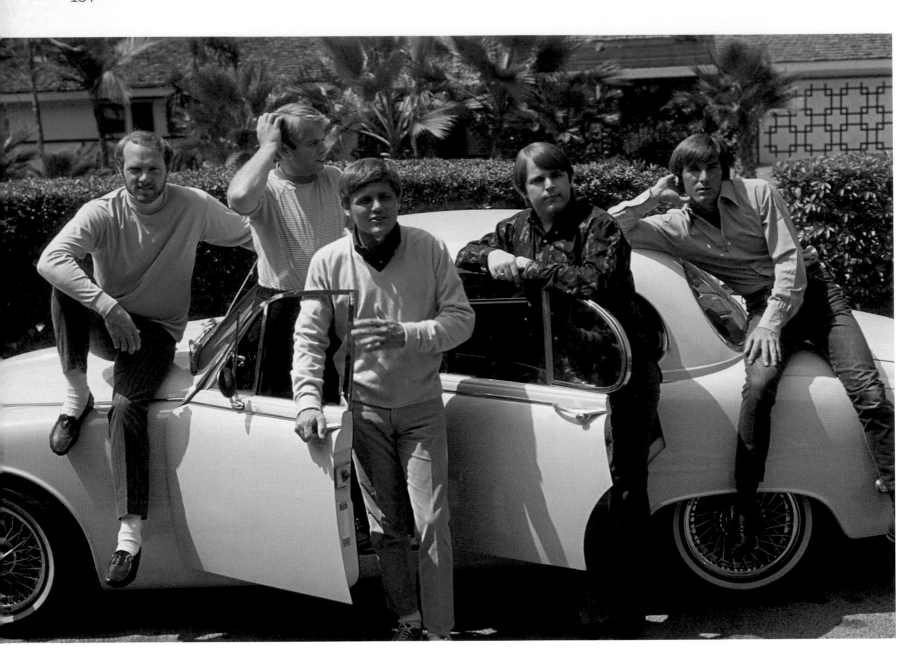

Above: The Beach Boys with their 1966 Jaguar 3.8 S.
Opposite: The Beach Boys in a London square with their wild dragster.

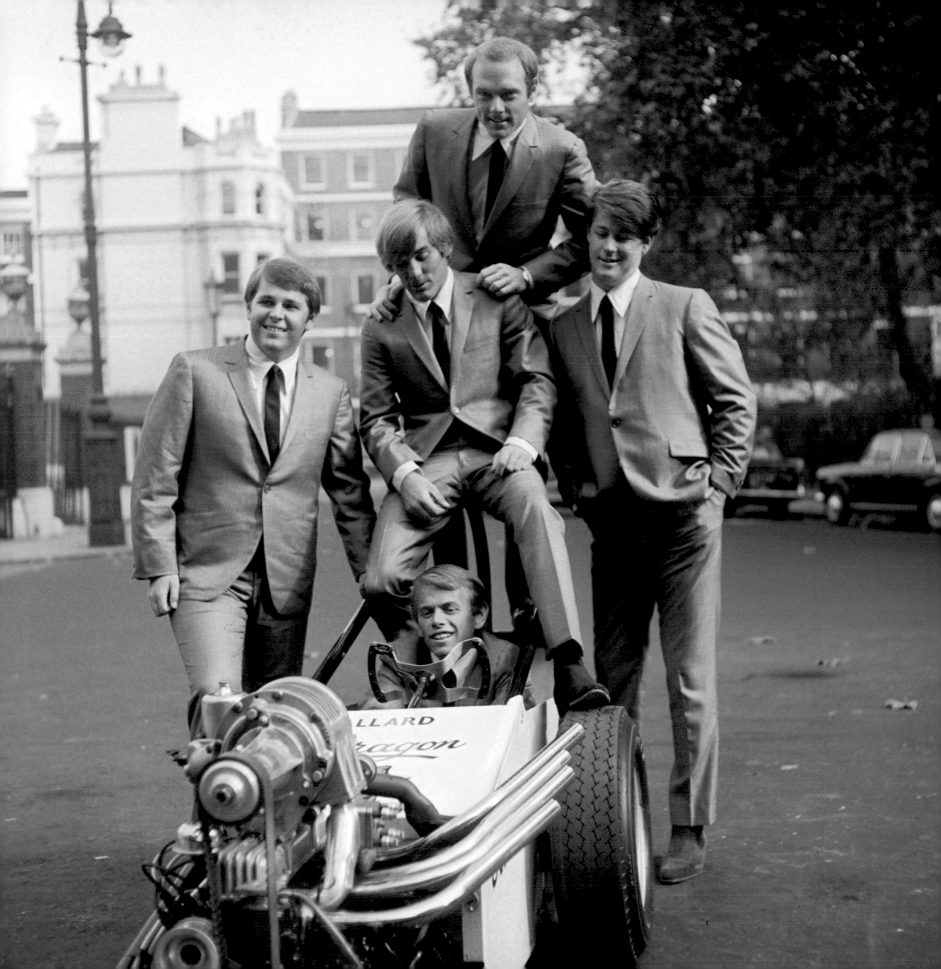

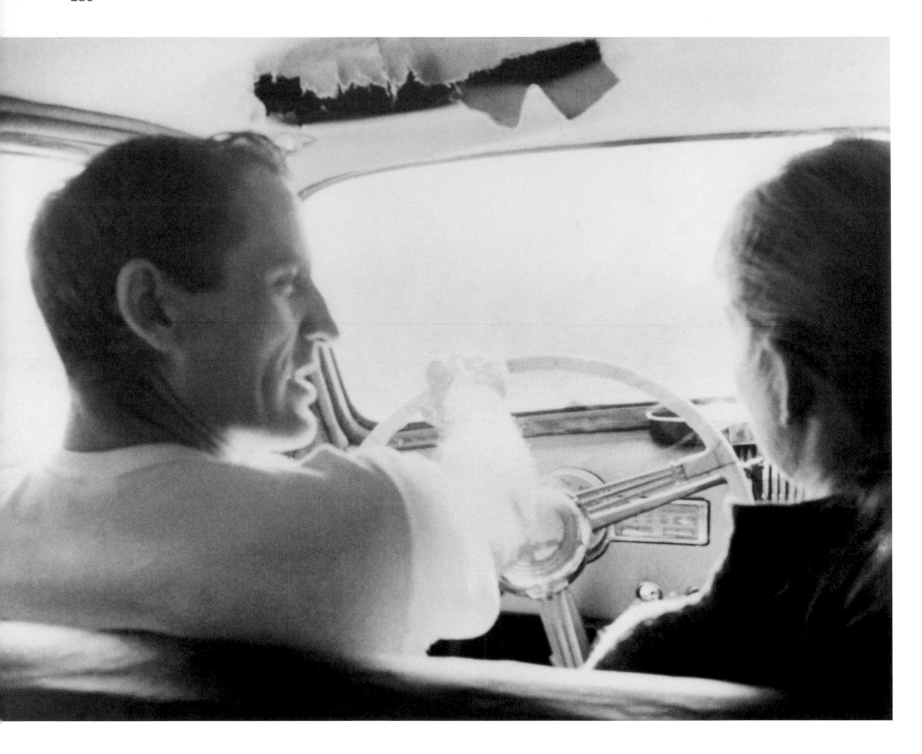

Above: Neal Cassady, the inspiration for Dean Moriarty in Jack Kerouac's novel *On the Road*, cruises the streets with a female friend in the 1950s.

Opposite: Hunter S. Thompson fires his favourite 45mm handgun in the air from the 1960s convertible he called 'The Red Shark'.

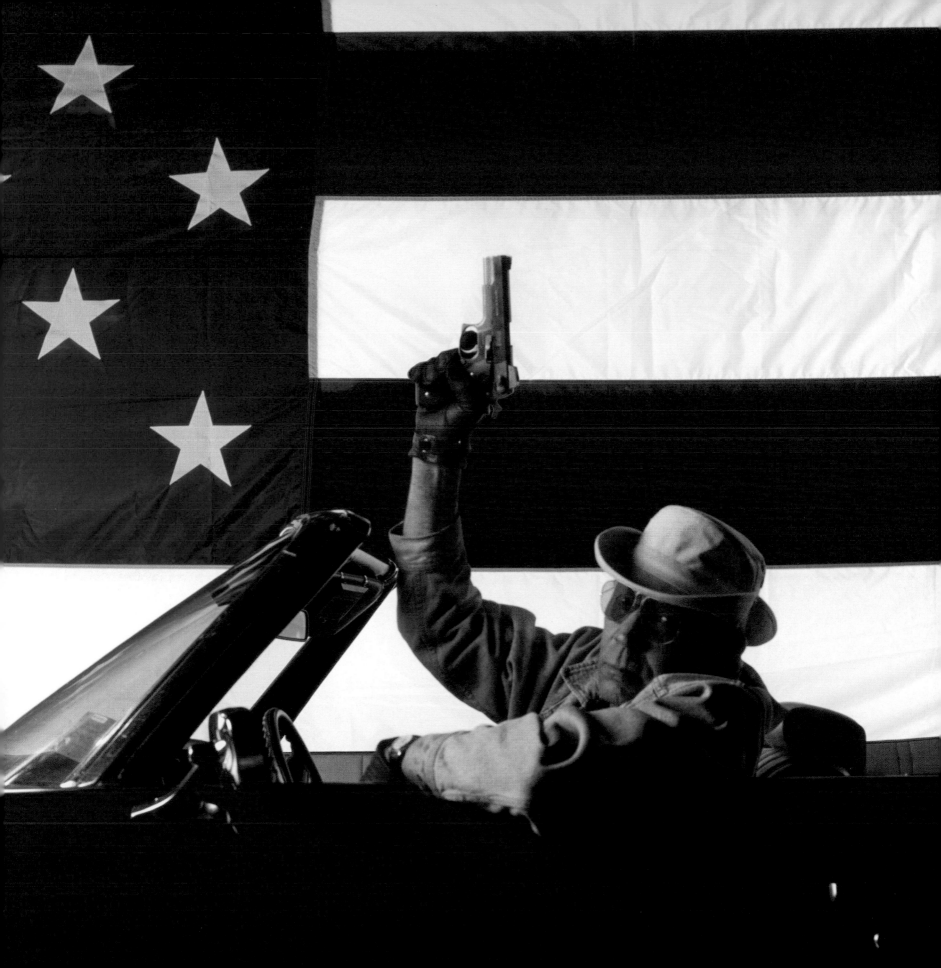

Index of Stars

Opposite: Actress Rita Hayworth sets a shining example in 1942 by donating the bumpers of her car to the war effort.

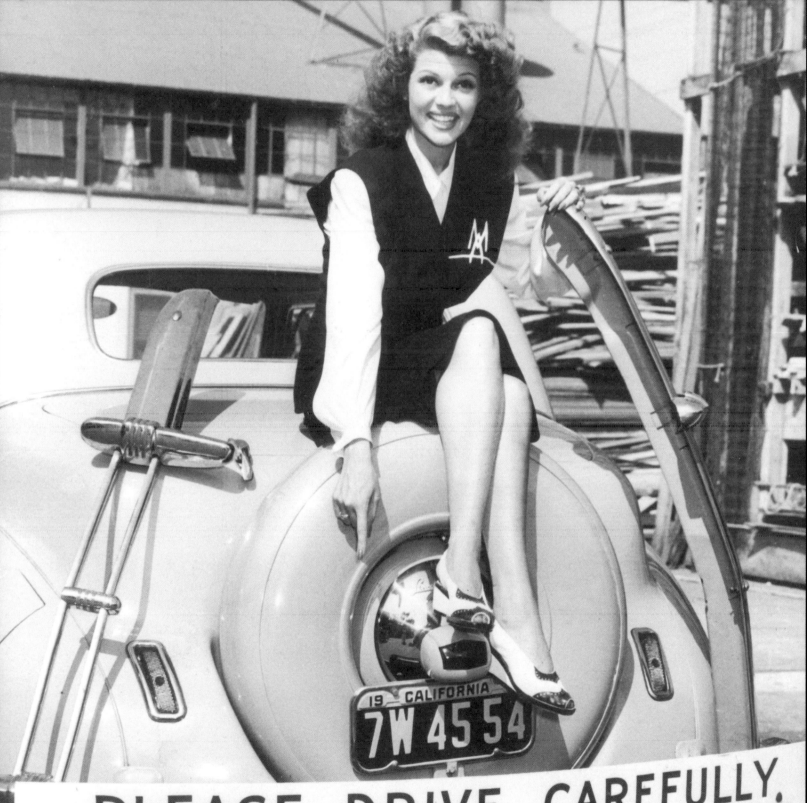

PLEASE DRIVE CAREFULLY.
MY BUMPERS ARE ON THE SCRAP HEAP

Index of Cars

Opposite: Cary Grant, as ever impeccably dressed, reads through a script at the seat of his early 1950s 'Woodie' station wagon.

Overleaf: Marilyn Monroe turns on her most seductive smile as she steps out of her car into the Californian sunshine.

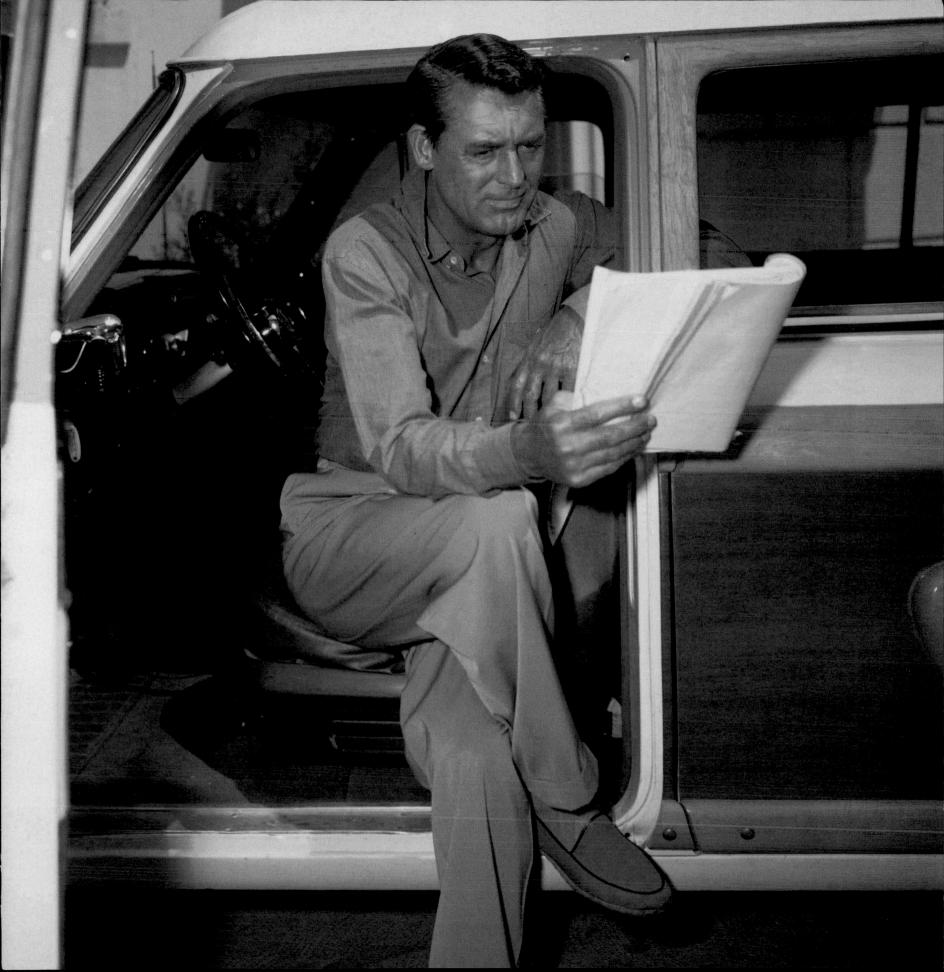

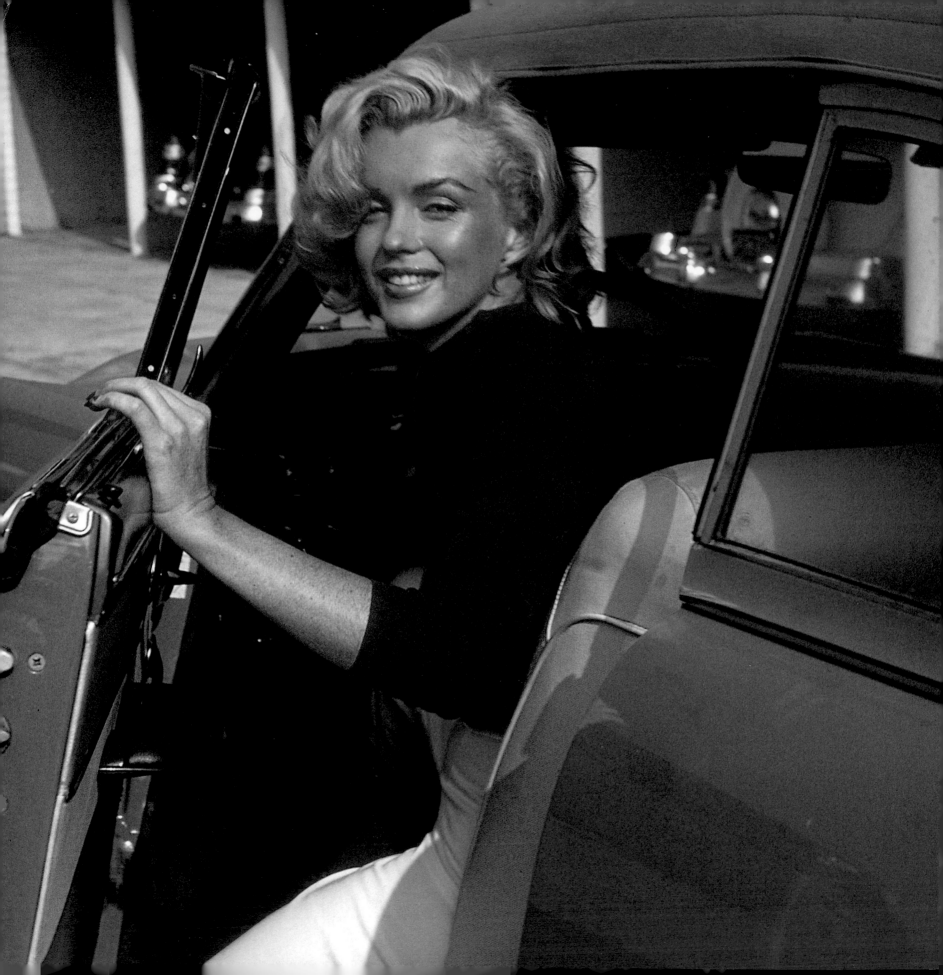